Aesthetics and Economics

AESTHETICS AND ECONOMICS

by

Gianfranco Mossetto

University of Venice,
and International Center for Art Economics

KLUWER ACADEMIC PUBLISHERS

DORDRECHT / BOSTON / LONDON

Library of Congress Cataloging-in-Publication Data

Mossetto, Gianfranco, 1944-
 Aesthetics and economics / by Gianfranco Mossetto.
 p. cm.
 Includes index.
 ISBN 0-7923-2296-7 (acid-free paper)
 1. Economics. 2. Aesthetics. I. Title.
 HB72.M58 1993
 330--dc20 93-15476

ISBN 0-7923-2296-7

Published by Kluwer Academic Publishers,
P.O. Box 17, 3300 AA Dordrecht, The Netherlands.

Kluwer Academic Publishers incorporates
the publishing programmes of
D. Reidel, Martinus Nijhoff, Dr W. Junk and MTP Press.

Sold and distributed in the U.S.A. and Canada
by Kluwer Academic Publishers,
101 Philip Drive, Norwell, MA 02061, U.S.A.

In all other countries, sold and distributed
by Kluwer Academic Publishers Group,
P.O. Box 322, 3300 AH Dordrecht, The Netherlands.

Printed on acid-free paper

Printed in the Netherlands

To Alexandra

"Nothing diverges more from beauty than utility; utility can well be added to beauty, but can never participate to constitute it."
(Pareyson L., (1991), p.215).

"The true function of welfare economics is to invade the discipline of applied ethics rather than to avoid it"
(Blaug M., (1978), p.541).

Table of contents

INTRODUCTION

General proposals

This book deals with the literary precedents and the consequences of the qualification of economic analysis with the use of attributes belonging to the field of aesthetics.

Even though economists have been concerned with art and beauty since the age of Classical economics, the real significance of the aesthetic qualification of goods and processes for economic theory has not yet been fully investigated.

During this century cultural and institutional economists have mainly dealt with the application of economics to artistic markets and their subsidization, and with that of the aesthetic theory of creativity to scientific processes. Therefore, there seems to be room for research on the scientific subject of the application of aesthetic qualification to economic analysis.

Starting from an inquiry into economic literature to understand the theoretical significance of economists' concern with the arts and culture, the book provides an approach to the market of cultural goods taking into account their specific aesthetic nature and its consequences on how production, consumption and collective decision-making functions are formulated.

Multiple equilibria and market optimization problems are discussed, together with possible administrative solutions of subsidization, rationing and regulation through standards. Unusual increasing marginal return laws as well as positive marginal transformation ratios are also investigated. The nature of cultural institutions and their behavior are analyzed in the light of historical evidence and of their role in the market and society. The specific problem of rights assignment and entitlement is reviewed to ground regulatory and law enforcement activities in the field. Scarcity and irreplaceability problems of choice, concerning subjects such as preservation of cultural heritage, the joint use of cultural products for cultural and non-cultural purposes, compatibility between cultural preservation and economic development, the transition from legal to illegal markets and the economic relationship between the genuine and the fake are studied on these premises.

CHAPTER 1

THE AESTHETIC QUALIFICATION

1.1 Why should we bother about aesthetics?

The first step in qualifying economics from the point of view of aesthetics is undoubtedly that of finding a suitable definition of the attribute to be applied.

What is the difference between an aesthetic good and any other good? And what importance does this difference have on the nature of the good itself?

Is it merely the difference that we connect to beautiful and ugly objects? If this is so, why should we bother about something which can be solved through the usual application of the well-established theory of preferences?

The easiest way to put the distinction is that the beautiful is what I like and the ugly is what I dislike. Normally we could stop there. Unfortunately, as we will show in chapter 3, this is of no help in analysing, and even less in prescribing, social choices on goods endowed with aesthetic qualification, nor in understanding the peculiarities of the process of taste formation and change on artistic markets, and those of the allocation of value following the artistic production.

Furthermore, and more precisely, the resort to the theory of preferences does not help in understanding why there is a difference in choosing, both individually and socially, the beneficial or the harmful, the good or the bad, the beautiful or the ugly.

Neo-classical economists tend to say that from their point of view there is no important difference in those sets of choices. They can all be reduced to the first: the choice between the beneficial and the harmful. If contradictions occur, that is if the beneficial happens not to be the good and the beautiful at the same time, this depends on a mistaken evaluation on the part of individuals because of their ignorance of some terms of the problem. They are supposed, therefore, time after time, either not to be endowed with perfect information, or not to be able to achieve a proper evaluation of the future, or to be incentivated by these reasons to some strategic behavior, etc..

Amartya Sen (1985) and his followers opened the way to analyzing a different solution, arguing that from the economists' point of view,

the difference between the good and the bad has different funda-
mentals and implications than that between the beneficial and the
harmful, as the former requires a greater degree of freedom than the
latter.

A further extension of this approach to the third alternative (the
"beautiful/ugly" set) is suggested here. The bases of this extension
are taken from modern and contemporary aesthetic theory.

The aesthetic qualification was condemned by Immanuel Kant to
perpetual "irrationality", not belonging, unlike economics, to the
domains of Practical Reason, since the eighteenth century (see
chapter 2). This extension will therefore require a higher degree of
non-consequentiality.

1.2 How to define the aesthetic qualification?

Given the economic importance of distinguishing alternatives in
terms of their efficiency, equity and beauty in order to improve the
capacity of economic analysis, it is important to attempt to achieve
better insight into the specific nature of what we have called
"aesthetic qualification".

This qualification must be based on the specific features of the
alternative it defines, which are methodologically different from
those characterizing efficient and equitable alternatives. In other
words, it must be based on a specific kind of judgement: aesthetic
judgement.

Let us therefore start this inquiry from the most "established"
definition of "aesthetic judgement", the one which (either qualified
or rejected) still remains the basis of modern aesthetics: Kant's
definition of "reflective judgement" as "taste judgement", to be
distinguished from "determinative judgement", belonging to the
domain of "intellect" and "practice".

Aesthetic judgement stems from the exercise of knowledge
capabilities but it does not have knowledge aims. It derives from the
conception of "finality" but it is not morally (or ethically) "final-
ized" (1). It is " a pleasure without interest", "a finality without aim",
"a regularity without law" (2). "Beauty", thus differs both from

"utility" and from "morals". The "useful" is judged by sensations, being an object of physical and intellectual knowledge (Pure Reason). The "good" is judged rationally with respect to some aims, or as an aim in itself (Practical Reason). The "beautiful" is judged by sentiments, being an object of pleasure or dislike rather than of knowledge (Pure Judgement) (3). The "useful" exists for all sentient beings, including animals. It does not distinguish sentiments from sensations (it is pleasure with knowledge of the object which produces sensations). The "good" exists for rational beings. It does not distinguish sentiments from needs (it is pleasure with willingness to achieve an end). The "beautiful" exists only for human beings, as they are rational animals, sentient and rational at the same time (it is pure pleasure).

The absence of "interest" and "aim" is a permanent feature of aesthetic judgements embodied in all current modern conceptions of art. Jean Genet, in his "L'atelier de Alberto Giacometti" (Lion, Barbezat, 1958) makes a revealing comment on the sculptor's aesthetic conception which is the best evidence of this permanent feature. "There must be a link between the severe and lonely faces of his statues and Giacometti's weakness for whores (....). Once he admitted:What I like in whores is that they are not of any use. They are there and that is all".

More theoretically, contemporary philosophers of art talk about "art which goes by the name of nothing" by which they mean that the specific characteristic of art is that of being "a methodological and functional nothing, that is no longer ontological and real and even less mystic or metaphysical" (4).

"The methodological nothing (...) is the tool to escape from the deadly halt in the identical". "The annihilating imagination after having repealed the world as given leads to the unknown of unpublished works and worlds" (5). Like Adorno's "fireworks" (inspired by Paul Valéry), the work of art is apparition, "empirical manifestation, free from the burden of empiria". "The separation of the domain of aesthetics resulting from the complete lack of ends of total effimerity" leads to art (6).

Aesthetic theory, having been developed in this century as a denial

of the theory of art (and of art itself), is responsible for the exclusion of beauty (as "the" aesthetic qualification) from the analysis of experience, unlike what usually happens with equity and utility.

1.3 Culture and art

The aesthetic qualification is also different from the cultural qualification, even if there is a large majority which strongly believes that culture has necessarily an aesthetic positive implication.

This is in no way justified.

Culture is a different way of using the same resources. This use can either be part of an aesthetic experience or not. Culture, therefore, is neutral from the aesthetic point of view. Moreover we will demonstrate that culture can be the cause of aesthetic waste (or loss of aesthetic quality) (see chapter 6).

Art, on the other hand, as it is always a part of culture, shares the economic attributes of culture. This not only means that it shares the characteristics mentioned in point 1.2, but also that:

a. It changes over the course of time. It is a product of fashion, addiction and generally of external consumption and intertemporal effects.

b. It can be learnt-by-doing; that is, it is a matter of private investment as human capital, but also a public (or "mixed") good, endowed with total or partial non-excludability and/or non-rivalry of consumption. Its production, consumption and preservation are subject to free-riding behaviors.

c. It includes technology, but is not only made up of technology. Besides aesthetic creativity and/or interpretation, it includes art and crafting skill.

d. It can be seen either as a good (I can sell my art and my work on the market) or as a production factor (like Schumpeter's "animal spirits"), or as a process (it conditions the formulation of production functions).

e. Its production and consumption can create both positive and negative externalities (seagulls are generally damaged by sculptor

Christo's packagings of the White Cliffs of Dover or of the Seine bridges. A famous Polish movie director in search of higher realism bombed and destroyed a block of ancient gothic houses in Crakow ghetto in Geriek's days etc...)

f. Its dynamics are made up of:

 f.1 an accumulation component (learning-by-doing-like), which is easier the larger its positive external effects;

 f.2 a dismissal component (dying-arts-like) which is quicker the more frequent the creativity (exogenous) process of production of new art and culture).

 When dismissed, it becomes irreplaceable. It cannot be reproduced, it can only be preserved, (see chapter 8).

g. Due to its specific aesthetic characteristics coming from creativity and interpretation, as mentioned above, the art market is endowed with a specific information asymmetry. What is art for someone able to create or to interpret it, can be non-art for someone else simply because he is not able to create or interpret, (see chapter 3). This leads to some significant consequences for artistic products, besides those generally affecting imperfect information markets (like stardom and demand non - monotonicity), (see chapter 4). They are:

 g.1 A general need for quality certification by those who are able to create or to interpret (that means self-certification), (see chapter 6).

 g.2 The possibility of the existence of two kinds of consumers: those who consume because they somehow interpret the product (cultural consumers) and those who do not interpret but still consume for different purposes (non- cultural consumers, like art-merchants, publishers, booksellers, hotel owners, corporations sponsoring the arts for the enhancement of their image etc.). They behave differently, and this has a specific effect on social welfare (see chapter 7 and 8).

h. The separation between efficiency and ethical and aesthetic qualifications leads to contradictions in the process of entitlement of the right to decide on art (as well as on culture). The "natural" assignment to the creator or to the interpreter following the general

rule of the "lowest cost avoider" (Coase, (1960)), proves to be controversial with the maximization of social welfare because the self-certification of quality leads these agents to act strategically (see chapters 5, 6, 7, 8).

1.4 Creativity and interpretation

A further understanding of the meaning of "aesthetic judgement", which will be useful in the following analysis comes from the exploration of the two main aesthetic processes: "creativity" and "interpretation". They are affected by the same denial of gnostical consequentiality which characterizes the "aesthetic judgement" as defined above.

"Artistic operation is a procedure one starts without any previous knowledge of what to do and of how to do it. This is progressively discovered and invented during the course of the operation. Only when the operation has been successful, one can clearly see that what was done was exactly what had to be done and that the way of doing it was the only one in which it could have been done" (...)". The artist does not imagine his work as a whole and then executes it. He outlines it while making it" (7). "The artist realizes he has found what he was looking for (...) because what he succeeds in working out fills an expectation and satisfies a necessity" (8).

"In non-artistic operations one thing, at least, does need to be invented: the verification of the possibilities offered by a given set of laws and ends. In the arts everything must be created, and, above all, the individual rules of each artwork" (9).

The absence of a model is the main feature of aesthetic creativity as a consequence of the fact that it is an "adventurous" self-formulating hypothesis of a "useless" theory (it can give pleasure but is of no use to anyone). In this sense, the effect of artistic creation, although it exists, may not be captured by the market. One could call it a positive "internality". It is an internal positive permanent feature of the good which is beneficial for its creator even if it is not perceived by the rest of the world.

Creativity has its consumption version in "interpretation" which is

a type of knowledge in which the object reveals itself as much as the subject expresses himself (10). "True understanding is not the result of a knowledge which defines and constitutes its object, but of an interpretation" (...) "which runs a permanent risk of misunderstanding" (11). True beauty is neither objective nor subjective. It is "necessary but logically non-demonstrable" as creativity, and subjective as interpretation.

The introduction of creativity and interpretation in our analysis has economic consequences, as we will see in chapter 3.

1.5 Art and history

We have already said that art, like culture, changes over the course of time.

This means not only that the conception of art itself, and of the "aesthetic judgement" with it, has been deeply modified over time, but also that its specific applications, that is the arts, have been subject to wide changes.

The eighteenth-century philosophical revolution in the field of aesthetics on the one side (12), and the history of the artistic market of the nineteenth century (13) on the other, are good evidence of this.

The Kantian theory of aesthetics, which is usually seen as the first formally established aesthetic theory of modern times, is a deliberate denial of the past theorization of artistic experience either as a part of the rational experience of the world (according to the Anglo-Saxon empiricists) or as a common feature of the process through which Reason masters reality (Descartes and Liebnitz). After Kant's work, the beautiful differs from the good (which coincided in Hume's thought) (14) as does the useful from the delightful (which were joined in Boileau's view according to the Cartesian ideal of rational control of passions (15).

The so-called Pre-Raphaelite Revolution and the revival (or better, the reappraisal) of Italian "primitive" painters in the mid-19th century, is another example of the failure of any evolutionist theory in the field of art (such as that of Vasari, to recall the most established

one). In this case the "progress" of "modern art" was identified by the contemporaries in the development of the Modern English School of painting (eg. Wilkie and his followers). Ancient masters' works were considered a danger for this development. In the opinion of the editorialist of the "Art-Journal", one of the outstanding critical sources of the period, Giotto's works were only good in order to learn what should be avoided in painting and Orcagna was considered "an overvalued terrorist" (16).

Despite all this, and despite the fact that it was also based on economic reasons (as this opinion was led by the half Maecenas/half merchant Robert Vernon for well concealed business purposes and by representatives of the artistic establishment such as Sir Richard Westmacott to defend their social status) the "odd" prevailed. Official galleries started buying Italian "primitives", thus following a private market which had anticipated the official change in tastes by almost fifty years. The Pre-Raphaelites themselves, who were mutually damaged by the general public adversion for "primitives", came into fashion within ten years.

Conceptual changes, of course, can also be seen in the field of Science. The fourteenth-century Aristotelian "scientific" approach is no longer such in our days in the same way that the seventeenth-century *poetica della maraviglia* is now considered an overwhelming manifestation of bad taste. The evolution of science, however, can be seen as a progressive improvement of the scientific material and immaterial tools in handling reality, that is as a modification of its analytical understanding and prescriptive capacity.

In the aesthetic field, on the contrary, as historical changes are a product of "creativity", they do not depend on increases in conceptual functionality of the ideas embodied in the artistic products or of the aesthetic theories themselves. The evolution of the concept of art arises from the denial of reality itself, either because it is based on a separate reference to a non-real "superior" world (in the idealistic conception) or because it is founded on a deliberate (and obligatory) attempt to re-establish reality on more or less non-consequential bases.

The history of aesthetics may be described from two different

extreme approaches. On the one side, it may be seen as "a progressive clarification of the autonomous role of art (17) over time", starting from a given established philosophical conception of art and aesthetics (following Benedetto Croce's definition of aesthetics "come scienza dell'espressione linguistica generale"). On the other side, we may deny the possibility of giving a "once-and-for-all" steady definition of art, and assert the permanent transformation of its role through ever-changing different aesthetic theories (see, for instance, Tatarkiewicz's History of Aesthetics) (18).

What we accept here, according to the prevailing contemporary thought on aesthetics (19), is the absence of an *a priori* theoretical model with which to judge the evaluation of aesthetic theory given the historical modification of artistic experience itself. This does not mean that a theoretical approach to aesthetics is unnecessary under the pretext that only real experience is significant. It means only that this approach is bound to change over time in no connection with any pre-established functional role and with no progressive identification with it.

Moreover, the definition of art itself did conceptually change over time. The original Greek combination of "téchne" (which means the capacity or instrumental skill to pursue an aim) and "mousiké" (which means artistic activity with no original distinction between music, dance and poetry), where truth and illusion are mixed, was superceded by Plato's conception of "tragedy" as a specific form of non-philosophical knowledge of reality, where reality itself is represented in its ambiguity through passions, with no reference to the harmonic idealistic fundament of perfect beauty (20).

The idea of the work of art either as a manifestation of Divine (Medieval) or as a finite reproduction of the infinite (Renaissance) has in modern times been superceded by the "pure invention" of Baroque, where art is a representation of truth because it contradicts itself (leading to the so-called poetica del non so che) (21).

The contemporary fundamentals of Aesthetics -where art is conceptually based on the denial of art and reality itself-deriving from eighteenth-and nineteenth-century Kantian and Romantic aesthetic theory (22), is historically separated from the seventeenth and eight-

eenth-century conception of artistic experience, where pleasure and beauty are coincident in human experience (23).

We may say that in art and aesthetics, more than in any other discipline, the need for an epistemologically based "border trespassing", like that theorized by Derrida (24), is undeniable. All previously established models have to be denied in order to understand progress. Progress itself is bound to have neither positive nor negative connotation. Changes in theory and taste have to be seen in this perspective.

1.6 Summary and conclusions

It has been proved that the logical common sense distinction between the beneficial, the good and the beautiful, resists the tendency of Neo-Classical economics to consider them as coincident from the point of view of utility.

A lower level of non-consequentiality is required to distinguish the beautiful from other sets of alternatives, just as a higher degree of freedom is required to give an ethic qualification to the analysis.

The aesthetic qualification is based on modern aesthetic theory, mainly derived from Kant, whose definition of aesthetic or Pure Judgement as a "finality without aim" is the undenied basis of any further theoretical development.

Kant's separation of knowledge into different spheres (Practical Reason, Pure Reason and Pure Judgement) each including different disciplines (the first economics, the second ethics and the third aesthetics) is also at the origin of the rejection of aesthetic qualification in economic analysis.

Art and culture, even though they include different sets of attributes, are usually compared to give art a social and historical perspective.

The exogenous nature of modifications of aesthetic theories as well as of people's tastes have to be recognized in a historical perspective.

A further qualification of the analysis is supplied by the definition

of the two main aesthetic processes: "creativity" and "interpretation", on which a specific information asymmetry that will henceforth prove of economic importance is grounded.

28

Footnotes

(1) Pareyson (1984), p.40.

(2) Ibidem, p.45.

(3) Ibidem, p.46.

(4) Formaggio (1977), p.66.

(5) Ibidem, p.68.

(6) Adorno (1975), p.117.

(7) Pareyson (1991), p.69.

(8) Ibidem, p.71.

(9) Ibidem, p.67.

(10) Ibidem, p.189.

(11) Ibidem, p.186.

(12) Givone (1988) pp. 1-8.

(13) Haskell (1990).

(14) See Hume D.(1742) *Moral and Political Essays*.

(15) See Descartes R. (1650) *Compendium Musicae*:"Let your fruitful Muse unify everywhere the useful and the delightful".

(16) Haskell (1990) pp.111-119.

(17) Givone (1988) p.9.

(18) Tartarkiewicz (1979-84).

(19) See, for instance,Givone (1988); Formaggio (1981); Vattimo (1977); Breadsley (1966); Bayer (1961).

(20) Givone (1988), pp.11-14.

(21) Ibidem, pp.16-24.

(22) Ibidem,pp.125-129.

(23) Ibidem,pp.26-29.

(24) See Derrida (1967).

CHAPTER 2

EXPLORING THE ECONOMISTS' CONCERN WITH THE ARTS

2.1 The resort to art in economic theorizing

Art is not such a recent subject of economic inquiry as the usual treatment of this matter by economists might suggest. It is of course well-known to historians of economic thought, as well as to cultural economists, that Adam Smith devoted more than a few significant pages of his "Inquiry" (mainly in the first and fifth Books) to the arts and their consequences on the quality of labor and on social systems. Quotations from Ricardo, Marshall and other outstanding masters of this discipline are also a frequent introductory reference to the main collections of papers in this field over the last fifteen years.

My aim, here, however, is not to record or demonstrate the interest of economists in the arts in a historical perspective, but to analyze the importance of the arts as a case study for the development of economic thought. In doing so, I will attempt to focus on some unsolved problems and to suggest some possible lines for an economist's approach.

Since Smith's time, economists adopted a twofold attitude in dealing with the arts. On the one side, they have apparently been embarrassed by the specific nature of artistic goods and have tried either to exclude them from the scope of their analysis or to include them in it, but by claiming their non-economic nature; that is, by stating their ethical influence on the economy. On the other side, the power of their examples concerning the arts has often been a self-evident demonstration of the theoretical importance of the related cases for economic science in general, since it has been true not only for recent years, but mainly for the past, that "the application of economics to the arts (...) teaches us almost as much about economics as about arts" (1).

This generalization fits explicitly the view of the Classical and the late Marginalist economists. The prevailing apparent neglect of the arts by the Marginalists implicitly confirms this.

The Classical economists' resort to the arts in order to build theoretical exceptions (in consumption and production) to their theory of value is not a matter of their artistic inclination, but rather of the significance of these subjects as examples of "scarcity" in the real

world. Goods are objectively differentiated between those whose value is based on labor (which are the vast majority) and those whose value is determined mainly by "scarcity" (which are an unimportant minority). Artistic goods are often classified among the latter. The "Marginalist Revolution" eliminated this difference. All goods have a value which is based on "scarcity". The production and consumption of artistic goods is thus theoretically irrelevant, as it is identical to any other production and consumption process.

2.2 The Classics

At first glance, Adam Smith seems probably the best example of an economist who did not specifically care about the arts, but whose interest in the economic aspects of reality was so keen as to allow him to realize the economic importance of artistic goods and artists themselves as general case studies for economic theory.

2.2.1 Smith and aesthetics

Even though he was writing his "Inquiry" at a time and in a place where the theory of aesthetics had been raised to the status of an independent discipline for the first time in the history of philosophy, Smith is apparently unaware of the existence of such a distinction. Discussing the opportunity of teaching philosophy in universities, Smith talks of four main branches: physics, metaphysics, ethics and logic (2), completely ignoring aesthetics from the first (1776) to the last (1789) version of his work.

The word "Aesthetica" was introduced into philosophical terminology by Baumgarten in 1750, and from 1753 the new term "esthétique" was used in France (3). And it was there that, mainly in the early 1760s (1759-1765), Diderot and other Encyclopaedists developed a theorization on "creativity" and "tastes", in many respects anticipating Romanticism (4), and laying the foundations of modern artistic criticism.

Smith travelled in France and from 1764 to 1766 lived in Paris where he met Quesnay and other Physiocrats, who profoundly influenced his work, but he seems to have been untouched by the aesthetic aspects of the philosophical debate.

If we compare this approach with Keynes' attitude during his stay in Paris in 1918, when he played an active role in persuading the Chancellor of the Exchequer to buy an important part of Degas' private art collection, and when he himself bought works by Cézanne, Delacroix, Ingres and Degas (5), we can say that Smith's inclination towards the arts was somewhat indifferent.

This is even more surprising if we consider that French theorists in this field wrote under the influence of English philosophers (mainly Shaftesbury) and that England itself had been developing a whole school of aesthetics since the beginning of the eighteenth century, through the works of Burke, Home, Hume and Hutcheson, who was Smith's predecessor on the chair of philosophy at Glasgow University.

Moreover, Smith's thought, while very strongly indebted to Hume's theory of science, does not take into account in any way Hume's aesthetic theory, which is however epistemologically important in Smith's own work.

As this peculiar contradiction is a constant characteristic not only of Smith's thought but generally of economic science, it is worth examining a little more closely.

In Hume's approach to science, as inspired by Bacon, theory becomes "empirically" an "inquiry", and Smith's work is an "Inquiry". Hume's theory of "associations" (which are the "external" logically-connected relationships among sensible, or perceptual, terms of reference) is one of the bases of modern social science: of economics as well as of law and political science (6). The analysis of the acknowledgment process is completed by the theory of "fiction", which explains not only how errors can arise, but also the way in which, through imagination, scientific hypotheses can develop and be "positively" discerned from mere beliefs. Passions are thus included together with "associations" among the sources of knowledge.

Passions, however, do not reflect themselves in the imagination

(the "naked imagination") as it is, but as it has been determined by the existing association principles (the "naturalized imagination").

Society itself is no longer to be conceived as the product of a mere contract (à la Rousseau), but as an "artifice" or a product of social conventions where moral, political, legal, aesthetic "sentiments" are commonly shared by people.

"Possessing passions find in association principles the means to determine the general rules of propriety and rights (...). Why should, otherwise, the throwing of a javelin on a door have secured the property of a deserted town?" (7).

"Aesthetic sentiments find in association principles true rules of taste" (8). The "useful", the "beautiful" and the "good" are therefore led to historical coincidence.

Tastes are grounded on steady historical but also subjective bases. This subjectivity, shared by Hutcheson's theory of utility value (9), is exactly what Smith seems to reject in founding his theory of labor value. For him, the difference between the value of a "barrel of water" or " a barrel of wine" in different times and places, is not due to different social conventions (or "artifices") in Hume's sense and to the individual tastes that stem from them, but to the different "quantity of labor required by their production" (10).

In this respect, aesthetic theory appears one of the philosophical pillars on which the subjective utility theory was based, and what was previously seen as Smith's unawareness, looks rather like his more or less conscious refusal to consider aesthetics as a scientifically-grounded discipline.

While apparently ignoring or rejecting the existence of aesthetics as a separate branch of philosophy, Smith frequently resorts to beauty and art to qualify the exceptions to his theory of value. In so doing, he helps to clarify further his attitude towards aesthetics in the above-mentioned methodological sense. Beauty and the arts are part of economic reality. On the one side, besides all other physical attributes, they contribute to determining the use of commodities. There is no matter of distinction between them and any other source of "utility". In this respect they should only contribute to determining the use value of goods, not their exchange value.

On the other side, beauty and art are also price determinant and can explain, with "scarcity" (being its cause), the paradoxical difference between use and exchange values (as for "diamonds" and "water").

This contradiction can be found both in Smith's consumption theory and his production theory. The value of precious stones stems from their beauty and from their "scarcity" as well as from the cost of mining them (11), even if they have no other utility than that of being used as ornaments. Even though their work is "unproductive" (12), the salaries of actors, singers and dancers are "exorbitant " due to the "rareness" and to the "beauty" of "their talents" (13).

Prevailing interpretations of Smith's thought, (14) however, deny the contradiction on the grounds of two main arguments. His explanation of prices based on relative scarcity is not seen as an alternative to that founded on labor costs; both instead rather belong to a sort of general theory of choice (15).

Smith's conception of "utility" is itself founded on the conventional values of his time (exactly as theorized by Hume for all "artifices" or aesthetic and scientific hypotheses of interpretation of reality). In this sense, Smith's classification of "productive" or "unproductive" labor is only "objective", because it corresponded to the prevailing bourgeois ethical beliefs of emerging capitalism in eighteenth-century England (16).

"Usefulness" and "uselessness", as well as "beauty" and "ugliness", are to be considered on historical bases rather than as absolute opposite conceptions. This does not mean that Smith was always aware of the apparent contradiction of his thought, but only that the contradiction itself can be conciliated through a proper interpretation of Smith's thought.

This is clear when thinking of the social disapproval leading to the classification of the work of writers, comedians, clowns, musicians, singers and dancers as unproductive, and, at the same time, to the justification of the extraordinarily high salaries of these categories (17) or to the ambiguous twofold effect of private art expenditures, some (books, statues, paintings, for instance) giving rise to wealth accumulation and to national and individual prosperity, others to waste and ruin (apparently all the rest) (18).

Both consequences are in disaccord with Smith's statement that the wealth of a nation increases with the increase of the ratio between productive and unproductive labor, artistic labor being considered generally unproductive. They are consistent, however, with his moralistic opinion opposing superior material artistic goods to all the rest, to be classified as leisure immaterial goods (e.g. the products of performing arts).

Smith's point of view seems to admit "productivity" of labor to be conditioned by the historical evolution of the economy and tastes. Thus an ancient Seymour family castle can become an inn on the way to Bath (19).

In this vein, the arts are historically considered by Smith to be "useful" if they are a means to humanize the citizens' soul and moderate their temper, in order to give them a better inclination towards morals and social duties in private and public life (20).

Puritan ethics prevail rather negatively in this part of Smith's analysis, leading him to argue that "music", the main public artistic subject of education in ancient times, was of no use in purifying morals (21) and that, in modern times, a man of real capacities can hardly find a more humiliating and less proficuous job than to be a scholar (22).

The only social legitimization he effectively recognizes for the arts is as a remedy against asociality and fanaticism. More than conceiving artistic education as a matter of public intervention, he seems to think of art as a leisure good to be used to provide social consent (the circenses of Roman tradition).

These are, however, the best known, but least important of Smith's statements on the arts. Their only interest is the fact that, as well as other "unproductive" examples, they disguise the true meaning of his methodological approach; that is, Smith's presentation of the historical assumptions of his value theory under the appearance of "objective" ever-lasting assessments on economic reality.

2.2.2 Ricardo's distinction

Ricardo's scientific approach to economics takes into account only the consequences but neither the historical nor the epistemological

premises of Smith's methodological misguidance. His theory is scientifically grounded on a well-circumscribed definition of commodities which methodologically eliminates the influence of "scarcity" as being due to the irreplaceability of goods.

He explicitly claims to deal only with those commodities the quantity of which can be increased through human labor and on the production of which competition operates without limits. This completely excludes "rare statues and paintings", "scarce books and coins" and wines of particular quality, their value being independent from the quantity of labor originally necessary to produce them, and varying on the contrary with their consumers' "wealth and tastes" (23). All historical relativity is banned. The exclusion is simply empirically motivated by the fact that the everyday exchanged market quantity of these goods is "very small" (24).

In this perspective, the "artistic" quality of labor also becomes irrelevant. On the one hand, more skilled labor creates higher value than unskilled labor, and that is all. On the other hand, Ricardo eliminates any distinction between necessary and simply leisure goods, all goods representing only the labor they were created by, and on which their value relies (25).

All contradictions, however, do not seem to disappear completely from Ricardo's theory by assuming these objective starting points. The arts, again, provide an interesting test.

Ricardo, like Smith, considers the arts ethically as products of leisure. Following his theory, the wealth of a nation increases as much as private expenditure in art decreases (26), because of the unproductive nature of artistic labor (which creates value, but not wealth in Ricardo's sense).

In Ricardo's opinion, artistic goods, however, are also "scarce" by definition. Scarcity diminishes, *ceteris paribus*, "the wealth of a nation and of individuals", depriving them at least partially of their "satisfaction" (27). A decrease in artistic goods, therefore, should also decrease wealth.

Aiming to give objective foundations to a general theory of distribution, Ricardo could not admit pure subjectivity in his schemes as required by the "pure pleasure" of leisure and art. Pure subjectivity, however, has always been part of the real market.

While Smith's historicism helped him to introduce objective tastes into his schemes, Ricardo's scientific empiricism prevented him from obtaining such a result.

2.2.3 Mills and "cultivation"

Historical objectivity of tastes "à la Hume", can also be found in the work of the last Classical (or the first Neo-classical) supporter of the theory of labor value, John Stuart Mill, even though it is on a subject where he showed strong opposition to Smith's prevailing opinion: public expenditure for education.

Smith was in favor of limited assistance to education, "leaving the teachers largely dependent on fees to give them an incentive to exert themselves" (28). Mill, on the contrary, supported public intervention, arguing that "the uncultivated cannot be competent judges of cultivation"; in other words, that "the buyer of education is typically incompetent to judge its quality" (29) and therefore, to determine its price.

The statement is rather surprising if referred to the last theorist of the material objectivity of value, but it is consistent with the views of the author of the first enunciation of the fiscal sacrifice equalization principle.

"Competence" to judge "cultivation" is, of course, individual "cultivation" to which some degree of social legitimization has been given, in order to permit it to be the basis of public intervention (that is, of social choice). On the contrary, no individual specific qualification of the buyer is needed in Classical schemes to determine demand. No social legitimation is needed to qualify equilibrium. Price is objectively fixed and the market is self-legitimizing.

In Mill's thought, therefore, subjective utility comes back into play in the same way as it does when it is used to justify the application of the ability-to-pay principle in his theory of optimal taxation. The above mentioned argument also contains the important suggestion that the tools of Classical economics be used in a historical perspective. Social economic decisions have to be grounded on historical bases.

Writing after Compte's criticism of political economy (30), Mill

adopts a cautious approach in applying the general laws of economics to different historical situations because he does not want "to try to draw the same conclusion from different premises" (31).

Mill's argument for public education goes even further. It anticipates the main contemporary debate in cultural economics, because it is "the first of the three economic justifications that have ever since been put forward", not only "for a system of public education" (32), but in general, for culture subsidization (the other two being natural monopoly and external economies, already evidenced by Smith, albeit on ethical bases).

Despite the above-mentioned methodological implications of his work, Mill, like Smith, was probably unaware of the possibilities offered by Hume's epistemology to ground his argument historically and feared governmental cultural paternalism as much as contemporary cultural economists.

Dealing with examples taken from the arts and leisure in order to determine the borders and scope of economic analysis was a logical consequence of the Classical economists' choice of basing their theory of value on labor instead of on subjective utility. The use of culture as historically determined to ground their assumptions (like in Smith's and Mill's work) is the unaccepted or unconscious consequence of Hume's heritage.

2.3 The Marginalists' indifference

The "Marginalist Revolution" formally cancelled the objective differences among goods that were created by Classical economists through the theory of productive and unproductive labor, aimed respectively at satisfying rational and irrational needs.

The utility theory, through the works of Menger, Walras and Jevons, is based on an "additive utility" function where quantity is the independent variable.

Materiality and immateriality, usefulness or agreeableness of goods are unimportant as is their being necessary or leisure commodities.

In Walras' opinion: "necessary, useful, agreeable, and superfluous, all that for us means only more or less useful. Morality or immorality of the needs to be satisfied by a useful good have not to be taken into account" (33). Scarcity is scientifically grounded on quantity rather than on quality. Moral as well as aesthetic qualifications are meaningless. "Others can bother very much about the reason why a substance is required, by a physician to heal a patient or by a murderer to poison a family. We, on the contrary, are totally indifferent" (34).

"A good is rare according to political economy when it is useful and limited in quantity, exactly as, according to mechanics, a body is said to have a speed when it goes through a given space in a given time" (35).

Crusoe's behavior can always be explained on the grounds of "the fundamental categories of economics" when "buying potatoes" as well as "philosophical books" (36).

The prevailing interpretation of the historical rise of the marginal utility theory gives some philosophical reasons for this. A general influence of Kantian thought is recognized: "Back to introspection and sense-impression was the watchword of this philosophical trend" (37). This influence is explicit in Cournot's work.

Reacting, as Mill did, to Compte's positivist criticism, which charged Classical political economy with idealism, Cournot adopted Kant's point of view on the social sciences, considering them as natural sciences and claiming that they could be grounded on probabilistic bases.

In doing so, not only did he accept Kant's view of political economy as an application branch of theoretical philosophy; among those disciplines "only aimed to a result through the application of the natural concepts of cause and effect" (38), but he also accepted the consequent separation between political economy, belonging to the domain of Pure Reason, and morals and freedom, belonging to the domain of Practical Reason.

Peculiarly enough, while sharing this point of view, which is included in the introduction to Kant's Critique of Judgement, Cournot apparently ignored Kant's theory of aesthetics, to which the Critique

of Judgement is almost completely dedicated, just as Smith apparently ignored Hume's aesthetic theory despite its epistemological implications. In Cournot's case, however, the "ignorance" is better justified by the economists' consolidated historical approach to reality, which sharply contrasts with Kant's aesthetic view. For economists, pleasure and displeasure are traditionally connected in a cause-effect relationship with knowledge and will. I can feel pleasure for something because and only because I have a sensible experience of it, that is I desire it and I know it.

In Kant's aesthetics, sentiments of pleasure and displeasure are autonomously conceived as separated from any other human faculty. I feel pleasure for anything but pleasure. No sensible experience is needed for poetry. Aesthetic pleasure is not submitted to the ends of knowledge or morals. Its a priori principle is not its conformity to rational laws or to a final aim, because it belongs to the domain of Pure Judgement.

In excluding political economy from the field of ethics, Kant excluded also aesthetics. Economists were, at least in England and France (39), influenced by this point of view.

The Marginalists, in conclusion, perceived in Kant's philosophy the importance of subjectivity in determining the link between an object and its sensible knowledge. This subjectivity was based on sentiments and was derived by Kant from eighteenth-century aesthetic theory, which was a theory of imagination and passions (40).

The Marginalists, however, refused just as Kant himself did, the extreme consequences of this for economics. Tastes are no longer historical expressions of individual sentiments expanded in social conventions as they were for Hume for the Classical economists. But instead of being included in a general theoretical system, as they were in philosophy, tastes were then seen by economists either as arbitrary (as Kant had done in his Critique of Pure Reason), or as irrational (the analysis of pure taste judgements being out of the scope of the application of economics).

In both cases, tastes, as well as moral beliefs, become irrelevant in the formulation of economic laws.

The Classical economists' postulates of the theory of value were

historically grounded, in coherence with the epistemological approach well exemplified by Hume's aesthetic theory. Their moralistic view of the artistic process was a consequence of this. The Marginalists exclude any possible reference to "history". They claim there is a sharp separation between history and economics as well as between history and natural science, the former not proceeding through the generalizing abstractions of the latter (41).

History is unnecessary to understand tastes and morals and social values in general. Social "organisms" become social "mechanisms" (42) and political economy is the basis of "social mechanics". The methodological denial of history as an exogenous source of objective knowledge is accompanied by the separation of the ethical and aesthetic from economic aspects of reality.

Following Cournot, "the law of large numbers cancels any ethical" (and we can now add any aesthetic) "qualification of individual behavior", that is to say, any attribution but that measured through marginal decreasing utility (43). The main postulate of the theory of value is that individuals can rank their preferences in a given order" (44), no matter what their source or their qualification.

Individual preferences need not be qualified as "historically relative" as a consequence of this postulate, as well as of all the fundamentals of Marginalist economics (45).

2.4 Contradictions

This strong discriminatory position on both the individual and collective unimportance of non-economic qualifications of reality for economics, led, by contradiction, to its own denial.

The late Marginalists (but also the most outstanding) were responsible for this. Starting from different points of view (respectively sociological and ethical), both Pareto and Marshall contributed to reintroducing quality and history into economic analysis, out of which Kant and the Marginalists had pushed them. As for Classical economists, illuminating contradictions emerge from their use of cases taken from the domain of aesthetics.

2.4.1 Pareto's vicious circles

Pareto, like the Marginalists, basically sees individual differences in motivations and sensibility as being unimportant for economics.

Scientifically speaking, this irrelevancy is so strong as to lead him to say that quality qualifications such as "good" or "bad" are useless in understanding economic reality. "If modern industry supplies low quality commodities at a low price, this depends on the demand of people who cannot afford a higher price to obtain higher quality commodities or do not want to (...) Ophelimity is an absolutely subjective quantity. Socialists of the Chair's rule of renouncing to any expenditure at all instead of buying low quality commodities, when first quality is not available, is bound to decrease social welfare, if imposed on people with different tastes" (46).

Claiming that "one should not ask for political economy poetical-ethical dissertations" as well as that "one should not look in Laplace's celestial mechanics for the means to build astronomical intruments" (47), he seems to follow the Kantian distinction adopted by Cournot.

Discussing the nature of social phenomena, however, he comes to a first contradiction, when he theorizes the existence of an "applied political economy", which is "nearer to the real man (...) characterized by attributes as those studied by law, ethics, aesthetics, etc.", given that "no real man obeys only pure economic motivations" (48).

Trying to avoid the contradiction, he builds up a theoretical vicious circle. He criticizes economists "because they absolutely want to discover 'the cause of value', not being able to conceive reality, but through cause-effect relationships" (which stand for him behind the concept of "value" itself, which he considers as the limit of scientific research in economics). All his theoretical frame, however, is built on cause-effect relationships, which are expressed by the concept of "ophelimity". This is a cause-effect relationship, too, but it is limited to linking "desire" and "satisfaction" in Pareto's terminology. ("Ophelimity expresses the convenience relationship

which makes something satisfying a more or less legitimate desire or need") (49).

Instead of investigating the qualitative nature of satisfaction, he is led by this new contradiction to distinguish between different kinds of ophelimity (religious, ethical, aesthetical...), which are seen as constraints to the economic concept of ophelimity (50).

Given that ophelimity is for him the "current individual welfare of utility" (that is, that ophelimity and utility are coincident concepts if referred to current expectations), a third theoretical bias originates from the above-mentioned distinction. Either the economic ophelimity is the current individual utility, and therefore includes all possible ophelimities, or it is one among the possible individual welfare conceptions (constrained by the other ones) and therefore it admits the importance of quality in measuring satisfaction (that is, the importance of also investigating the cause-effect relationships that Pareto calls "the cause of value").

Starting from the same Marginalist point of view, and writing in the same years as Pareto, Ugo Mazzola, one of the founders of the Italian "Scienza delle Finanze", admitted - on the contrary - the importance of quality in defining pleasure and satisfaction.

In his "Prolusione" to the Academic Year 1897 at Pavia University on "Il momento economico dell'arte", he defined the difference between aesthetic and non-aesthetic emotions as a "higher and finer degree of pleasure"- thus qualitatively different from other hedonistic causes, but nevertheless "of the same kind" and "intimately connected" with all of them.

More light can be thrown on this problem following Pareto's discussion on interpersonal and inter-societal comparisons of ophelimity and utility.

Dealing with comparisons among individuals, Pareto allows the possibility of differences among individual ophelimities for the same pleasure or displeasure due to its aesthetic quality.

"A guide has a lighter task than a beginner tourist in climbing a mountain; the same psychological attitude of the two being given. But it may happen that the tourist feels less pain than the guide does, due to his enthusiasm for natural beauties" (51).

This may sound trivial, and as if it is nothing more than admitting

the existence of a specific utility for beauty and assuming that it is marginally decreasing with two different laws for the guide and the tourist. But it can also lead to the conclusion that only one kind of ophelimity exists which is related to all the features of a good, including beauty.

To include beauty, moreover, raises a set of problems of measurement. One cannot measure the same pain in the same way (e.g. walking hours). The same pain needs different weights in order to be related to satisfaction. These weights differ according to experience (that of the guide makes his pain stronger because he is more used to natural beauty). Experience may not have the same effect on individual utility laws. The tourist's enthusiasm may lead to increasing marginal utility (what we now call addiction), while the guide's indifference may lead to a decreasing one.

The pleasure or displeasure of "walking" raise different measurement problems from those of the pleasure or displeasure of "walking in a beautiful environment".

Individual ophelimities are not comparable and neither are pleasures. No cardinal measure of utility or of ophelimity is available.

Pareto, however, is not prepared to accept this implicit suggestion of his study case. He therefore comes to a different conclusion which, in any case, opened the way to the subsequent application of his criterion of collective choice, as did the above-mentioned contradiction.

Individuals are effectively different; no absolute measure can be conceived to compare their satisfaction, but they can nevertheless be seen as similar on average, if socially considered in a historical perspective.

"Such things as absolute happiness or unhappiness have been supposed to exist and to be investigated through social welfare or malaise criteria to be found in more or less pessimistic literary works. These works, however, are not good evidence of such an existence or they are controversial to it. People have to have reached a fairly high enough level of material welfare to have time and to be willing to compose pessimistic literary works (...). No Schopenhauer existed in Medieval times simply because constant exposure to

burgling, war, plague and famine did not leave time to dream of the philosophy of inconscious" (52).

Welfare criteria change over time according to the changes in economic conditions. Happiness is "historically-relative" again. Individual tastes also change over time, so that there is no absolute way of judging them.

"The assumption of a given set of common qualities shared by the compared individuals" (53) allows, however, comparisons among social aggregates as well as among individuals. Tastes are therefore objectively grounded again on historical bases as in Hume's aesthetics.

2.4.2 Marshall's half-commitment

A very strong but little explored argument to support the usefulness of a rediscussion of marginal utility theory is also put forward by Marshall in chapter II, par. I, of the first book of his Principles. He claims that, even if estimating "the incentives to action by their effects (...) without attempting to fathom the mental and spiritual characteristics of individuals", the economist "does not ignore the mental and spiritual side of life. On the contrary, even for the narrower uses of economic studies, it is important to know whether the desires which prevail are such as will help to build up a strong and righteous character. And in the broader uses of those studies, when they are being applied to practical problems, the economist (...) must concern himself with the ultimate aims of a man, and take account of differences in real value between gratifications which are equally powerful incentives to action and have therefore equal economic measures. A study of these measures is only the starting point of economics" (54).

Marshall's point is very similar to Mill's consideration of the different "desirability" of pleasures of different qualities, quality being an attribute of intellectual and spiritual pleasures. How could pleasure evaluation be assumed as only being dependent on quantity, while the evaluation of all other things is based on quality as well as on quantity? (55). Pareto's different ophelimities might be recalled here, too.

Like Mill and Pareto, however, Marshall avoids any further analysis of the consequences of his statement. Therefore he hastens to add to it that "economic measures" or "differences between gratifications" are in any case "the starting point" of economics. No objection on the different nature of pleasures is possible for him because economists do not deal with pleasures but with the desire of feeling a given pleasure or "self-satisfaction" (56). He also assumes individual equality of satisfaction, all individuals and all unities of satisfaction being equal in large numbers.

All this prevents him from discussing taste modifications and their effects on the Marginalists' schemes. Presenting the diminishing marginal utility law, he declares: "We do not suppose time to be allowed for any alteration in the character of tastes of the man himself (...). If we take man as he is, without allowing time for any change in his character, the marginal utility of a thing to him diminishes steadily with every increase in his supply of it" (57).

In the same context, however, he needs to add: "It is (...) no exception to the law that the more good music a man hears, the stronger is his taste for it likely to become (...) for in such cases our observations range over some period of time and the man is not the same at the beginning and at the end of it" (58). This is not only an anticipation of the ongoing discussion on constancy of tastes and addiction (59), but also the logical premise to allow exogenous taste changes whilst trying to leave the general theory of marginal utility untouched.

Discussing the development relationship between new wants and new activities in the aggregate, Marshall effectively allows the possibility of exogenous taste changes: "It is the desire for the exercise and development of activities (...) which leads not only to the pursuit of science, literature and art for their own sake, but to the rapid increase of demand for the work of those who pursue them as professions. Leisure is used less and less as an opportunity for mere stagnation" (60). "The desire for excellence for its own sake" creates new tastes (or taste changes) and new demand.

Marshall thinks that "nothing but true artistic excellence has enabled a ballad or a melody, a style of dress or a pattern of furniture to retain its popularity among a whole nation for many generations

together" and he calls these determinants of taste innovation "traditional instincts" (61).

These rather Classical pre-Schumpeterian "animal spirits", referring to which Marshall himself significantly quotes Mc Cullock, are very far from the endogenous tastes of the rational consumer's theory.

Unlike Pareto, Marshall uses beauty to make a distinction between "well made" and "badly made" things. All the rest being equal, the former must be preferred to the latter (62). This risks sounding trivial if we do not add that value also has to be considered equal in the above-mentioned comparison. This means that in Marshall's opinion, in opposition to Pareto's, beauty makes a difference for individuals as well as for the society, which must somehow be considered.

Marshall thought that the widening of the market could actually result in a worsening of quality and that this could generally affect social welfare: "Technical education can yet save much natural artistic genius from running to waste (...) when a great deal of excellent talent is insensibly diverted from high aims by the ready pay to be got by hastily writing half-thoughts for periodical literature" (63).

Coming to this logical conclusion, however, Marshall escapes from its consequences again, by saying that their analysis and the discussion of the influence on general well-being which is exerted by the manner in which each individual spends his income, should exceed the scope of his book even if "this is one of the more important applications of economic science to the art of living" (64).

What is uncontroversial in Marshall's thought is his admission of the external effects of the arts. These effects also have qualitative results. For him, as for Smith, these externalities are displayed at an individual as well as at a collective level. People's tastes change according to other people's behavior.

"A person of high musical sensibility in a large town will avoid bad concerts, though he might go to them gladly if he lived in a small town, where no good concerts are to be heard because there are not enough persons willing to pay the high price required to cover their expenses" (65).

But in this case, rather than assuring social peace as Smith thought, the arts are conceived of as a significant production factor, or better as

a cause of increases in productivity.

"The development of the artistic faculties of the people (...) is becoming a chief factor of industrial efficiency" (66). Even though it applies specifically only to "those branches of art which appeal to the eye", that is to visual arts (and mainly to industrial design), this statement cancels out the Classical classification of the arts among unproductive labor.

This is also the best exemplification of the historical-ethical grounds of Marshall's attitude. In Marshall's work unlike that of Smith, the arts are ethically positive attributes. They are a general reference for civilization and in his opinion no social blame rests on artists. Medieval patterns of artists-artisans identification qualify workers in their production schemes. In this respect Marshall's thought is deeply influenced by the Pre-Raphaelite Movement of William Morris, while only partially still standing, like Smith's, on old Puritan grounds. "Education in art stands on a somewhat different footing from education in hard thinking: for, while the latter nearly always strengthens the character, the former not unfrequently fails to do this" (67) just as musical education failed to improve the morals of Ancient Greece in Smith's opinion.

There is no Puritanism at all, however, in Marshall's opinion that: "Leisure is used less and less as an opportunity for mere stagnation" (68), which explains his final grouping of scientists and artists under the same positive social judgement : "All that is spent during many years in opening the means of higher education to the masses would be well paid for if it called out one more Newton or Darwin, Shakespeare or Beethoven" (69).

Social concern is present here "to give the masses of the people much greater opportunities than they can avail themselves of" (70) in the firm belief that development brings with it civilization. A strong modern Englishman's temper leads him to this conclusion: "As a minor point it may be noticed that those drinks that stimulate the mental activities are largely displacing those which merely gratify the senses. The consumption of the tea is increasing very fast, while that of alcohol is stationary" (71).

2.5 Contemporary efforts

The problem of the instability of tastes, like that of the effects of quality (and /or of its non-consideration), on the measurement of preferences have influenced the discussion on the subjective theory of value for some time (72), both in its individual and in its social welfare aspects.

Contemporary economists take into account both fields, the first under the approach of the analysis of the nature of the creative process, developed by Institutionalist economists; the second throughout the growth of the so-called cultural economics stream in the Sixties and in the Seventies, mainly on the bases of an inquiry into the opportunity and/or justification of arts subsidization.

Analytically speaking, traditional economists are now consciously willing to deal with the arts either as the field where the phenomena in which they are interested are displayed, or as a new area in which to apply their well-established tools of analysis.

Unfortunately this consciousness seems to lead them to a lack of interest in the original implications of art applications. Innovation and taste formation are less examined than consumption and production. This leaves out important fields, and supplies economists with highly stimulating tasks for their work.

2.5.1 The Institutionalists' reversed approach

Institutionalists' work on the arts is well represented by Veblen's original contribution and by the more recent work of Boulding.

Kant's Critique of Judgement is used by Veblen to found his "inductive" theory of the logic of scientific inquiry, his aim not actually being to deal with aesthetic but with scientific creativity. His contribution to clarifying the creation process is, however, significant as it helps in suggesting the possible use for this purpose of aesthetic theory and semiology (namely Pierce's theory of "abduction" (74)). The investigation is shifted here from the effects of some revealed preferences on the economy to the process of preference formation, which is exactly what the Marginalists claimed had to be avoided.

This is parallel to the Institutionalists' criticism of the traditional theory of consumer behavior as it justifies "the tendency of wants to expand and change" out of any regularity law. Creativity also allows changes which are "irrational" from the point of view of the "consistency postulate". "If an individual prefers A to B in one situation he will not be found to choose B in preference to A in another situation" (75). If tastes change exogenously, that can happen. Pierce's "abduction" on which Veblen's "induction" is based, is an interpretation of reality breaching previously established laws and it can, therefore, create an exogenous change of tastes.

As in Marshall's case, however, this relevant point is abandoned for the sake of general theorization. Veblen, and other Institutionalists, are more interested in destroying the traditional consumption theory than in improving its methodology, just as Pareto and Marshall are more interested in preserving it than in improving it. The concern here is to deny the possibility of utilizing deductively-established laws, in general, and negatively-inclined demand functions, in particular, rather than analyze the causes of possible exceptions to this (76) (see chapter 4).

Further epistemological implications can be derived from Boulding's approach where the creativity problem becomes an information problem (77). Creativity is the "capacity of forming images of the future" (78) and the artistic process is a process of transmission of this new information. Art under this respect is a value generator like any other source of information. Unfortunately, once more, Boulding's concern with changing the assumptions of economic theory is stronger than that of analyzing the effects of these changes.

Nothing has been said, therefore, about whether markets can or cannot evaluate this information, how it interacts with other types of existing information, how its interpretation can affect its value, etc.

2.5.2 "Cultural economics"

The theory of value having been the true original historical field of application of art to economics, its still-recent (since the Sixties) acceptance as an institutional subject of economic research however,

is due to an analysis with completely different aims.

Normative economics are predominant in the early work of the so-called "cultural economists" exploring aggregate artistic production and consumption processes by means of the analytical tools of economic science in search of their optimization. This is reflected in the pioneering work of Baumol and Bowen, Netzer, Peacock and Throsby (79) and others.

From Keynes' (80) and Robbin's (81) contributions to the less orthodox work by Galbraith (82), the general matter of concern is the inquiry on the subsidization of the arts either with respect to their specific economic nature (of a semi-public good, endowed with external effects, causing market failures, with specific market characterizations etc.) or regarding its influence on economic development (as a production factor - that is "culture" - affecting individual and aggregate production function). These discussions are in many respects the heirs of the above-mentioned discussions of the Classical and late Marginalist economists, dealing respectively with the opportunity of public funding of education (in the arts but not only in the arts) and the economic role of culture in society.

Public economists largely contributed to opening the field to the intervention of those who were later to be called "cultural economists". Generally speaking, they gladly adapted their analytical tools (for prediction and prescription) to these subjects starting from the mentioned crucial point of the justification of subsidies to the arts (83).

Artistic products were thus seen as "different" as they were public or mixed goods of specific interest for non-active consumers (optional and those of future generations). Artistic production was characterized by specific non-appropriable externalities (besides the well-known specific limited substitutability of labor with capital pointed out by Baumol (1966)).

All these "differences", however, were and still are only based on attributes (non-rivalry, non-appropriability, "publicity", non-substitutability) commonly shared with the general domain of economic goods.

Cultural economists commonly say that "the arts are different from other commodities and services" (84), but if asked to give a methodo-

logical specification to this difference, they reply referring to the ordinary indifferent attributes of non-artistic goods.

Few of them show a specific interest in the effective nature of aesthetic judgement as distinct from any other "judgement (to be associated with attributions such as "objective", "scientific" or "of value" or not).

Important attempts have been made by Shanahan (1978) and more recently by Throsby (1990). The former directly aimed "to deal with the aesthetic nature of art" (85), the latter "to identify the components of quality judgements in the performing arts" (86).

In the first case a new tentative definition of artistic quality is adopted. "Intimate and private experience with the object "of art", "non-cognitive" and "unlimited" (87), is taken into account to distinguish aesthetic from non-aesthetic goods, together with the fact that "it must not have any purpose beyond the possible stimulation of intellect, imagination and, certainly at least, the stimulation of feeling". As with Mazzola, here too "art can intensify the rest of human experience" (88).

The second case constitutes a new approach to the interpretation of "aesthetic quality" without referring to the usual utilitarian quantitative indicators. Here the "components of quality judgements in the performing arts are described" by "breaking down the evaluation into a set of criteria". A descriptive quality index is thus introduced into a demand function, to be estimated in an "exploratory" mode (neither predictive nor perspective).

In the first case, however, the re-definition of the aesthetic pattern, is, unfortunately, not followed by an attempt to draw economic consequences from it, the interest being rather the investigation of possible non-aesthetic goods. In the second case the methodological innovation in measuring aesthetic judgements is unfortunately not accompanied by an analysis of the theoretical fundamentals of this choice.

Thus the discussion both on "the fundamental nature of aesthetics" and on the bases of aesthetic quality judgement (good or bad) is explicitly avoiding the former as a subject for "particularly vain, fool hardy or gifted economic analysts with supernatural powers" while the

latter is useless in the light of empirical evidence or risky as a source of value judgements (89).

In the first case the methodological importance of conclusions is accompanied by an understatement of the premises. Viceversa, in the second. For aesthetics again, a "reductionist exorcism from economics" has been practiced as it was for ethics (90).

The point to be emphasized is that the correct goal of an economist is not the explanation of the "fundamental nature of aesthetics" but may be the analysis of the consequences of the application of the philosophically-determined fundamentals of aesthetics to economics, as economists currently do with ethics. This will further clarify the bases of "interpretation of quality", and at the same time, the original problem (or sin, as it remains unsolved) of the justification of subsidies to the arts (91), as I will attempt to do in the next chapter.

Following the general stream of public economics, which came to this methodological bias in applying Pareto-optimality to social choice, cultural economists developed the analysis of public policies in the field of art to the extreme point of the confrontation between ethical and economic goals; that is, to the "paternalism" objection as well as to the opposite "merit good" solution to the subsidization question (92). To escape from this methodological cul-de-sac, cultural economists then turned either to empirical applications where new analytical tools could be found (93) or to an advisorial attitude with strong operational references (94).

Such conclusions leave some uncovered areas of inquiry which are strictly connected to the traditional application of the arts as a case study for the theory of value, both in the field of individual and collective choice.

Quality can still be a serious challenge to economic analysis, as the application of ethics to economists has shown (95). The works of Classical and Marginalist economics are good evidence of the possible implications of introducing aesthetic quality for economic goods and factors.

That does not mean that we should reject all the traditional contents of utilitarian economics on new bases, e.g. those afforded by the Kantian definition of beauty as an independent attribute of reality,

different from "rationally useful" (in the economic sense) and "rationally aimed to an end" (in the ethical sense). It means, however, that there is room for new research on the methodological and analytical consequences for economics to accept this additional qualification.

The suggestion is that, instead of limiting their investigation to the possible economic features of artistic processes, economists could largely investigate the possible artistic features of economic processes, as they have already done for ethics. This could result in a better understanding of the theory of value, on the one side, considering both price and distribution problems, and, on the other, in a more satisfactory foundation of social choices involving artistic or merely aesthetic problems, and consequently trade- offs between efficiency, equity and beauty.

This could also satisfy the supporters of operational advisory roles for economists. It could ground a new interest in general compatibility problems like those between social resources with cultural destination and their distributional and development effects on the economy, on the one side, or those regarding the effective return on public investments in culture versus the total budget requirements for their preservation, on the other.

2.6 Summary and conclusions

Economists have been dealing with the arts since the very beginning of modern economic science. Apparently they were embarrassed by the scientific nature of artistic goods and either tried to exclude them from the scope of their analysis altogether or tried to include them by claiming their ethical influence on the economy.

In essence, the Classical economists realized the importance of the arts as theoretical exceptions to their analytical schemes both for production and consumption. These exceptions are of considerable importance in interpreting the Theory of Value of Smith, Ricardo and Mill.

The "Marginalist Revolution" formally cancelled all objective differences between goods. Through the works of Menger, Walras and

Jevons, the utility theory was based on an "additive utility" function where the independent variable was the quantity of the given commodity, independently of that of other consumed commodities as well as of any qualitative argument. No rights of citizenship to aesthetic qualifications of goods could be afforded in such a world. A specific Kantian influence on this choice is revealed by Cournot's works.

Even through contradictions, the importance of ethical and aesthetic quality was reintroduced into economic analysis by late Marginalists such as Pareto and Marshall. These authors substitute the Classical economists' objective differences between goods with the subjective differences of motivations and sensibility between individuals. Interaction is here admitted and it affects both production and consumption. Controversially, beauty and art are back into account. Moral and sociological reasons are again applied to justify this. The theory of value having been the true original historical field of application of art to economics, its still-recent acceptance as an institutional subject of economic research in the Sixties, however, is due to an analysis with a completely different aim.

Positive economics are here predominant in explaining aggregate artistic production and consumption processes with the use of the analytical tools of economic science in general and of public economics in particular. The institutional economists' discussion on the nature of creativity and the effects of the arts stand equally on positive bases. Some important questions on innovation and taste formation have been stressed by their contributions.

Traditional economists originally dealt with the rationale of subsidizing of the arts. This generally led to discussions on "paternalism" and "merit goods" in cultural economics as well.

Both approaches have left problems unsolved which can represent significant research fields for economists together with the more usual paths of empirical analysis.

Notes

The first part of this chapter was published in Mossetto (1992c)

(1) Blaug (1976) n. 13.

(2) Smith (1789) p. 758.

(3) Desné (1976) p. 73.

(4) Diderot published in 1759, "Salon de 1759, in 1760, "Sur l'art de peindre", in 1765. "Essais sur la peinture, in 1776, "Pensées détachées sur la peinture", all collected in Neri G. (ed) (1957), Diderot: Scritti di estetica, Milano, Feltrinelli.

(5) Hellbrun (1984) p. 37.

(6) Déleuze (1976) p. 42-43.

(7) Ibidem, p.48.

(8) Ibidem, loc. cit.

(9) See, for example, Hutcheson (1747), p.53.

(10) Anonymous (1738).

(11) Smith (1776), p. 173.

(12) Ibidem, p. 326.

(13) Ibidem, p. 105, where Smith lists these reasons in addition to the risk of being unsuccessful and the long training time of these professions.

(14) See, Denis (1968), p.230; Hollander (1973), p. 152-153; Pietranera (1963), pp.86-118.

(15) Hollander (1973), p. 156.

(16) Pietranera (1963), p. 95; Denis (1968), p. 230.

(17) Smith (1776) p. 326 and p. 105.

(18) Ibidem, pp.341-343.

(19) Ibidem, p. 342.

(20) Ibidem, p.763-764.

(21) Ibidem, p. 764.

(22) Ibidem, p.768.

(23) Ricardo (1817) p. 8.

(24) Ibidem, loc. cit.

(25) Ibidem, p. 212.

(26) Ibidem, p. 207.

(27) Ibidem, p. 206.

(28) Blaug (1978), p. 226.

58

(29) Ibidem, loc. cit., quoting Mill (1848), book V, chapter II, section 8.

(30) Compte A., (1839), *Cours de philosophie positive*, Paris, pp. 270-272.

(31) Mill (1848), p.500.

(32) Blaug (1978) loc. cit.

(33) Walras (1874) p. 141.

(34) Ibidem, p. 142.

(35) Ibidem, loc. cit.

(36) Robbins (1935), pp. 12-19.

(37) Blaug (1978), pp. 316, Denis (1968) p. 169-172, and Cournot (1872), p. 224.

(38) See Kant (1790), Introduction.

(39) Blaug (1978), p. 316, where Kant's influence on Menger and Walras is rejected, but Jevon's interest in philosophical approaches to reality is stressed.

(40) See the discussion on this derivation in Pareyson (1984), p.10-12.

(41) Robbins (1935), p.90.

(42) Denis (1976), p.171.

(43) Cournot (1872), p.536-537.

(44) Robbins (1935), pp.90-96.

(45) Ibidem, pp.96-100.

(46) Pareto (1896-97), book II, chap. II, pp.178-179.

(47) Ibidem, book I, chap. I, p. 22.

(48) Ibidem, book II, chap., p.15-16.

(49) Ibidem, book I, chap. I, p. 10.

(50) Ibidem, loc. cit. p.14.

(51) Ibidem, book II, chap. I, p.54.

(52) Ibidem, loc. cit. p. 55.

(53) Ibidem, loc. cit., p. 54.

(54) Marshall (1920), p.16-17.

(55) Mill (1863), p. 196.

(56) Marshall (1920), loc. cit.

(57) Ibidem, p. 94.

(58) Ibidem, loc. cit.

(59) See Mossetto (1992 a) and chapter four of this book.

(60) Marshall (1920), p. 109-110.

(61) Ibidem, p. 108.

(62) Ibidem, p. 137.

(63) Ibidem, p. 215-216.

(64) Ibidem, p. 137.

(65) Ibidem, p.88-89.

(66) Ibidem, p.213.

(67) Ibidem, loc. cit.

(68) Ibidem, p.109-110.

(69) Ibidem, p. 215-216.

(70) Ibidem, loc. cit.

(71) Ibidem, p. 89.

(72) See Blaug (1978) pp. 372-374.

(73) See Veblen (1964) and Mc Closkey (1981) and (1985), Dyer (1986), (1988).

(74) See Pierce (1931-58).

(75) Blaug (1978) p. 373.

(76) Which is actually the case of demand functions when prices affect tastes in the arts. (See Mossetto (1992 a)).

(77) See Boulding (1978), Troub (1980).

(78) Boulding (1978) p. 132.

(79) See Baumol and Bowen (1956), Baumol (1966) and (1967), Peacock (1968)and (1969), Netzer (1978), Throsby and Whiters (1979).

(80) Hellbrun (1984).

(81) Robbins (1963).

(82) Galbraith (1973).

(83) See Austen - Smith (1980).

(84) Troub (1980), p.10.

(85) Shanahan (1978), p.13.

(86) Throsby (1990), p.68.

(87) Shanahan (1978), p.15-16.

(88) Ibidem.

(89) Throsby (1990), p.66.

(90) Gramm (1978), p. 181.

(91) See Austen - Smith (1980) which is the best and most exhaustive contribution on the discussion from the standard point of view of welfarism.

(92) See Abbin (1980), Austen - Smith (1980), to the most recent Fullerton (1991).

(93) For example the most recent above-mentioned Throsby (1990).

(94) See Peacock (1991).

(95) In Sen's sense, see Sen (1982).

CHAPTER 3

CHANGING THE AXIOMS:
BETWEEN THEORY AND META-THEORY

3.1 Is social choice biased by aesthetic decisions?

The case of state support to the arts is probably one of the most important unsolved problems of welfare optimization through social choice as well as one of the suitable trespassing points of the Neo-classical theoretical border.

Let us therefore start our discussion with this.

Economists have been dealing with the justification of subsidies to art and culture throughout the twentieth century without coming to a generally satisfactory solution exactly as if they were dealing with decisions on subsidies to education in the nineteenth century. The reasons for this have been very well summarized in Peacock's recent review of this subject (Peacock 1991). The most significant points of disagreement, refer mainly to the general possibility of explaining the whole production and consumption process in the arts through the theory of rational consumption (consumer sovereignty), which would exclude the rationale of any state intervention. This is biased by at least four unsolved problems:

a.1 How to avoid the limitation of considering tastes as given and constant, provided that tastes change in reality and therefore the demand for art-works fluctuates impredictably (Baumol (1986));

a.2 How to decide what the optimal level of cultural education (that is, of investment in taste formation) is likely to be, provided that no competitive market can guarantee it (Blaug (1976)) because the equalization of individual opportunities does not necessarily imply the equalization of judging capacities. ("The uncultivated cannot be competent judges of cultivation", Mill, (1848));

a.3 How to measure the external positive effects which can be derived from arts and culture, by such means as willingness-to-pay, provided that they are weak tools to represent such interests as those of future generations vis-à-vis dying art forms or to compare opposite stronger free-riding behaviors or ethical choices (e.g. arts versus science subsidizing). (Peacock (1991));

a.4 How to optimize production through the market without "some prior judgement about rights in the creation and exploitation of

intellectual property" (Peacock, (1991)), provided that this could be considered as a value definition.

At least two other unsolved problems which come directly from the analysis of the specific features of art markets have to be added :

b.1 How to come to a general optimum position, given that art markets very often provide multiple equilibria, or s-shaped demand curves. This is due to the existence of external (Veblen and bandwagon) and intertemporal (addiction) consumption effects (Mossetto (1992 a)), and of endogenous cultivation of tastes (Mc Cain, (1979)). (See also chapter 4);

b.2 How to define quality or rationing standards which are the suboptimizing solution in a market where imperfect (or asymmetrical) information causes the utilization of price as a signal of quality (Stiglitz, (1987)), provided that Samuelson's optimum conditions for the production of public goods might be repealed as price becomes an exogenous variable which endogenously modifies preferences (Greenwald and Stiglitz, 1986) (1).

Unavoidably any attempt to solve these problems leads either to "paternalism" or to "merit goods" as positions. In other words, the foundation of subsidization policies via individual rationality and Pareto-efficiency proves to be very critical on these grounds.

3.2 Shubik's centipede paradox

In order to get out of this methodological cul-de-sac one could resort (as Peacock does) to Shubik's centipede paradox (Shubik, (1984)) "to link the principles to the practice of cultural policy". One could stand on the side of the centipede and argue that the economist's function is "to devise (...) the path to be trodden" in achieving aims, rather than solving conceptual problems on how these aims are defined through solutions of impossible implementation, like those suggested by the owl for the centipede diseases (2).

The centipede paradox, however, can be interpreted inversely, but as usefully as in Peacock's suggestion, in order to overcome the

above-mentioned bias. If it is undeniably true that prescriptions are useless if not grounded on practice (from which one can eventually go back to theory), it is also true that theory is useless if it is unable to provide solutions of practical implementation.

In this case, both logical consequences are valid: either abstract theorization has to be abandoned to privilege efficiency analysis in policy-making, as Peacock and many other cultural economists seem to suggest with their scientific production, or the theory has to be changed.

Epistemologically speaking, what has to be changed is not really the theory, but the meta-theory; in other words the set of axioms on which the theory is based. If we assume as our theory, a "rational" structure of preferences (that is a transitive, reflexive, complete, set of preferences) and we hypothesize a "rational" behavior of individuals (in the sense that they will always choose "the most preferred bundle of commodities"), and we apply this theory to the case of culture or of aesthetic needs, we obtain unrealistic solutions. In other words, either we do not solve the problems we listed above, or we do not explain the impossibility of their solution. To achieve this, we have to take into account the effective features of aesthetic phenomena and inquire into their inclusion in the set of axioms; that is of the meta-theory we currently use to define economic "rationality".

3.3 On aesthetic judgement once more

What are these features and which of them are important for a better economic explanation of reality?

My proposal here is to go back to the original Kantian definition of aesthetic judgement on which we based the inquiry into the meaning of aesthetic qualification in the first chapter. This definition is the most clear and simple in order to distinguish ethic from economic and aesthetic qualifications and, besides that, it is also the most consistent (and persistent) in a historical perspective, which is not epistemologically irrelevant, as we have already seen.

To qualify aesthetically any good or process is therefore

metodologically intended in the sense of making an assumption of "no aim" for the so-qualified economic resource or activity.

As already mentioned in Chapter 1, this does not mean that the related object of this qualification is subtracted from the domain of logics or of knowledge.

Art, as we have seen, has its own unaimed finality and is endowed with an internal model, but it has no pre-established and steady rules. Qualifying it as being "with no aims" only means to distinguish it by denial from those different objects which belong to economically- or ethically-finalized worlds. This definition of aesthetic quality is critical to the use of the established utilitarian schemes in the analysis of a world with aesthetic qualifications.

The concept of rational behavior stems from the empirical fact that human behavior is largely finalized towards an aim. Essentially rational behavior consists in the mere coherent pursuit of a well-defined end, to be followed according to some well-defined set of preferences or priorities.

The analytical and predictive power of many sectors of human research relies upon the high level of rationality in human behavior (3). Normative disciplines (such as decision- making theories, the theory of games and ethics) help individuals to act more rationally and to reach a fuller understanding of the real nature of rationality (4). From this point of view, aesthetic quality, as defined above, is irrational and therefore outside any analytical, predictive or normative discipline.

Aesthetic quality, however, is a part of economic reality.

Subjectivity is usually re-introduced into utilitarian schemes of analysis through ethics. Ethical choices can be rationalized through an "a posteriori cognitivism" based on the possibility of controlling ex post the logical consequentiality between means and ends (5). Moral objectivity is based on some kind of "empathy" or "similarity principle" (6) or on social consent among individuals, which leads to the problem of interpersonal comparison of preferences, and of the application of the Pareto principle (7).

Quality differences among individuals are taken into account, formally preserving the validity of the hedonistic principle of utility maximization as the basis of individual and social choice, no longer

applying the Benthamian criterion of total utility, but through the application of specific decision- making rules (or social welfare function) as the maxim or its "lexicographic version" ("the leximin"). Social situations are judged on the basis of the utility level of the less advantaged person. If, in two different social situations the less advantaged people have a benefit from the same utility level, alternatives will be ordered according to the ranking of the second less advantaged person, and so on (8).

Liberalism is the methodological limit on the attempt of welfarism to embody ethics. The "conditions L" of "minimal liberalism" stated by Sen leads necessarily to a limitation of the Pareto principle (9). Freedom implies a minimum level of tolerance, which is denied by the basic need for unanimity, which is part of even the weakest formulation of Pareto- efficiency.

Aesthetic judgement needs freedom, too. "Beauty is free and gratuitous legality" (10). Its moral law is at the same time both the freest and the most binding. It is the subjective commitment of the author to his work, as an aim in itself (with no aim and no law beyond this). In many theoretical cases of limited applicability of the Pareto principle to an ethical world, the qualification of the level of freedom is significantly aesthetic.

The choice between white and pink walls of Sen's Paretian liberal or his attitude towards reading Lady Chatterley's Lover (11), as well as the decision on the colors of the dresses of Gibbard's Zubeida and Rehana (12), are all, aesthetic judgements.

Aesthetic judgement, however, is different from moral judgement. Jack's choice of sleeping on his stomach or on his back (13) is a matter of freedom but not necessarily a matter of aesthetics. As already mentioned, aesthetic judgement is not ontological: it is finalized but it does not have external or objective aims. Its object is not viewed (as in moral judgement) as a means to be adopted to a given end (thereby becoming "useful" from the utilitarian and ethical point of view). It is internally adequate to its own conception (or internal law) and therefore becomes "perfect" (14).

"Moral preferences are characterized by an equiprobability assumption" (15), aesthetic ones by an assumption of "irrationality" or

rather, as we shall say from now on, by an assumption of "non-consistency" under the usual utilitarian postulates, as these preferences and their orderings involve something "useless" giving pleasure. The "correct" distribution of rights is, in this case, a necessary but not a sufficient condition of optimization.

The problem we mentioned in point a.4 is therefore necessarily indetermined. To reverse it: no prior judgement about rights is possible for aesthetic goods under the ordinary axioms of "rationality".

3.4 Analyzing aesthetic "non-consequentiality"

The rational disconnection between causes and effects in individual and social orderings, or, in other words, a non-consequentialist structure of the relationship between reality (or phenomena) and preferences, are specific to aesthetic judgement. Let us examine an example of this, using a tool which has also been used by Sen to discuss the ethical limitation of the Pareto principle: the well-known prisoner's dilemma which under ethical qualification could be reformulated as follows.

Two prisoners are convicted at Reading Gaol. The legal consequences of their behaviors are the usual ones. If both confess, they will be tried for a major crime and given a reduced prison service of ten years. If nobody confesses they will be tried for a minor crime and sentenced to two years imprisonment. If one confesses and the other does not, the former will go free and the latter will be sentenced to the full term of twenty years. They also act in the usual conditions of reciprocal ignorance, but with an aesthetic qualification: one prisoner is Oscar Wilde and he absurdly knows he "needs" some gaol in order to write his "Ballad"; the other is a poetry lover and knows the identity of the former and wants to be present at Oscar Wilde's creation. By means of absurd assumptions, this aesthetic qualification breaks the "rational" link between causes (the years of prison) and effects (the prisoners' preferences). Non-consequentiality comes into play. The dilemma can thus be "irrationally" solved (see scheme 1) in the sense that individual preferences are "irrationally" altered.

They move from the usual:

A: $a_1 b_0, a_0 b_0, a_1 b_1, a_0 b_1$
B: $a_0, b_1, a_0 b_0, a_1 b_1, a_1 b_0$

where a_0 and a_1, and b_0 and b_1 are the positions "not to confess" or "to confess" of prisoners A and B respectively, and where, as the dominant strategies are a_1 and b_1 (to confess under certainty conditions) the critical result is $a_1 b_1$ which does not maximize the welfare of the system, as $a_0 b_0$ is preferred to $a_1 b_1$ by both A and B;

to their aesthetic version:

A: $a_0 b_0, a_1 b_1, a_0 b_1, a_1 b_0$
B: $a_0 b_0, a_1 b_1, a_1 b_0, a_0 b_1$

Here the dominant strategies are not to confess (a_0 and b_0) and a minimum stay of A and B in gaol is the solution ($a_0 b_0$) which also maximizes social welfare.

As for ethics (co-operation, altruism) (16), this conclusion stresses the importance of what Sen called "the cultural guidance of behavior" (17), which can reorganize individual orderings, offering maximizing solutions under non-utilitarian assumptions.

In Mill's words: "qualitative criteria are important in measuring pleasure" coming from different sources, in order to distinguish between the "superior pleasure", (18) derived from art production and its enjoyment, and the "inferior pleasure" arising from the fact of not being convicted.

3.5 The aesthetic "trade-off"

The deliberate absurdity of the above example helps to understand the basic necessity of determining economic phenomena with respect to three different scales: the Pareto-efficient, the moral and the aesthetic. A new domain of choice is delineated by the intersection of

the three sets of measures, each pertinent alternative being defined by a subset of three attributes establishing its relative, or absolute, efficiency, equitableness and aesthetic quality (fig.1).

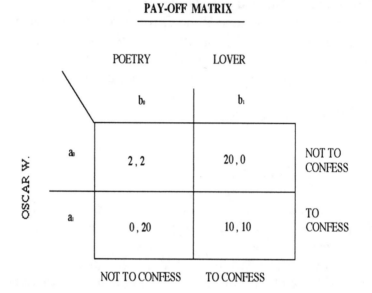

PAY-OFF MATRIX

	POETRY	LOVER	
	b_0	b_1	
a_0	2 , 2	20 , 0	NOT TO CONFESS
a_1	0 , 20	10 , 10	TO CONFESS

OSCAR W.

NOT TO CONFESS TO CONFESS

ORDINARY
DILEMMA
(GAOL HAS
 TO BE AVOIDED)

A: $a_1, b_1 P_A a_0, b_0 P_A a_1, b_1 P_A a_0, b_1$
B: $a_0, b_1 P_B a_0, b_0 P_B a_1, b_1 P_B a_1, b_0$
Nash : a_1, b_1
Pareto: a_0, b_0

CUM
AESTHETICS
(GAOL IS
 NEEDED)

A: $a_0, b_0 P_A a_1, b_1 P_A a_0, b_1 P_A a_1, b_0$
B: $a_0, b_0 P_B a_1, b_1 P_B a_1, b_0 P_B a_0, b_1$

Nash
Pareto $>$: a_0, b_0

SCHEME 1

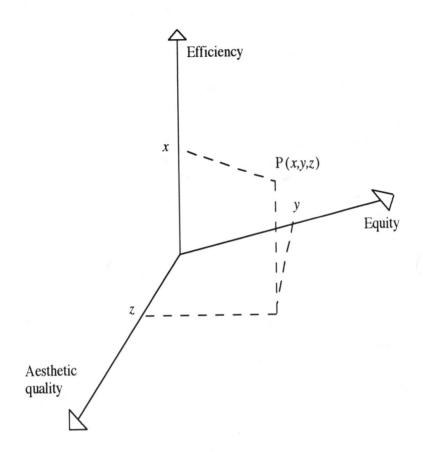

FIGURE 1

A trade-off surface can thus be determined. All sub-optimum feasible points have to lie on it. Trade-offs among these three attributes are possible in reality, to determine social choice, starting from Sen's demonstration of the necessity of limiting either the Pareto-constrained or the libertarian/equalitarian domain. These trade-offs are combinations of what Sen calls "conditional versions" of the Pareto principle (or of its conditions of application, which are here of two kinds: ethical and aesthetic). It is therefore possible to define trade-off paths by determining the "motivations" which lie "beneath the prefer-

ences" (19).

Building council houses in the neighbourhood of the historic center of a city of art is certainly equitable; minimizing their operational costs by using rolled plate roofs is certainly efficient, but the result is certainly ugly!

More attractive results are more expensive and probably less equitable. Working class houses in remote suburbs with rolled plate roofs are aesthetically more acceptable. Why should the poor be removed from the Pope's gaze on a Papal tour? Neither economic nor ethical reasons justify this historical practice, which is the result of an aesthetic trade-off. Social decisions on cultural education and standards such as those implied in points a.2, a.3, b.5, b.6, as well as the appreciation of cultural external positive effects can be based on such trade-offs.

3.6 The economic significance of creativity and interpretation

As aesthetic judgement is one of the fundamentals both of production and consumption, a further economic analysis of creativity and interpretation, as defined above, clarifies the consequences of accepting the aesthetic axiom of "non-consequentiality" as a meta-theory for economics. "Creativity" and "interpretation", the two main aesthetic processes, must both be examined as information processes or as a part of them.

As we have already seen in chapters 1 and 2, the aesthetic bases of creativity have already largely been recognized by institutionalist approaches to science and to economic science as well (20). The point here is to reverse their epistemological approach and try to analyze the economic consequences of aesthetic creativity instead of investigating the aesthetic roots of economic creativity.

This has at least two main consequences on the application of the theory of value on the supply side of a market endowed with aesthetic qualification.

a. The relationship between labor and leisure (the time constraint) can be modified by creativity, both varying labor productivity

and qualifying leisure. Possible substitution effects can come from this. Here the increase in "intensity" theorized by Mazzola, as well as Smith's improvement of the "quality" of people, finds an analytical justification. Due to the "non-consequentialist" nature of aesthetic creativity, its effects cannot be taken into account only by means of the usual analytical tools. This does not necessarily mean that they can not be measured ex-post keeping the relative price set meaningful. This means, however, that the usual positive marginal decreasing productivity assumptions may be repealed. We will discuss all this further in the next section and in chapter 5.

b. The fundamentals of market distribution of income among factors can also be biased.

What kind of productivity is that which comes from aesthetic creativity, given that it should be measured by means of the subjective quality of the product instead of through its quantity? Added value, however, is undeniably created by aesthetically-qualified labor, which cannot therefore be distributed on usual efficiency bases. Relative prices may be inefficient allocation tools.

Creativity has its consumption version in "interpretation" which is a knowledge in which the object reveals itself as much as the subject expresses himself. "Interpretation" is characterized by the same features of creativity we mentioned above and it is at the same time a "non-consequentialist" way of consumption. "It runs a permanent risk of misunderstanding": that is, the aesthetic qualification as defined through creativity can be eliminated or modified by interpretation. Thus interpretation has, again, some consequences on the theory of utility itself.

c. On the one hand, this recalls the argument of the subjective "difference" among people raised by the application of ethics to welfarism (21). It makes an objective measurement of scarcity through the market impossible and, furthermore, represents a serious obstacle to the maximization of social welfare through prices.

As Sen underlines, if the utility functions of individuals are essentially similar, the utilitarian need to maximize total utility as

74

a sum of individual utilities could result in the equalization of individual marginal utility levels. Differences among individuals, on the contrary, can lead to non-equalizing equilibria and to non-clearing markets as those recalled in points b.1 and b.2 (22). This is often the case for the art market itself, where these theoretical consequences can be drawn from the subjective "interpretation" of quality through prices (23).

d. "Interpretation" is based not only on the subjectivity of the interpreter, but also on the "novelty" of the object. As creativity is the source of taste, so too is interpretation. This means that taste changes are exogenous to any economic system as and when they are "created" by artists, which avoids the analytical limits discussed in point a.1.

Endogenous taste modifications are the conceptual bases of the "constancy" of tastes on which the theory of rational consumption is based.

Aesthetic judgements involve changes which are not included in Stigler and Becker's rational categories of "De Gustibus Non est Disputandum", even if they are the specific source of what Stigler and Becker call "style goods", or of commodities characterized by "the demonstration of alert leadership, or, at least, not lethargy, in recognizing and adopting that which will be in due time, widely approved" (24).

In this sense Schoenberg's music or Kandinsky's paintings were "style goods" when they were first performed or exhibited. What does not fit with the nature of aesthetic process is the statement according to which a "style good" is consequently classified in the domain of rationally consumable goods: "It is a commendation of a style good that it be superior to previous goods, and style will not be sought intentionally through less functional goods" (25). The consumer's changing attitude towards goods is thus explained through increases or decreases in its functionality.

Aesthetic changes (creativity) are not necessarily created by functional changes and do not necessarily create them, (26). Again: "Utility can well be added to beauty but can never participate to constitute it" (27).

Exogenous taste changes are thus permitted, and "instability" of tastes does not depend in this case on "variables in the household production functions for commodities". All changes are "no longer explained by changes in prices and incomes". A particular "explanation of why some people become alcohol addicted and others to Mozart" (28) seems thus to be possible without denying the "box of instruments" of economic analysis. This does not mean that the whole process can no longer be studied in the light of "the constraints imposed by the theorem of negatively inclined demand curves" (29). This means only that the violation of this theorem as defined by compared statics and dynamic analysis of the consumption function of artistic goods, as well as that of the First General Theorem of Welfare Economics, (a.1 and b.1), can be interpreted on new bases.

3.7 Creativity and interpretation as information asymmetries

Following Kant's definition and the "formativity theory" of aesthetics (e.g. Pareyson (1991)), the aesthetic assumption can also be considered as a specific feature of the information process (Pierce's "abduction", or Veblen's "principle of adaptation") which result in an increase of individual power in the "interpretation" (Boulding's "capability of forming images of the future") (30).

The capability of hypothesizing new "forms "or "laws" to "inform reality" without adopting established rational schemes (and laws) adds value to the usual inductive/deductive process. This leads to an increase in information on reality either for the artist or for the interpreter (asymmetrically) or for both of them. Only when the "beautiful" and "functional beauty" (31) concide -that is in the case theorized by Hume and others of the identification of the useful with the good and the beautiful- can this increase of information be appreciated by the market. In all other cases (the majority) the market fails to evaluate the aesthetic experience correctly either on the demand or on the supply side.

Aesthetic qualification can thus be analyzed using the conceptual model of externalities, even if it is not an externality. It is not

dependent on someone else's behavior like externalities, but only on the internal personal subjective qualification of the producer or of the consumer. The latter, through his experience (which gives form to the aesthetic contents of the artwork) "interprets" the "beauty" of the good that the former created, as an end in itself. He is unaware of it until that moment. This ignorance causes *ceteris paribus* a loss in social welfare.

Let us consider for analytical purposes a perfect competitive world where the "beautiful" is "functional beauty". In this case, as in Stigler and Becker's model, everything can be reduced (again for analytical simplification) to the usual demand and supply system, in equilibrium at their intersection (K in figure 2).

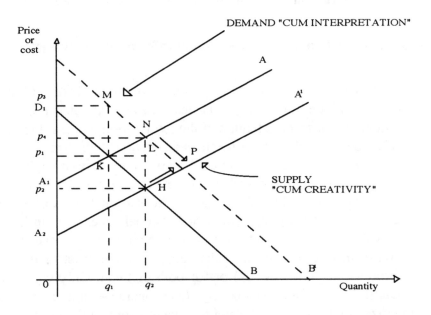

FIGURE 2

If the weight of aesthetic qualification is increased and therefore the "beautiful" is taken to differ from "functional beauty" (32), a new supply function "cum creativity" can be identified (A', in figure 2). a. This function is characterized by lower information costs (higher

information benefits or value). The increase in information result-
ing from "creativity" reduces the supply cost, as in the case of any
positive external effect. It is not, however, an external effect but an
"internal" attribute of the supply itself.

b. The ordinary consumer ignores the "formativity" of the object and,
therefore he refuses to consume q_2, his subjective cost being p_1.

c. Society thus suffers a net welfare loss, corresponding to the
difference between the two total surplus areas:

$$A_2 HD_1 - A_1 KD_1 = R > 0 \text{ always};$$

as the second term of the difference is inscribed in the first.

d. Let p_1 be the equilibrium supply price in perfect competition. To
avoid the social loss and move the consumer to H (q_2, p_2), the
producer has to be subsidized for the area:

$$S = p_2 HLp_1$$

not always being

$$R - S > 0 \text{ (33)}$$

e. If, on the contrary, the consumer "interprets" the supply aestheti-
cally, he can shift his demand curve (from B to B'), as if an external
positive effect were present. This is not, in any case, an external
positive effect, because "interpretation" is a subjective internal
differentiation of quality among individual consumers. In this case
the consumer can feel, initially, that he is enjoying an extra
aesthetic surplus from his consumption, paying p_1 for what he
estimates to be worth p_3. He is then incentivated to expand his
demand to q_2, raising the price to p_4.
Here the net social benefit is higher than in q_1, as

$$A_1 ND_2 - A_1 KD_1 = P > 0$$

and of course

$$R=P$$

No subsidies are needed in the presence of the aesthetic qualification of demand. Aesthetic "interpretation" without aesthetic "creativity" on the supply side generates *ceteris paribus* a price increase. Superstardom is good evidence of this (34). The increase in consumer information provided by "popularity" leads to a market discrimination in favor of the star. Specific producer surplus and extra-price levels characterize the market concentration around the star.

f. There is a large difference between N and H-like points. In the former the producer is in a net profit position, in the latter a subsidy is needed for him. Neither of them is likely to be the steady one, because N is not a perfect competition equilibrium, including a net profit neither is H, including a net loss. The system is likely to stop in P, which creates neither net profits nor subsidization needs.

This demonstrates that the asymmetry in the agents' quality, and specifically the consumer's lack of "interpretation" in the presence of producer's aesthetic "creativity", is a basic reason for subsidizing art, while in presence of "interpretation" without "creativity", subsidies are not only unnecessary but can possibly widen the producer's surplus position. We do not have to take into account specific externalities of the arts, or their non-excludability, or even their limited saleability in support of the rationale of subsidizing the arts (35), but we need only consider the subjective qualification of their agents.

It is useless to distinguish ethical judgements either in terms of the interest of future generations, national pride, civilization, or for the absolute "increases they originate in the size of individuals' choice sets" (36). This does not mean that these arguments are worthless. They are simply not necessary for this demonstration. They are more significant in analyzing all the other aspects of art markets, which derive from this first one.

The Pareto judgement is accepted here only for analytical purposes as well as the identity of the "beautiful" and "functional beauty". One could weaken the Pareto judgement as has been done for the aesthetic equivalence "beautiful=functional beauty". This will not lead to a

refutation of the hypothesis but only to a weakening of the "economic side of the demonstration", offering, as a trade-off, stronger bases for imposing moral or aesthetic conditions.

3.8 Conclusions and summary

The literature of cultural economics has generally come to the conclusion that the problem of grounding rationally subsidization policies for the arts is not resolvable via "individual rationality" and "Pareto-efficiency".

Shubik's centipede paradox can be utilized here both to argue that prescriptions are useless if they are not based on practice and that theory is useless if it supplies solutions of practical implementation.

Instead of analyzing the way of improving policy-making efficiency, the possibility of improving metatheoretical axioms is here suggested in order to supply more realistic (or less contradictory) theoretical approaches of economics to the field of aesthetic goods.

The suggestion is to adopt an "irrationality axiom", (or a "non-consequentiality" one) for these goods and processes, originating from the Kantian definition of "taste" or "pure judgement".

Two consequences derive from this:
- a non-consequentialist structure of the relationship between reality (or phenomena) and preferences;
- a possible qualitative (informative) asymmetry among agents, whose individual "evaluations" differ because of the "value" of their aesthetical information.

On these grounds, social and individual choice schemes can be adjusted for a better justification of art subsidization on rational bases. These schemes result from a trade-off among efficiency, equity and aesthetic qualifications of commodities.

In this sense, there is some truth in the conclusion of those who say that using market failure as an argument for art subsidies leads either to equity-based justifications or to political-paternalistic assumptions, or to the violation of both, as these qualifications contradict each other (37).

The suggestion here is that:

a. "political-paternalistic" is not the only definition of the aesthetic nature of the analyzed judgement. As we have seen, this judgement lies outside the scope of the utilitarian schemes but it does not have to be paternalistic. It refers internally to the agents, not to an external deus ex machina. Thus "a redistribution of resources among agents on grounds of tastes" becomes rationally possible, as seen in section 3.7, even if it may be contradictory to "the fundamentals of the liberal democratic society " (38).

b. The contradiction between Pareto-efficiency and equity-based justifications is recognized as unavoidable, because it is the consequence of the specific nature of the judgement, as well as in the case of the ethical (libertarian) judgement discussed by Sen. Under the "aesthetic judgement", the contradiction is apparently complicated, but epistemologically clarified by imposing to the theory a "finality without aim" condition (that is a non-consequentiality axiom). This improves the capacity of the theory to represent real world choices.

Notes

* The contents of this chapter were discussed at the ESPC Conference, Turin 1992, April 22-25, as in Mossetto (1992 b).

(1) To anticipate here some contents of chapter 4:
the marginal rate of transformation (or the marginal cost in equilibrium) may not be equal to the sum of the marginal rates of substitution for consumers. In terms of utility, their "perceived" prices (and costs) are different from market prices (and costs). Applied to the problem of establishing an optimum quality standard, this further complicates the possible violation of Samuelson's equality, which is already involved in the choice of quality for public goods. "A collective indifference curve for quality does not exist (...) Only collective indifference points exist, and they are the points at which two given indifference curves for quality of two individuals (A and B) intersect" (Giardina (1969)).
The sets of intersection points, which are also tangential between the indifference curves of each consumer and the curves of iso-expenditure (public-private)for quality, are optimum sets which define an area of Paretian optimum quality. In this area, the following is valid:

$$\text{SMS}_A \leq \text{SMT} \geq \text{SMS}_B$$

where the equality between the individual marginal rates of substitution (quality/quantity) and the marginal rate of trasformation (public/private) can only be verified within each boundary set, but not necessarily in the area they define.
The use of preference-revealing instruments, such as auctions or Clarke's taxes, or voting rules in general, in deciding optimum standards is, therefore, critical (See chapter 4).

(2) "The owl was the wisest of animals. A centipede with 99 sore feet came to him seeking advice. "Walk for two weeks one inch above the ground; the air under your feet and the lack of pressure will cure you", said the owl. "How am I to do that?", asked the centipede. "I have solved your conceptual problem, do not bother me with trivia concerning implementation, " replied the owl". (Shubik, 1984, p.615).

(3) Harsanyi (1977), p.55.

(4) Rizzacasa *Il modello utilitaristico applicato al concetto di giustizia secondo Harsanyi*, in Biolo (1991), p.122.

(5) Ibidem, pp.122-123.

(6) See Sen (1986), and Sen, Williams (1982), and also Biolo (1991).

(7) Sen (1986), p.346-347.

(8) Ibidem, p.329.

(9) Ibidem, p.321-324.

(10) Pareyson (1984), p.43.

(11) Sen (1986), p.279 and 290.

(12) Gibbard (1974), p.31.

(13) Sen (1986), p.289.

(14) Pareyson (1984), p.43

(15) Veca (1986), p.97.

(16) Sen (1986), p.138-139.

(17) Ibidem, p.145.

(18) Mill (1863), p.196.

(19) Sen (1986), p.324.

(20) See Dyer (1988), Mc Closkey (1983), Veblen (1964).

(21) See Sen's critics to Rawls, in Sen (1986), p.355.

(22) Ibidem, loc. cit.

(23) See Mossetto (1992 a) and chapter 4 of this book.

(24) Stigler, Becker (1977), p.88.

(25) Ibidem, loc.cit.

(26) See Puu (1991) and chapter 1 of this book.

(27) Pareyson (1991), p.215.

(28) Stigler, Becker (1977), p.89.

(29) Ibidem, loc.cit.

(30) See Troub (1980), Dyer (1986) and (1988), and specifically Pierce (1931-35-58), Veblen (1964) and Boulding (1978).

(31) Where "the beauty is reduced to that special adaptation to an external aim which is utility" (Pareyson (1991), p.216).

(32) Which is plausible:"functional beauty" is temporary, referring to a moment when utility has not yet penetrated into the form to constitute its own structure. On one side the utility principle tries to inform uninformed materials, being their external finality (...).

On the other, the form is searching itself, by attempts that will result in a logical order, only at the accomplishment of the art work" (Pareyson (1991), p.216).

(33) This depends, of course, on the elasticity of supply and demand.

(34) See Rosen (1981), Adler (1985).

(35) Abbing (1980), p.35 and p.39.

(36) Austen - Smith (1980), p.28.

(37) Ibidem, and also Robbins (1963), Peacock (1969), Blaug (1976).

(38) Austen - Smith (1980), p.30.

CHAPTER 4

THE DEMAND SIDE: AESTHETIC INFORMATION

ASYMMETRY AND THE THEORY OF RATIONAL

CONSUMPTION

4.1 The leading assumptions

The information asymmetry rising from creativity and interpretation is assumed to provide a basis of the analysis of individual and collective demand functions with aesthetic qualification. The effects of this will be studied with respect to
a. the individual demand function;
b. market equilibria;
c. possible strategic behaviors;
d. taste formation and changes.
More realism will be introduced into our analysis adding the usual assumption of non-excludability for mixed goods to the aesthetic qualification of the good.

Creativity and interpretation, as described in chapter 1, cause an information asymmetry between producer and consumer, the latter generally having a lower degree of information than the former. The consumer can react to this in two ways: either searching for information on the market or asking someone to inform him.

The first is a case of information through price (which will be examined in this chapter); the second of information through "certification" (which we will discuss in chapter 6).

4.2 Consequences on individual demand

Information asymmetry makes artistic goods not perfectly homogeneous. The consumer's choice can be based on information contained in the price itself (the price is the information revealer). The consumer assumes the price to be an indicator of the quality of a given product: the higher the price, the higher the perception of the quality and vice versa. In such a situation the usual assumptions of consumer price-taking behavior, irrelevance of the consumer distribution, on the market and well-defined markets, are no longer valid.

"In these models, the choices may convey information: individuals know this, and this affects their actions. (...) In each of these instances, the uninformed party (the seller of insurance, the used car buyer, etc)

forms rational expectations concerning the quality mix of what is being offered on the market; the price serves as a signal or as a screening device" (1). Price transmits information on quality and influences the behavior of agents on the market. The high price of performances by the Berliner Philharmoniker (both live and recorded) is an indicator of the high quality of their music and it is also an incentive to maintain high internal selection standards.

The dependence of quality on price can be represented by means of a function linking the price to "the cost per efficiency unit" (that is to say, to the cost per effective unit of production, however this is measured). The lower this cost, the higher the quality and, hence, the price.

In Stiglitz's models (Stiglitz (1987)), physical units (effective working hours) or monetary units (returns on invested dollars) are employed to measure the "product" resulting from the use of the good in question. This is not true in our case where, as we are dealing with a consumption good, the way of measuring quality differences is the relationship between expected utility and expenditure. The "cost per efficiency unit" is the cost of reaching each possible maximum utility level on the utility boundary for a given consumer and for a given good.

The optimization of the system can be dealt with as a dual problem of cost minimization for a given (constant) utility curve

$$\text{MIN } C = pq \qquad [1]$$

subject to

$$v(q) = u$$

Where the determinants are u and p.
This results in a Hicksian cost function (2) of the type.

$$C(u, p)$$

for which

$$\frac{\delta(u_i, p_i)}{\delta p_i} = q_i \frac{\delta(u_i, p_i)}{\delta p_i} = q_i \qquad [2]$$

with

$$u_i = \bar{u}$$

which is our compensated demand function, where q. is influenced by price variations, u_i being constant (3).

Given the dependence of quality on price (4), and the additional assumption of a positive relation between quality and utility (the higher the quality, the greater the utility (5)), the following should always be valid for equation [2]:

$$\frac{\delta q_i}{\delta p_i} > 0 \qquad [3]$$

namely that any price increase leads to a quantity increase.
Kalman has shown (1968) (6), however, that this is not necessarily true. In fact, given the above-mentioned assumptions:

$$v(q_i) = u_i > 0 \; ; i = 1, \ldots., n$$

that consumer always prefers a higher quantity to a lower one and

$$\frac{\delta v(q_i)}{\delta p_i} = u_{n+1.} \geq 0; i = 1, \ldots., n,$$

that is: whatever is more expensive is always better.

Slutsky's standard equation can also be generalized as follows, inserting the price in the utility function:

$$\frac{\delta q_i}{\delta p_i} = \frac{\delta q_i}{\delta p_i}\bigg|_{\bar{u}} - q_i \frac{\delta q_i}{\delta m} + \frac{u_{n+i}}{\lambda} \frac{\delta q_i}{\delta m} \qquad [4]$$

where the first term of the right-hand side of the equation represents

the substitution effect, when utility is constant (with i = 1,, n), while the second represents the "price offsetting income effect". It measures the increase in quality, when income varies, as weighted by the ratio between the marginal utility of price, and the marginal utility of income (6).

The sign of the first term is the opposite of that of the price variation, while those of the second and of the third are the same as that of the price variation, when the good is normal or superior (as in the case of artistic goods). As the signs of the last two terms are the opposites of each other, the solution is undetermined, for artistic goods. The slope of the demand curve can either be negative (as it normally is), or positive.

On further analysis, Kalman's conclusion seems to be analogous to that obtained in Slutsky's standard equation, if the initial endowment income effect is taken into account.

$$\frac{\delta q_i}{\delta p_i} = \frac{\delta q_i}{\delta p_i}\bigg|_{\bar{u}} - q_i \frac{\delta q_i}{\delta m} + k_i \frac{\delta q_i}{\delta m} \qquad [5]$$

where $k_i \dfrac{\delta m}{\delta p_i}$ is the initial endowment (7).

In this case

$$\frac{\delta m}{\delta p_i} > 0$$

if

$$\left(k_i - q_i\right) \frac{\delta q_i}{\delta m} > -\frac{\delta q_i}{\delta p_i}\bigg|_{\bar{u}} \qquad [6]$$

which can be transformed à la Kalman by means of a few simple modifications (8).

$$\left(\frac{\delta u_i}{\delta u_m} k_i - q_i\right) \frac{\delta q_i}{\delta m} > -\frac{\delta q_i}{\delta p_i}\bigg|_{\bar{u}} \qquad [7]$$

In order to satisfy condition 7, the total income effect has to have an opposite sign and be greater than the substitution effect.

Here the influence of the initial endowment as a determinant of the purchasing power of the consumer (and of his revaluation or devaluation following prices) is weighted through a coefficient defining quality in terms of utility. This coefficient represents, in real terms, the marginal utility of price (the marginal variation of utility when quality varies in relation to price), as it relates the marginal utility of quality (δu_i) to the marginal utility of money (income) (δu_m) -, to eliminate the purely monetary effects. This coefficient is always greater than zero, but not always greater than one. Slutsky's perverse endowment effect can be thus revisited. It may generally imply a modification in the sign of the slope of the demand curve (9) when the variation of the initial endowment value (k_i), according to price variations, incentivates consumers who are net buyers to become net sellers, or vice-versa (9).

This is reinforced when there is a strong preference for quality causing utility to increase more than price,

$$\frac{\delta u_i}{\delta u_m} \geq 1$$

while it is weakened when the preference for quality is weaker and utility increases less than price

$$0 < \frac{\delta u_i}{\delta u_m} < 1$$

with a weakening of Slutsky's ordinary effect as a result.

An art consumer's market position can vary following the way he thinks about his own cultural endowment. He can sell it on the market either as an independent good (a painting, a sculpture, a copyright and so on), or as a qualifying share of his own labor force (culture itself). This endowment value may therefore increase or decrease according either to the variations of price, or to those of the price-quality/utility ratio.

4.3 Some addictive consequences of information asymmetry

Imperfect information on quality also incentivates consumers to minimize information-searching costs as a part of consumption costs. Consumption requires knowledge, which is accumulated over time, forming the consumption capital of each consumer, in a process of "learning-by-doing". The refinement of taste and the accumulation of knowledge are necessary for the appreciation of artistic goods. The more I know, the more I like. The generation of consumption capital, as well as the existence of an initial endowment, conditions the demand function.

In the case of artistic goods, Slutsky's "initial endowment" and Becker's "consumption capital" may prove to be two different ways of looking at the same stock. The cultural endowment of an individual is, on the one hand, a stock he can sell on the market as a part of his labor force. On the other hand, it is the investment which is needed for his consumption.

Price variations have different effects on the demand function according to each way of considering this stock. While the initial endowment influences the budget constraint, the consumption capital affects the current utility of the good (which is to say, it reduces the current cost of consumption per efficiency unit).

Addiction between past and present consumption, is therefore caused by information asymmetry. The greater the past consumption and the larger the consumption capital, the greater the current consumption (10).

In the presence of addiction (according to Becker and Stigler's model (1977), later developed in Becker and Murphy (1988)) the consumer price (his shadow-price) differs from the equilibrium price without addiction. The former price is lower than the marginal market cost in the case of "beneficial" addition. It includes the advantage of current investment in consumption capital, expressed in terms of future consumption.

The consumer shadow price, on the contrary, is higher than the marginal market cost when addiction is "harmful", as it includes the future lower income resulting to an individual from the current

exposure to the "harmful" good.

The consumer utility of the good i at the time is not *ceteris paribus*, only a function of his consumption of i, q_i, t but it is also a function of the "stock" of his consumption capital of

$$i, (S_{i, t})$$

$$U_{i, t} = u (q_{i, t}, S_{i, t}) \qquad [8]$$

On further analysis, addicted behavior proves to be characterized by two components: "reinforcement" of current utility, on the basis of past consumption; and "tolerance" which decreases as the size of past consumption increases, when addiction is "harmful", and vice versa when addiction is "beneficial" (11). Due to the reinforcement effect, any increase in past consumption results in an increase in the marginal utility of present consumption. With:

$$\frac{\delta q_{i,t}}{\delta S_{i,t}} > 0$$

$$\frac{\delta^2 u}{\delta q_{i,t}\, \delta S_{i,t}} > u_{q,\,s} > 0$$

"Tolerance", on the other hand, in its "beneficial" version, permits past consumption to raise the level of future utility, thereby causing a growth in consumption capital.

The condition of this is:

$$\frac{\delta u}{\delta S_{i,t}} > u_s > 0$$

The opposite holds true in the "harmful" version.

Both of these phenomena reinforce the quality coefficient in equation 7. This affects the shape of the demand curve in a way which can be analyzed by reversing the structure of Becker and Murphy's "heroin model" (1988) (12). Unlike the "heroin model", our case deals with a good which generates "beneficial" addiction (the various art forms). Therefore the consumption function of a good over time, expressed in terms of consumption capital, at a given price is both convex and increasing. Moreover, artistic goods are normal goods. If initial income rises, current consumption rises, too (that is, $\frac{\delta q_i}{\delta m} \geq 0$).

Further increases in current consumption are then caused by the positive effects on future income of the increases of current consumption created by the growth of the initial endowment.

The extent to which addiction is beneficial depends on the fact that artistic goods are generally considered normal or superior goods in economic literature. In the "heroin model", on the contrary, the harmful effects on future income due to the increase in consumption, deriving from a rise in the endowment income, cause a reduction in current consumption. Hence, it is the presence of an inferior good which contributes to determining the "harmful" nature of addiction (13).

No consumption is foreseen below a certain level of learning accumulation (S_0). There is at least one point at which q and S (where $q = \delta S$) are steady over time, and consequently, where there is no "reinforcement" of S by q.

Whenever the current price increases and, therefore, the consumption function passes from A to A', the consumed quantity (q^*) decreases to \hat{q}, which corresponds to an unsteady state on the new curve A'. It will then increase to $q^{*'}$, a new steady point, due to the "reinforcement" effect. The opposite will occur in the case of price reduction.

The model also explains how an expected increase in the future price, shifting the consumption function from A to A', can cause an

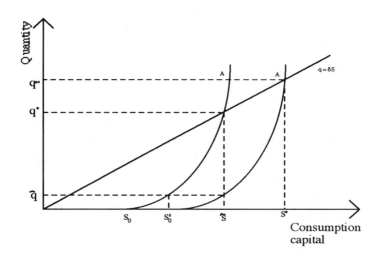

FIGURE 1

unsteady reduction in current consumption from q* to \hat{q}, reducing

from S* to \hat{S} the stock of consumption capital now considered necessary. The signs of current price variation effects can differ from those of the effects of equal expected price variations.

All this leads to the possibility of cycles in the original demand function, with changes in the slope of the curve and in its sign (from positive to negative), as well as to the possibility of a lower limit in the consumed quantity (14).

Sufficiently large reductions in consumption can cause a termination of addiction, reducing the consumption capital to a level that is

lower than the initial minimum if ($\hat{S} < S_0^|$) (figure 1). Furthermore, the consumer's position in the initial distribution of income is important in determining demand. The higher the relative income of the consumer, the weaker his reaction to changes in future benefits and, therefore, to current and expected price variations.

Finally, demand is a function of the optimistic or pessimistic attitude of the consumer to the future (and, therefore, of his actualization rate). Demand, in fact, does not depend only on current preferences but also on the evaluation of the future effects of present consumption. Consumers with higher discount rates (more pessimistic) are less sensitive to future advantages and, therefore, to price variations (15).

An endogenous component of "tastes" (preferences) is here specified. Changes in tastes are here based on the reinforcement of future preferences by past preferences, and on the relationship of tolerance between past, present and future consumption.

The analysis also confirms the characteristics imposed on the demand function by the dependence of quality on price, as discussed by Stiglitz (1987) for capital and labor markets.

a. The demand curve may have a non-negative slope, which does not mean that it always has to be positive. Non- monotonic demand curves give rise to multiple equilibria and unstable solutions. Addiction increases this possibility.

b. Thresholds and discontinuities can be caused by "binges", and "cold turkeys" (in Becker's sense).

c. Consumers can adopt strategic behavior conditioned by their personal position in the distribution of income and their personal attitude towards risk.

4.4 The "mixed good" assumption

In the art market model, these conclusions are subject to the additional assumption of the public nature of the good (which, as has already been said, is a mixed good). Artistic goods are endowed with non-excludability, even if their consumption is sometimes "rival". Indivisibility of consumption and free-riding can thus affect the determination of total demand. Non-excludability of consumption has, therefore, to be introduced into the addiction model. Non-exclusion can be assumed, either for the good itself, or for its consumption capital, or for both. In other words, it is possible that one consumer cannot exclude another from the consumption of a good, but

can exclusively appropriate his own consumption capital. I can exclude others from my acquired musical experience, but not from listening to the music of the Berliner Philharmoniker.

When total demand is determined as a vertical sum of the individual demand curves, situations which were initially steady, can become permanently unsteady. Let us go back to Becker and Murphy's model of consumption and take (fig. 2) $q*$ as the steady consumption level of two consumers (for whom $q_1 = \delta_1 S_1$ and $q_2 = \delta_2 S_2$) corresponding to S_1^* and S_2^* consumption capitals. For the first consumer, this will take place at a price expressed by the consumption function A_1, and for the second at a price expressed by A_2. As the good is public, the optimum price will be expressed by A_T, which is not the horizontal sum of the two consumption functions, but the consumption function corresponding to a price which is the sum of the shadow prices of the two consumers (see note (10)).

A capital consumption S_T^* will correspond to this price level.

a. Faced with a situation of uncertainty in price distribution (free-riding), consumer 1 will move to an appropriate consumption level $q_{T_1}^*$, while consumer 2 will move to $q_{T_2}^*$. As neither of these two positions is steady, a process of progressive future consumption growth is triggered off, given that new expanding consumption capitals correspond on A_T to $q_{T_1}^*$ and $q_{T_2}^*$.

In other words, when addiction is present, the possibility of free consumption (or the idea of free-riding itself) causes demand increases - a case of "eyes that are bigger than the stomach".

FIGURE 2

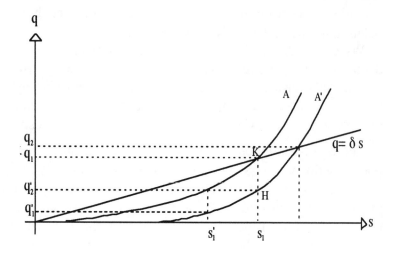

FIGURE 3

b. The second hypothesis, as stated above, is that of indivisibility for consumption capital, too. The possibility of free-riding on consumption capital was already recognized by Downs (1957) who observed that party supporters can free-ride on the cost of opinion formation sustained by their leaders. Initial stocks of consumption capital and price increases being equal, this causes a greater expansion of consumption than is possible with private goods.
Let us assume that the initial stock of consumption capital with private goods is S_1, which involves a consumption quantity q_1. Free-riding on the consumption capital of others makes it possible to continue to consume q_1, with a lower stock than would otherwise be necessary ($S_1^* < S_1$).
Whenever the price increases from A to A' private consumption drops first to q_1 and then rises to q_2. Consumption with free-riding decreases first to q^* and then rises to q_2. With:

$$q_2 - q_1^* < q_2 - q_1^*$$

Non-excludability causes an extra expansion of quantity. The effects discussed in point a. and b. can cause market concentrations due to information asymmetry. This leads, from a different starting point, to a well-known phenomenon of art markets: stardom.

The star phenomenon is, first and foremost, a market instrument for economizing on learning and searching costs (16). This is achieved by sharing one's own choice with that of the largest possible number of consumers. Each consumer has a tendency to specialize in a limited number of goods. The acquisition of the product of the "most popular artist" has positive welfare effects by saving consumption capital accumulation costs.

Listening to Pavarotti in "La Bohème" is not necessarily the best choice in terms of taste, but it is certainly less "expensive", in terms of learning accumulation, than listening to a performance of electronic music by John Cage. The information contained in the consumption capital is thus subject to a joint use of the "star" on the part of all consumers.

4.5 Effects on the market

In conclusion, the use of price as a quality signal joined with the addictiveness and non-excludability of the consumption of the good gives rise to some specific features of its market, which are the following:
a. non-monotonicity of demand;
b. buyers' strategies of risk aversion and information cost saving;
c. market concentration;
They create the possibility of:
a. non-equality between supply and demand in equilibrium;
b. non-single prices;
c. product discrimination.

Stiglitz's standard analysis (1987), with some modifications, provides a framework for the study of these problems, when adapting the measurement of utility in terms of "cost per unit of efficiency", as discussed above.

4.5.1 Non-clearing markets

Stiglitz attributes non-equality between supply and demand in equilibrium to the existence of optimal "contracts" including a clause, which makes them acceptable to one party, but is not considered really binding by the other. (17) Let us, therefore, reformulate Stiglitz's model of the "default curve" for the credit market in terms of the art market.

We can assume that skilled and unskilled consumers are operating in this market, as well as scrupulous and unscrupulous artists. Consumers maximize their own utility with the least probability that their quality expectation will not be met ("they don't want to get swindled"). Their behavior is illustrated in figure 4.

The expected pay-off from the act of consumption is in equilibrium

$$\zeta = P(wt + p)$$

where \quad P \quad is the probability of not being disappointed;

$\qquad\quad$ wt \quad is the income relinquished in exchange for consumption (assumed to be constant: A);

$\qquad\quad$ p \quad is the price, or cost, of consumption.

The expected pay-off can increase if the price increases, to p*, where

$$P = 1$$

and

$$\frac{1}{\zeta} = A + p^*.$$

after that it may decrease if unscrupulous artists supply increasingly lower quality products, in order to achieve increasingly higher prices, offered by consumers who aim thereby to increase their own utility. Some might call it the "Pavarotti effect"!

Expert consumers become aware of this and they return to p*. The optimum will be achieved by means of an excess of supply, or a rationing of demand. q depends on p, which in turn depends on the consumer's attitude towards risk (and/or towards the future).

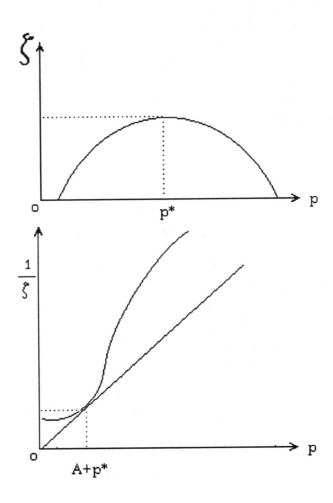

FIGURE 4

The contractual optimum moves towards p** >p*

The analysis of supply and demand shows their interdependence. Individual (and total) demand depends on the price-based assumptions of consumers concerning the quality of goods. The validity of these assumptions depends on the nature of the responses from the supply side.

Music lovers are right in thinking that high price corresponds to high quality of performance. It is possible, however, that prices are high simply because productivity is low: the Rome Opera House is an example. Outdated back-stage machinery, union conflict, organizational inefficiency and limited seating capacity, reduce the number of performances and the attendance. Problems of consumer distribution on the market arise as a consequence of the distribution of the supply characteristics.

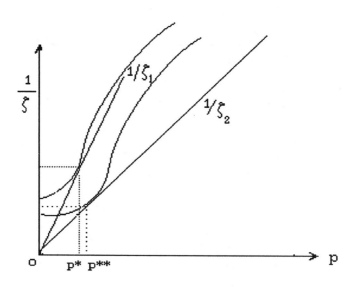

FIGURE 5

An excessive consumer aversion to risk, rather than the inexistence of an acceptable minimum quality, can make p*-like points impossi-

ble. In this case, equilibrium can even imply the absence of market. A pessimistic music lover can decide not to subscribe to a concert season because he is not certain who the performers will be, even if he would have subscribed had more information been available. This model can also be used to explain why a sharp division cannot be made between demand and supply analysis. The expected "default curve" can be modified for reasons which do not depend on the consumer's preferences or on his attitude towards risk, but rather on the productivity (in quality terms) of the artists. If deontologically-oriented artists impose their behavior on those who are not so, thereby compelling the latter to increase the quality of their production, then the "default curve" can fall to the right. Price (or perceived quality) being equal, the probability of consumer satisfaction increases.

Figure 6, illustrates the possibility that unskilled consumers move to $\frac{1}{\zeta_2}$, under uncertainty concerning the distribution of good and mediocre artists on the market. This will give rise to two different contractual optima: one for the unskilled (p^{**}), and one for the skilled consumers (p^*). In this case, the skilled consumer (or the pessimist) practices a higher rationing of demand and offers a lower price than the unskilled consumer.

4.5.2 Non-single prices

This is only one of the possible cases where prices are "non-single", even in the presence of private goods. In general, this conclusion is justified by non-monotonic demand functions.

Here, non-single prices are not only created by the existence of a different optimum price for each consumer (as illustrated by Stiglitz (1987)), but also by the above mentioned "non-single-peaked" preferences of every single consumer.

The market automatically uses queueing to resolve the problem of non-single prices. It imposes a waiting or congestion cost on the lower bidder, thereby bringing his total cost of consumption to the level of the higher bidder. In the case of public or "mixed" goods, however, the possibility of free-riding can limit automatic rationing. The possibility of non-single prices for the individual consumer (several sub-optimum

104

positions), can complicate administrative rationing as well.

4.5.3 Product discrimination

Finally, as has been seen, the demand curve can be non- continuous in relation to price. Discontinuity may cause product discrimination (as well as consumer discrimination), involving also rationing, rather than market solutions. Addiction gives rise to thresholds below which consumption does not take place independently of price changes.

When addiction is present, discrimination is practiced on an individual basis ("I do not consume because I am not used to consuming").

The lack of homogeneity in consumption is due to different "perceptions" of the quality of the good. The individual will never consume goods which he rates below a minimum expected level of satisfaction (q^*). This value is endogenously defined for him, because it is that of his alternative consumption opportunities (18).

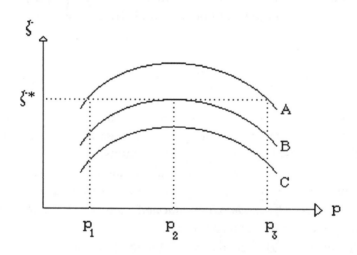

FIGURE 6

Let the curves A, B, C, (figure 6) be functions of the expected satisfaction returns of three types of products, as distributed at three different quality levels. Only the first type of product can be consumed at prices ranging from p_1 to p_2. The second can be consumed only at price p_3. The third type of product will never be consumed, independently of the price level. Also in this case there will be an excess of supply, which the market will not resolve with a price reduction - no-one is willing to consume products with a quality as low as that of group C (19).

In this sense, when discrimination is based on price, price is not only the source of information on quality. It is also the vehicle of a specific incentive to the producer/seller "not to swindle". The damage suffered for a breach of contract increases with price. The "principal" (the consumer) can, therefore, exercise an indirect control on the "agent" (the artist), by means of the price (20). If he is, for example, an investor in contemporary art he can use price-ceilings to control the quality level of future production. He thus reduces the "moral hazard" of the adverse effect of a decline in the artist's quality, and therefore of the average price of the stock signed by the artist. As Stiglitz points out (21), both a certain level of unemployment and a minimum wage are necessary in order to discourage "shirking".

4.5.4 Market optimization

Similar situations (22) are constrained Pareto-inefficient: improvements in collective welfare are always possible through public intervention (23).

These policies can be built up normatively, by bringing the market back to the theoretical situation of perfect information (with all the other usual conditions present). This means supplying information about quality to consumers, which can be achieved by means of administrative price-fixing, rationing or quality regulation.

All three approaches require the determination of a quality standard. Public intervention is theoretically intended to prevent one of the

parties from seeing the contractual optimum quality (or utility) constraint imposed by the others as not binding (24).

The simplest example is that of "over-booking". The quality standard must be fixed as a limit on the utilization of available places in order to provide optimal listening conditions for the audience. Music lovers consider this limit contractually binding, while the impresario does not. He tends to make price equal to average cost, while the social optimum condition would make price equal to marginal cost. A quality standard must be imposed by rationing the good. For example, a public regulation could be imposed, stipulating that the number of people permitted inside a concert hall cannot exceed the seating capacity. Perfect information must be economically available in order to determine a quality standard. Efficient means of signaling the existence of the standard to the consumers are also needed (prices, queues or other signals). Leaving aside, for a moment, the former requirement, let us examine the latter. Its fulfillment is conditioned by four sets of problems:

a. Each consumer perceives the price-signal in his own quality frame of reference.
b. Production functions interact with consumption functions and can distort the consumer's response.
c. The good in question is either public or "mixed".
d. Price can be a distorted means of information about quality.

a. Whatever reason consumers have for assessing quantity on the basis of price (to minimize information costs or consumption costs), the fact that they do so causes an endogenous modification of their preferences in relation to prices (25). The way in which this takes place is influenced by each consumer's frame of reference (26). Each individual reacts in a different way to the fixing of a standard, whether it be a price increase or a quantity rationing. This depends on the following: the difference between the standard and the quality he has consumed so far, the extent of his past consumption over time, the quality enjoyed by other consumers etc.
b. Production functions interact with consumption choices. In this case, a quality standard can be, in itself, an incentive to further

"distortion".

Let us assume different production cost functions for two goods of the same type, but of different quality. C_1 is the marginal cost curve of a good A with quality F_1 (q_1) while C_2 is that of the same good with quality F_2 (q_2). Let q_0 be a Paretian non-optimum quantity. The situation can be improved moving to q_1 by rationing consumption. The fixing of an administrative standard can result in a shift of consumption towards the good with an inferior marginal cost. The quantity consumed increases rather than decreases (to q_2).

c. Administrative standards are also complicated by non- excludability of consumption. If quality (the standard) can be established by administrative pricing or rationing (queues), free-riding complicates this (or makes it more costly). This is particularly evident when consumer discrimination is on a group basis (when practised between higher and lower bidders). In this case the possibility of free-riding, whether on consumption or on consumption capital, always involves the exploitation of higher bidders by lower bidders. There is, therefore, no incentive to oppose the quality standards set by the former (27), even when they are worse in terms of social welfare than the standards of the latter.

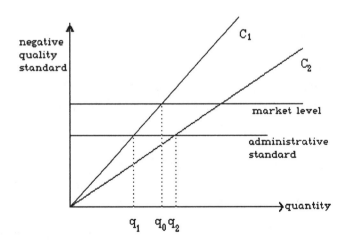

FIGURE 8

d. Price can either be an efficient or an inefficient means of information. It has already been seen (section 4.3) that information asymmetry causing addictive behaviors can also be an endogenous source of taste changes independently from any price/quality relationship. Addiction concentrates demand on a limited number of products ("stars"), ignoring lower quality levels, even if slightly inferior.

External and internal consumption effects exacerbate the relationship between quality and price. Fashion, snobbery and "conspicuousness" increase the price of art, outstripping quality increases (28). Price overestimates quality. The use of administrative prices is thus limited. The setting of "non-popular" quality standards (with no reference to the "stars") has no effect. Despite the new standard, the "star" product continues to be consumed, because the high price has made it "popular". There is no use explaining to Italians that Katia Ricciarelli is not the greatest living soprano. People will continue to flock to her concerts simply because her husband is Italy's most famous TV personality.

4.6 About perfect information

Up to this point the analysis has been concerned with the practicability of rationing instruments in the imposition of quality standards to obtain welfare improvements on the artistic market. Solutions to these problems apart, the possibility of economic access to perfect information, in order to determine optimal standards, is still an open question.

a. The dependence of quality on price is originally based on the role of price as a source of information, and on the necessity of minimizing information costs, when consumer information is imperfect. As we have seen this causes the consumer to prefer the most expensive and the most "popular" products.

But if tastes are endogenous in relation to prices, imperfection of the information can thus be increased rather than reduced.

Prices, as well as individual behavior over time, vary as a consequence of individual interaction, independently of quality.

If it is true that choosing a product with a wider market decreases information cost, it is equally true that the larger the number of consumers, the greater this interactive effect of information/price distortion, and the higher the cost of perfect information (29). Even if perfect information were available, under our assumption of information asymmetry and non-perfect excludability the price system would be unlikely to be an efficient means of providing it.

b. Prices are vehicles of information because of the uncertainty of individuals concerning the future benefits of their present consumption.

There are two methodological responses to this fact:

b.1 The first involves considering the imperfection of price information as greater, the more the consumer feels that he is receiving more (or less) "efficient utility units" than he really is (30).

Price shifts preferences. New endogenous preferences are, thus "defective", while the original preferences are "effective", as only the latter guarantee the initial equality between the marginal rates of transformation and substitution. The difference is due to a faulty consumer perception of the probability signal contained in price. The consumer wrongly evaluates the probability of future benefit deriving from his consumption.

Following this model, artistic goods can also be defined as merit goods (31) in the light of the difference between revealed and "effective" preferences. If a planner with perfect information exists, and can, therefore, evaluate consumer preferences correctly, he can substitute (ex-ante), in the social welfare function, individual choices with the correct ones, or he can carry out (ex-post) the appropriate corrections to the market, to make it Paretian efficient.

If such a planner exists, it remains to be seen if he can avoid being influenced by the process of endogenous changes in tastes illustrated above. If tastes are at least partially endogenous, planners immune to influence do not belong to the real world. Perhaps Bruckner was right in dedicating his last work, the Ninth sym-

phony, to God himself, the best judge of his talent.

b.2 The other approach is to leave things as they are. Reality is no different from that which has been "revealed". In this case, the good becomes, technically, a "commodity" in Beker's sense of the word. Its production cost includes, not only market costs, but also the costs of learning, information etc.

The distinction between perceived and effective utility is no longer necessary in pricing the good. This does not eliminate, however, the above mentioned market problems. An intervention in order to improve social welfare is still possible. It can be determined through the ordinary decision-making process of public choice. This solution, however, involves some equilibrium problems, too. Samuelson's optimum condition for the production of public goods might be repealed (32) as prices become exogenous variables which endogenously modify preferences. The marginal rate of transformation (or the marginal cost in equilibrium (33)), may not be equal to the sum of the marginal rates of substitution for consumers. In terms of utility, their "perceived" prices (and costs) are different from market prices (and costs). Applied to the problem of establishing an optimum quality standard, this further complicates the possible violation of Samuelson's equality, which is already involved in the choice of quality for public goods (Giardina (1969)).

"A collective indifference curve for quality does not exist (...). Only collective indifference points exist, and they are the points at which two given indifference curves for quality of two individuals (A and B) intersect" (34). The sets of intersection points, which are also tangential between the indifference curves of each consumer and the curves of iso-expenditure (public-private) for quality, are optimum sets which define an area of Paretian optimum quality. In this area, the following is valid:

$$SMSA \geq SMT \geq SMSB$$

where the equality between the individual marginal rates of substitution (quality/quantity) and the marginal rate of transformation (public/private) can only be verified within each boundary set, but not necessarily in the area they define.

The use of preference-revealing instruments, such as auctions or Clarke's taxes, or voting rules in general, in deciding optimum standards is, therefore, critical (35). The deciding of optimum artistic quality standards following the above-mentioned methodological biases, appears therefore to lead to a dead-lock, unless analysis is to be considered as no more than a reproduction of reality.

"Trop de notes, Mozart", was the famous comment of Emperor Joseph II following the premiere of "Il Serraglio".

"Pas une plus que le necessaire, Sire", was the musician's reply (36).

4.7 Conclusions and summary

The aesthetic qualification assumption of a need for "interpretation" for the products of "creativity" leads to the search of supplementary information on artistic quality. The possibility of finding it in prices as quality market signals is discussed by the tools of rational consumption theory.

This results in the quality-dependent-on-price kind of non-optimization markets and to the more unusual analysis of an addiction process under non-excludability conditions.

Markets are non-clearing, with multiple equilibria or concentration around quality non-optimizing solutions and adverse selection may occur.

Pareto-inefficient outcomes are possible. This is confirmed by the evidence arising from empirical studies on prices series of artistic products (eg. Baumol (1986))which demonstrate the impredictability high level of unpredictability of market results in the field.

The need for administrative quality standards for optimization purposes stems from this. Their determination processes, however, suffer the same theoretical biases of the availability of perfect information, if we accept the "merit good" approach to this problem, or of the possibility of Pareto-optimum public decision-making on quality, if we resort to second-best solutions following the Public Choice

approach.

In conclusion, the information asymmetry problem due to aesthetic qualification cannot be solved by taking price as a substitute for the lacking information on quality. Consumers, therefore, have to turn somewhere else in search of certainty on quality. As we will see in chapter 6, they usually resort to a specific institutional "certifiers": the cultural establishment.

Notes

* An early version of one part of this chapter was discussed at the SIEP
1991 meeting, Pavia, October, 6-8, 1991.

(1) Stiglitz, (1987). p. 2, which includes a complete survey of the literature on
the causes and consequences of the dependence of quality on price.

(2) See Deaton, and Muellbauer (1987) p. 37.

(3) This permits us to remain within a set of "well-behaved" preferences, and
not be forced to tackle the problem of the measurement of utility, which
might cast doubts on the use of the derivatives of C (u, p) by u to represent
the expected returns in terms of costs of the output originating from the use
of the good (for us, its utility). In Stiglitz's models, such a representation
is possible, because this output can be measured physically. Demand is
thus a monotonic transformation of cost also in our case.

(4) In addition to the authors cited by Stiglitz (1987), namely: Akerlof,
(1970); Grossman, Sanford and Stiglitz (1976) and (1980), further discus-
sions of such demand curves can be found in: Kalman, (1968), Pollak,
(1977), Mc Cain, (1979) and (1981) and Mossetto, (1990).

(5) Deaton and Muellbauer (1986), p. 260, who discuss the dependence on
quality of the "observed" characteristics of a good.

(6) See Kalman (1968), p. 498 and p. 501.

(7) As the budget constraint is:

$$p_i \, k_i + p_2 \, k_2 = m$$

which derived by p_i, becomes:

$$\frac{\delta m_i}{\delta \, p_i} = k_i$$

which explains how monetary income varies when price varies.

(8) Because, u_m being the utility of money,

$$\lambda = \frac{\delta u_{mi}}{\delta_m}$$

$$u_i = n \, (q_i)$$

114

$$u_{n+i} = \frac{\delta v(q_i)}{\delta p_i}$$

substituting and regrouping the second and third term of equation 4, we have:

$$\frac{\delta q_i}{\delta m}\left(\frac{\delta u_i}{\delta p_i}\frac{\delta m_i}{\delta u_m} - q_i\right) = \frac{\delta q_i}{\delta m}\left(\frac{\delta u_i}{\delta u_m}k_i - q_i\right)$$

because

$$k_i = \frac{\delta m}{\delta p_i}$$

(9) If the value of a good sold by a consumer varies, it is certain that his monetary income varies, too. In the case where the consumer has an initial endowment, a price variation automatically implies an income variation. (Varian, (1987) p. 152)

As a result of the shift of the budget constraint, according to Slutsky's standard equation, for example, if a price increases and the consumer becomes a net seller ($k_i - q_i > 0$), he must return to being a net buyer in order to maximize his utility. The sign of demand variation is uncertain: positive, when the income effect is greater than the substitution effect; negative in the opposite situation.

(10) Becker, Grossman and Murphy (1991), Becker and Murphy (1988) and Becker and Stiglitz (1977), for the most important discussions on the subject.

The state of addictiveness results from an increase in the marginal utility of consumption of addictive goods. Marginal utility grows with exposure (that is to say, with their consumption). Specifically: "past consumption (...) affects current utility through a process of 'learning by doing' as summarized by the stock of 'consumption capital' of each individual, accumulated by learning and any other possible appreciation activities" (Becker and Murphy (1988) p. 677).

If the consumption capital of a good i at time t_i ($S_{i,t}$) is a function of the past appreciation (M) and of other factors (E), that is to say:

$$S_{i,t} = h(M_{t-1}, M_{t-z},, E) \quad (a)$$

addiction will be "beneficial" if:

$$\frac{\delta S_{i,t}}{\delta M_{t-v}} > 0$$

for every v in (a)

that is to say, if the increase in past appreciation involves a net positive variation in consumption capital.

The opposite is the case for "harmful" addiction.

For a "rational consumer", consumption of a "harmful" good ("harmful" addiction) also has negative effects on future utility (u_1) and on his future incomes (w_1), while the effects of a "beneficial" good ("beneficial" addiction) are positive (therefore: $u_1, w_1 < 0$) in the first case and vice versa in the second.

In Becker and Stigler's model (1977), which is further developed in Becker and Murphy (1988), this is expressed by means of the shadow price of the consumption function ($p_{i,t}$). In the case of optimum allocation of consumption over time, (when the individual marginal utilities of consumption over time are equal as well as their shadow prices), the shadow price which equals the marginal costs is (Becker and Stigler (1977) p. 79):

$$\pi_{i,t} = \frac{\dfrac{w\,\delta T_{i,t}}{\delta M_t} - w\sum_{z=1}^{n-t}-\dfrac{\delta M_{t,z}}{\delta S_{i,t,z}}}{\dfrac{\delta M_{t,z}}{\delta T_{i,t,z}}\dfrac{\delta S_{i,t,z}}{\delta M_t}\dfrac{1}{(1+r)^z}} = \frac{\delta T_{i,t}}{\delta M_t} - A_t$$

Where the shadow price is expressed both in terms of lower wages (w) due to the marginal destination of time (T) to addictive consumption,

$$w\frac{\delta T_{i,t}}{\delta M_t}$$

and in terms of the effect of present consumption [expressed as an investment in lower wages (w), at time (t)] on future consumption capital.

116

This return is foreseeable during the whole length of the expected life (n) of the consumer at an estimated rate r. It is equal to the second element of the second term, A_t. If $A_t > 0$, addiction is "beneficial", if $A_t < 0$, addiction is "harmful".

Consequently, in the case of "beneficial" addiction:

$$\pi_{i,t} = w \frac{\delta T_{i,t}}{\delta M_t}$$

price is inferior to the marginal cost without addiction, and vice versa for "harmful" addiction. The existence of "beneficial" addiction increases the slope of the demand curve of a good, *ceteris paribus*, making it more elastic than that of initial equilibrium. The opposite is true in the case of "harmful" addiction.

(11) Becker, Grossman and Murphy (1991) p. 237.

(12) Becker and Murphy (1988) p. 677.

(13) Ibidem p. 688.

(14) Ibidem pp. 693-4, where cyclical movements are defined as "binges" and the falls as "cold turkeys".

(15) Becker and Murphy (1988) p.680.

(16) See Rosen, S. (1981), Adler, M. (1985).

"Superstardom" is structured as follows:

a. prices are a source of information on quality in this case, too;

b. the differences between goods are quality differences, expressed in terms of information costs, and are a function of the number of users;

c. given that producers are price-takers, the utility function of the consumer is maximized in Adler's model (1985) on the basis of the constraint of the total time they devote to "searching", "learning" and subsequent consumption of the good, as the "searching" and "learning" times are inversely proportional to the number of consumers of each good;

d. given that the goods in question are imperfect substitutes, major price differences correspond to small quality differences (Rosen's "magnification effect" (1981) p.846). Hence, market size influences price through a multiplier. While our model deals with the dependence of quality on price, the "superstar" model explains the way in which price depends on quality, the latter being a function of consumption cost. Several significant affinities, however, can be found between the two models;

e. even with decreasing marginal supply costs, the marginal consumer always

chooses the products which have the largest market. In other words, he moves strategically to minimize his own costs in the same way as a consumer who considers quality dependent on price.

The consumer will continue to choose the good which, utility being equal, will give him a lower total cost (and therefore A until $C(u_A) < C(u_B)$ and vice versa). If U is a monotonic function of q, the compensated transformed function of the cost will be discontinuous;

f. in addition, price variations are not significant until they are greater then the surplus accumulated by the "superstar" in terms of lower "searching" costs. Prices which are higher than p* do not reduce consumption because there is a surplus which can be re-absorbed. Prices which are lower than p* are not feasible because the consumer will choose another good. Price is the product discriminator, as in the model under discussion here above.

(17) Stiglitz, (1987) p.7.

Assumed:

$$U = [p, q, Q(p, q)]$$

as the utility of the buyer, for a price p. of a quantity q. where $Q(p, q)$ is the expected value of the quality of

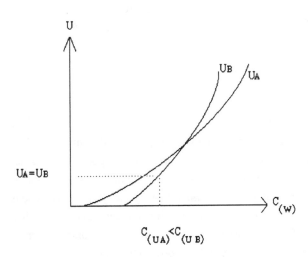

118

the good (in incremental terms, our $\dfrac{\delta u_{i,t}}{\delta u_m}$) then p and q are chosen in such a way that

$$\underset{(p,q)}{\text{MAX}} \quad U$$

subject to

$$V = [p, q, Q(p, q)] \geq V^{\cdot}$$

that is, with the constraint that the (expected) utility of a seller is always greater, or equal to a given "reservation utility level". In the case of "non-clearing" markets, the constraint is not binding for some sellers. It should be noted that V* is determined endogenously, as it represents the best alternative opportunity for the seller, or the limit below which there is "no deal". The great artists offer their services at a minimum price: mediocre artists are ready to accept any price whatsoever.

(18) See the previous note, and for the credit market model, Stiglitz, (1987) p.12, applied here after appropriate modifications.

(19) Ibidem p.23.

(20) Ibidem p.19.

(21) Ibidem p.21.

(22) Stiglitz (1987), and other authors cited above, develop further lines of analysis. These are, however, beyond the scope of this paper.

(23) See, in general, Greenwald and Stiglitz (1986) and (1988), and, in particular, Lee, (1991) on the specific issue of establishing the price of public goods under imperfect information.

(24) See note (22).

(25) Pollak, (1977), p. 64, maintains that preferences are influenced by "normal prices", taken as a function of present and past relative prices. See also Pollak, (1978), where advertising and the habit formation are listed as other causes of endogenous changes in tastes.

(26) Frank, (1989) p.84.

(27) See Jessen, (1989).

(28) The first of these effects, the bandwagon effect (17) involves increases in individual demand, dependent on the way each consumer perceives total (expected) demand, price being constant. The greater the perceived total demand, the greater the increases in individual demand. The utility of the fashionable good rises when the quantity demanded by the others increases (Liebenstein (1950)) pp.190-196).

On some occasions the bandwagon effect can be accompanied by its opposite, namely the presence of what Liebenstein has called "taboos". These are total demand thresholds expressed, not in consumed quantity, but in number of consumers. They also can condition individual demand. The only audience for a new composer might be his family, but he will not be judged by "the public" until one of his works has been performed in a concert hall.

A non-monotonic demand function can also be created by it.

"Conspicuousness", or the Veblen effect, is normally mixed with the bandwagon effect, for artistic goods. Its consequences are concurrent with those of the dependence of quality on price, although its nature is different. A price rise can increase demand, even when it is not necessarily an indicator of a quality (and a consumption utility) rise. Utility increases because the price, or rather the "conspicuous" price, is a source of social distinction (Liebenstein (1950) p.203).

Thin markets can result from Veblen effects, as well as from "taboos". They depend on the price rather than on the consumed quantity. Consumers can withdraw from the market below a certain price, because "conspicuousness" is impossible (Liebenstein (1950) p. 204). It is well known that these effects develop in the process of the construction of the total demand.

Fashion increases the negative slope of the curve, making it more elastic. Conspicuousness makes it inelastic and can change the sign of the slope from negative to positive. The combination of these two effects can, therefore, increase the possibility of the existence of a non-monotonic demand curve and the uncertainty of the sign of its slope. This depends on whether or not the price effect prevails on the external effects. The Veblen effect itself may cause such an uncertainty.

In the case of a "snob" collapse of the market, or of a "taboo" threshold being reached, discontinuity in the demand curve is possible. The inclusion of fashion and ostentation among the behavioral assumptions of our consumption model is therefore coherent with the above-discussed conclusions on the effects of aesthetic information asymmetry. The combination of these effects with non-excludability may give rise to an even higher level of information distortion. Non-excludability, in fact, also modifies the conclusions of the standard analytical models of external consumption effects, as it does for addiction.

In the case of the bandwagon, the increases in individual demand, which are external effects of the total expected demand, have now to be summed vertically, and no longer horizontally. The bandwagon is, then, defined by means of a price increase, quantity being equal.

The perception of the existence of the demand of other consumers, which contributes to the formation of a total expected demand, does not necessarily give rise to an increase in individual demand, even if it leads to an increase in the average utility of the good. Total consumption can be satisfied with the same initial quantity consumed by the individual.

The perception of the demand of other consumers may thus cause an endogenous price increase in the individual demand curve, which is vertically summed with those of the others. If my pleasure in a piece of music increases the more famous the composer is, it is also true that my appreciation increases independently of the quantity of music consumed.

Here the total demand is more inelastic than when fashion is not present - the opposite of Liebenstein's model (1950) for private goods.

The Veblen effect is, on the contrary, accentuated in the presence of public goods. The price of each quantity is defined as the sum of the prices of each individual demand function for the given quantity. With imperfect information on free-riding, this sum is the "conspicuous price" - the price on which the construction of the total demand curve *à la Veblen* is based.

The "conspicuous price" of a public good is, therefore, always greater than that of a private good. The difference between the conspicuous price and the real price, *ceteris paribus*, is greater, as the Veblen effect (net of the price effect) is greater. Therefore, the slope of the total demand curve and its elasticity are greater than those of the same curve for private goods since the price is higher for the same quantity.

Finally, an increase of the "conspicuous price" associated with an increase in the total perceived demand (Veblen plus bandwagon) can set off automatic endogenous price increases where the only upper limit is the budget constraint.

Let us assume a consumer demanding a quantity q_T at a "conspicuous" price p_T with a demand curve D_T. The bandwagon effect will lead him to a curve D_T » with a "conspicuous" price p_T » etc.

As a consequence of indivisibility, price overestimates quality. Under bandwagon with private goods, the price diminishes as the number of consumers grows and the total demand curve becomes more elastic. Therefore price moves in the opposite direction to the "popularity" of the good. The wider the "popularity"the lower the price. For public goods, on the contrary, price increases with the widening of the market, even beyond quality differences. The wider the "popularity", the higher the price. Similar conclusions are valid for the Veblen effect as well. Non-rivalry makes the "conspicuous" price a function of the number of consumers, but not necessarily of the quality. Price is not necessarily an efficient market signal for quality in this case.

The existence of free-riding on the consumption capital brings us back to "superstardom", again, where large differences in price correspond to small differences in quality, given the concentration of consumers around the "stars".

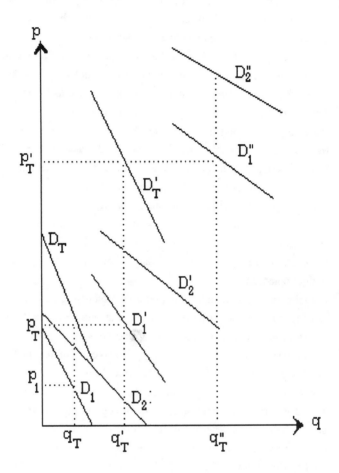

(29) Giardina, (1969) notes that the assumption of a given price system *à la Lindhal* is restrictive if applied to the choice of quality for public goods. He also notes that abandoning such a system leads to "conflict" solutions. These involve "strategic behavior" by the parties which can lead to non-optimal solutions (Ibidem p.608).

Baumol, (1986), p.14, comes to the same conclusion through a statistical analysis of the art market: "If the prediction as applied to stock prices is a losing game, it is certainly unlikely to be a winner in the market for works of art". The market "may well represent a valid choice for those who derive a high rate of return in the form of aesthetic pleasure".

(30) Besley (1988) p.374.

(31) See Musgrave (1959) and Hammond (1981); Besley (1988) and Sadmo (1983).

(32) Greenwald, and Stiglitz, (1986) p. 256.

(33) Varian, (1987) p.558.

Consider the following:

$$\frac{\dfrac{\delta u_1 (x_1 - G)}{\delta G}}{\dfrac{\delta u_1 (x_1 - G)}{\delta x_1}} + \frac{\dfrac{\delta u_2 (x_2 - G)}{\delta G}}{\dfrac{\delta u_2 (x_2 - G)}{\delta x_2}} = \frac{\delta c (G)}{\delta G}$$

where u_1 and u_2 are the utilities of two consumers, which are functions of their consumption of the private good x_1, x_2 and of the public good G. For us

$$U = u_i (x_i, G, p) \gtreqless u_i (x_i, G)$$

according to price variations.

(34) Giardina, (1969), pp.15-20.

The "collective" indifference curve in question should, in fact, "indicate the set of combinations of the two characteristics of the public good which permit both individuals to maintain the given level of welfare, while in our case, only one of these combinations is associated with a given level of welfare of A or B".

(35) These conclusions are reinforced by the existence of non-single-peaked preferences, with the well known problem of cyclic majorities, and by the strategic behavior which can be adopted by specific groups of consumers (see note (27)).

(36) Mozart's music, now so universally "popular", was considered "horrid" by his contemporaries, with very few exceptions. After the first perform-

ance of "La Clemenza di Tito", Leopold II's wife called it "une cochonnerie allemande"!

CHAPTER 5

THE SUPPLY SIDE: ON PRODUCTIVITY, TECHNOLOGY

AND DISTRIBUTION

5.1 Allocation effects of aesthetic qualification

The introduction of "creativity" and "interpretation" has significant consequences on the supply side of the market referring to the supply of labor and the distribution of income among factors.

This is easy to understand in the light of the representation of aesthetic qualification by means of an increase in the supplied and demanded value due to the additional information derived from aesthetic processes of "creation" and "interpretation".

Since aesthetic creativity is free, this additional value is costless for the creating artist and for the interpreter, but it has an economic value which can be defined on the market.

Creativity in itself cannot be transferred but its effects can be transferred to "people" endowed with "interpretation" (and in specific market conditions also to people not endowed with it).

Creativity and interpretation, therefore, *ceteris paribus*, have the same effects of a wage increase for artistic labor, even if they are not necessarily accompanied by an increase in the supplied quantity, that is, in the physical productivity of labor.

This can affect the artists' rate of substitution between leisure and consumption, like any wage increase, and bias the bases of distribution theory, in the same way as the equalization of marginal productivity ratios with price ratios can be biased.

Furthermore, the non-coincidence of creativity and interpretation (as they are entitled to two different agents), and their contribution to defining the total value of the information increase, create some important problems in output evaluation.

5.2 Leisure versus consumption choices under aesthetic qualification

The aesthetic qualification of the labor factor modifying its output evaluation can cause a

128

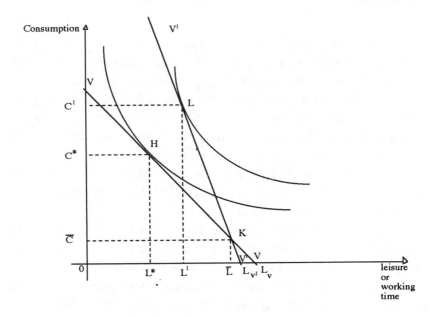

FIGURE 1

consequent modification in the leisure/consumption ratio and there-
fore in the leisure/working-time ratio of the creating or interpreting
agent.

Let us assume (figure 1), that VV is the transformation function
(budget constraint) between leisure and consumption, and that we start
from a point K ($\overline{L},\overline{C}$) where the maximum working or leisure time is
\overline{L}, which represents the initial endowment of resources of our agent.
Equilibrium is in H (L*, C*), where the working time is (L_v-L*).

To assume creativity for the agent's work means modifying the
budget constraint from VV to V'V', by increasing *ceteris paribus* the
intrinsic value of his work. With the same quantity of labor, he can
therefore have access to greater consumption. Equilibrium will shift
to L (L', C') where

$$\overline{L} - L'$$

is the new working time, which is

$$\overline{L}-L'<\overline{L}-L*$$

In this case the increase in the value of labor induces the worker to reduce the supply of labor.

Formally speaking, this depends on the prevalence of an endowment effect on the usual substitution effect in the definition of the inclination of the labor supply curve, similar to what we have already seen for demand in the previous chapter.

Here the budget constraint is (1):

$$pC+w(\overline{L}-L)=p\overline{C}+w\overline{L}$$

where
p = consumption price
w = wages

This means, of course, that the sum of the resources distributed between consumption (pC) and leisure w $(\overline{L}-L)= R$

w $(\overline{L}-L) = R$ as evaluated at their market prices, must always be equal to the initial endowment $(p\overline{C}+w\overline{L})$.

The inclination of the budget constraint is $-\dfrac{w}{p}$

The increase in leisure (and consequently in working time) deriving from any value increase is defined by

$$\frac{\delta R}{\delta w}=\frac{\delta R}{\delta w}\bigg|_{u}+(\overline{R}-R)\frac{\delta R}{\delta m} \qquad [1]$$

where the substitution effect between leisure and consumption has

the usual negative sign, while both $(\bar{R} - R)$ and dR/dm are positive.

The usual Slutsky endowment effect can be strengthened by means of a coefficient "à la Kalman" here too, as for demand in chapter 4.

The above [1] can therefore be re-written on the same bases as

$$\frac{\delta R_i}{\delta w_i} = \frac{\delta R_i}{\delta w_i}\bigg|_{\bar{u}} + \left(\bar{R_i}\frac{\delta u_i}{\delta u_m} - R_i\right)\frac{\delta R_i}{\delta m} \qquad [2]$$

where $\delta u_i / \delta u_m$ relates the marginal utility of creativity to the marginal utility of money (that is the marginal variation of utility when labor value varies in relation to the existence of creativity).

with consequences we already discussed for the demand side.

$$\frac{\delta R_i}{\delta w_i} > 0$$

if

$$\left(\frac{\delta u_i}{\delta u_m}\bar{R_i} - R_i\right)\frac{\delta R_i}{\delta m} > \frac{\delta R_i}{\delta w_i}\bigg|_{\bar{u}}$$

Some conclusions can be drawn from the analysis of the effects of interpretation as it modifies our budget constraint in the same way as creativity. .

Creativity and interpretation are therefore responsible for possible non-monotonic "back-orientated" supply curves. By their own existence, they produce an increase in the perceived initial endowment which can be used to buy more leisure time instead of more consumption goods, and therefore they can give rise to a decrease of the labor supply under aesthetic qualification.

This does not mean that "artists are sluggish", but only that the determination of their labor supply can lead to conclusions that differ from those attainable in a non-aesthetic environment.

5.3 Productivity of the aesthetic labor factor

The aesthetic qualification of a production process can be assimilated to the introduction of a specific input (production factor) expressed through creativity and interpretation. This results in the increase of the informative value of the output.

Artists hold this production factor and they therefore represent the necessary condition to "create" an aesthetically- qualified product. If there are no artists, there is no art.

In this sense, artists (who represent their ability to "create", just as entrepreneurs represent their ability to organize and undertake activities under conditions of risk and/or uncertainty) are a fixed production factor. From this point of view, they can be compared to land. If there is no land, there are no crops. This means that their earnings are determined through a rent-like mechanism.

They depend on price, that is

$$\text{Rent} = p^*q^* - cv\ (q^*) = r \qquad [3]$$

p^* and q^* being the optimum price and output respectively, and cv (q^*) being the variable costs under the same conditions.

[3] also expresses the usual producer's surplus; that is, the area included between the marginalist cost curve and the abscissae.

Under aesthetic qualification, however, a further specification must be added. The rent depends on creativity *and* interpretation. Creativity may produce interpretation, interpretation affects price.

The artists' rent, therefore, depends on price as does land owners' rent, and, at the same time, the price depends on the original rent (as it depends on interpretation which depends on creativity) (see figure 2).

This shows the unpredictability of the coexistence of creativity and interpretation conditions. If interpretation is impossible without creativity, however, we may have creativity without interpretation.

The final result of the creative process is therefore undetermined, as in specific conditions (of elasticity and interpretation/creation

132

ratios), the absence of interpretation can lead to an output decrease, despite creativity (H'-like points in figure 2).

Artists can be discouraged by people's insensitivity. The returns of creativity are therefore not submitted to any "diminishing law", like the returns on land.

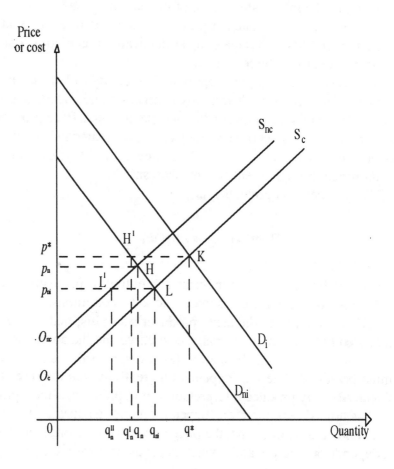

FIGURE 2

Here the areas

$$r_a = O_c K\, p^* \qquad = \qquad \text{total artist's rent}$$
$$r_c = O_c L\, p_{ni} \qquad = \qquad \text{"creativity" rent}$$
$$r_i = p_{ni}\, LKp^* \qquad = \qquad \text{"interpretation" rent}$$
$$ra - rc + ri$$

Marginal productivity of creativity can be either increasing or diminishing, either positive or negative as it modifies the "state of the world" itself.

Mac Cain (4) was the only cultural economist, to talk about the arts "transforming consciousness" in analytic terms.

"Artistic masterpieces and breakthroughs in science and technology share a characteristic which creates a problem for resource allocations. The characteristic is that they transform consciousness. The breakthroughs lead people to see the world in ways that they did not see it before, and thus cannot be predicted, since prediction would presume a consciousness already transformed. This explains why investment in research escapes the Ricardian principles of diminishing returns: we cannot tell what the "best land" is until we are committed to "farming" it, so that we cannot proceed from the best to less good and so on." (5).

Technological changes must therefore be treated as exogenous, like taste changes, in the light of the aesthetic qualification; or better, they are the exogenous source of interpretation changes which result in changes in demand. Mistakes in interpretation can also occur and from L-like points the system can shift to L'as in figure 2. Not all that is thought to be art is really art.

5.4 Productivity in non-profit conditions

A further complication can be introduced in this argument to verify it in real terms. It comes from the possibility of producing the good in the absence of interpretation, either by subsidizing the artist or through "non-profit" organizations to which artists belong (or who pay the artists starting from a demand-"cum interpretation" point of view) and

from the consequent possibility of artists adopting strategic behaviors.

In the previous chapter we assumed increasing marginal costs for aesthetically-qualified production because of a low technical substitutability between labor and capital. This is plausible for the artistic sector even though it may have nothing to do with the productivity of the artistic factor in itself as discussed here. The M_c curve in figure 3, and those that follow, refer simply to all the production costs excluding the creativity cost which is represented by the difference between the

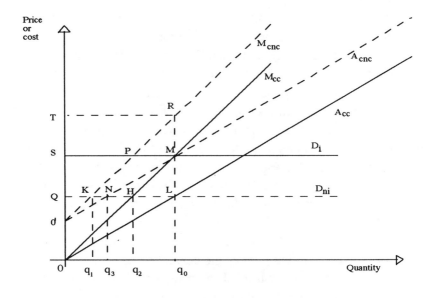

FIGURE 3

marginal cost curves (with and without creativity) and which is in our assumption a negative cost.

This does not mean that creating is cost-free, but only that for an artist creating is assumed to be better than not creating, under the non-consequentialist conditions discussed in chapter 3 (6).

All artists willing to create, however, are not always able to do so and achieve the involved cost reduction. They may not be able to obtain this; something they will know ex-post. The self-recognition of

a masterpiece results from its creation (7). Public subsidies or private donations provide them with an incentive. This creates the possibility that incentives cause negative marginal productivity variations (such as the supply-cost increase, all the rest being equal).

Let us start (figure 3) from any point K of intersection between a non-qualified demand (D_{ni}) and a non-qualified supply (M_{cnc}), and assume that the artist decides to create, passing to H and qualifying his supply (M_{cc}). As H, however, is not optimum from the consumers' point of view, there is social interest in inducing him to go to L, as socially

$$L\,P_s\,H\,P_s\,N\,P_s\,K$$

To do this without interpretation, someone (the state, private donors) has to pay to him an amount equal to the area HLM which represents his net welfare loss to pass from H to L.

Suppose now that the artist were indifferent to L and M, as in both cases his rent plus his subsidy are equal, that is

$$OHQ + HLM = O'PS + PMR$$

Suppose, moreover, that "interpretation" (or better, misinterpretation) made the system shift from K to P. The passage from P to M will have the same cost as shifting from H to L.

No creativity will occur. Marginal cost will rise from S to T, and marginal productivity will become negative.

The Dutch government subsidized the visual arts from 1949 to 1987. To obtain yearly subsidies, artists had to transfer four of their works to the state every year. More than 123, 000 works were accumulated in the state storerooms during the period. In 1992 the state decided to destroy more than 100, 000 of these. "Don't be afraid. No masterpieces will be destroyed", commented an expert.

5.5 General production conditions under aesthetic qualification

Production functions are generally qualified by three well-known

features:
a. monotonic and convex technologies;
b. positive decreasing marginal productivity (of a factor, the other being kept constant);
c. decreasing technical rates of substitutions (on the same isoquant) (8).

This corresponds to convex isoquants, the inclination of which is equal to the technical rate of substitution, that is to

$$TRS\ (x_1, x_2) = MP_1\ (x_1, x_2)\ /\ MP_2\ (x_1 x_2) < 0$$

If non-consequentiality is assumed, the aesthetically-qualified production factor shows the following characteristics, as discussed above:

a. marginal productivity can either be positive or negative, either decreasing or increasing ("creativity" increases it);
b. the technical rate of substitution between factors can therefore be either decreasing or increasing;
c. isoquants (and technologies) can be either convex or concave.

This has some effects on the shape of functions describing the supply side.

a. First of all, an increasing marginal productivity can cause an inverse demand curve with positive inclination for the artistic factor, which is something even more disruptive (from the point of view of equilibrium stability) than the non-monotonicity we discussed in chapter 4. We will analyze it, referring to the problem of the assignment of rights on the aesthetic qualification in chapter 7.

b. Furthermore, we can say that isoquants are likely to be circular (or ellipsoids).
Any tangent to an isoquant, in fact, measuring the isoquant inclination, is an isocost line, of the kind

$$x_2 = -w_1\ /\ w_2\ x_1$$

the inclination of which is determined by the relation between the prices of the two factors.

As we have already seen, aesthetic qualification means *ceteris paribus* the assumption of two different prices (and costs) for each quantity of the aesthetic factor (say x_1), without the possibility of predicting ex-ante. which one will be valid. We can, therefore, represent it by means of a system with two different tangency points for each quantity of x_2 (the other factor or non-aesthetic set of factors) on the same isoquant. This will correspond to the two different values of w_1 to be taken into account (that is, to the two different marginal productivities of the aesthetic factor whether aesthetically qualified or not).

It can therefore be

$$TRS\ (x_1, x_2) \overset{\geq}{\underset{\leq}{}} 0$$

This conclusion is consistent with Gapinski's empirical tests on the production of culture (9):

"The isoquants are either circular or facing semicircles, consonant with the argument (...) that (...) a given quantity of output may be generated by two different levels of an input." (10).

This is obtained by testing the empirical consistency of a transcendental production function "à la Haller" (11) adopted because "its specification admits a wide range of marginal product configurations allowing the possibility that marginal products may be negative" (12).

Gapinski, however, adopts this testing device because of the "non-profit nature of the companies under investigation", founding on the lack of profit-motivation the possibility of the breach of "the doctrine of positive, but declining marginal products" (13), which is theoretically controversial (14);

c. non-single prices are grounded on all this;
d. the inverse supply function

$$p=MC\ (q)$$

is changed, too, as it depends on a non-single marginal cost function with two different inclinations. Its ordinates are the

isocosts for a given quantity, which are non-single and are defined as the first derivates of the same isoquant, keeping the quantity of one factor (for instance x_2) constant. The new function, therefore, is hyperbolic and tends to be equilateral as much as isoquants tend to be elliptical.

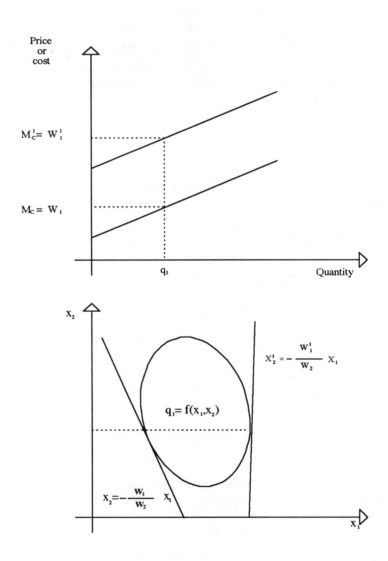

FIGURE 4

5.6 Some distributional consequences

If we consider two sets of factors (the x_1 and x_2 referred to above) and we apply to them the general production conditions under aesthetic qualification, we can also derive some significant distributional consequences:

a. The first is the denial of the "fixed proportion" assumption characterizing production factors in the arts.

We are used to assuming from Baumol's "unbalanced growth" that in the artistic field the proportion in which the labor factor is employed is relatively constant with reference to capital and other secondary inputs, because of the relative unsubstitutability between the two inputs. If

$$\text{TRS}(x_1, x_2) = - w_1/w_2 = - MP_1(x_1 x_2) / MP_2(x_1 x_2) < 0$$

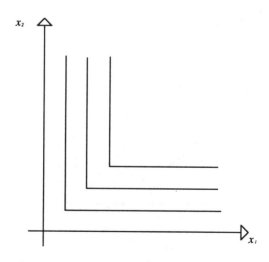

FIGURE 5

that is if isoquants are relatively well-behaved, corresponding to

usual decreasing positive marginal productivity conditions, if we are indifferent to the initial income positions, and if earnings are made equal or proportional to the employed quantity of labor, this leads to a sort of Rawlsian distribution (15) of the product.

The new isoquant for aesthetically-qualified output shows on the contrary the possibility of strong conflictual solutions with no reference to any equity principle of general acceptability.

Any budget constraint could theoretically intersect the isoquant in two points (K, H) where the distribution of income is different between the two sets of factors.

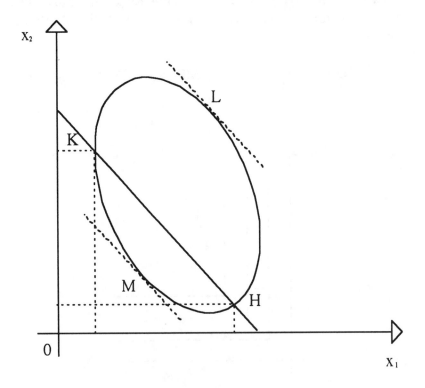

FIGURE 6

This is, of course, also true for optimum points (M, L) which can be non-single.

5.7 Baumol's "disease" revisited

The re-statement of general production conditions can be usefully employed to re-examine Baumol's well-known theorem of unbalanced growth for the artistic sector.

His theorem depends on the divergence between marginal productivity and wages, which is due, on one side, to non-substitutability (that is to fixed proportions) of production factors namely labor and capital, in the artistic field. This causes a relative decrease of the productivity of the artistic factor if compared with that of the industrial sector. On the other side, it depends on the rigidity of the general wages level.

We will try to explain how the same conclusions can be based on aesthetic qualification of labor, in other words on the already-discussed marginal productivity decrease specifically due to creativity and interpretation.

The usual demonstration of the Theorem (16), is presented in fig. 7.

Here the increase of productivity of the artistic sector, (which makes the non-artistic production function shift from a to b in quadrant I), causes a modification in the artistic/non-artistic product transformation function (from T'T to T"T in quadrant II).

If the artistic/non-artistic production ratio is kept constant (that is, if we keep the system on the bisector of quadrant II, because $Y_1/X_1 = Y_o/X_o$) the following is true:

$$W'y/W'x > W_{oy}/W_{ox}$$

that is, relative wages of the artistic sector increase together with the relative quantity of labor employed in it.

This conclusion is based on a zero-profit (perfect competition) assumption, which allows costs to be equal to price ratios between the

sectors:

$$P_y Y_o / P_x X_o = W_{yo} S_o / W_{xo} S_o$$

where P_y = price index of artistic output
 P_x = price index of non-artistic output
 W = labor quantities
 S_o = wage index of the economy

which leads to:

$$P_y Y_i / P_x X_i = W_{yi}/W_{xi}$$

that is, to the equality between the values ratio and the labor quantities ratio.

Under aesthetic qualifications this equality is matched because the same quantity of artistic labor can give rise to different values.

With creativity/interpretation assumptions, it can be, *ceteris paribus*:

$$P_y Y_c / P_x X_i > W_{yi} / W_{xi}$$

This leads to the possibility of an exogenous price and wage increase in the artistic sector, artistic output being constant ($Y_c = Y_i$). In other words, if under aesthetic qualification the condition

$$P_{yc} Y_c / P_x X_i = W_{yc} / W_{xi}$$

is true, then

$$W_{yc} / W_{xi} > W_{yi} / W_{xi}$$

is also true and can be represented in fig.7. by means of a downward shift of the artistic production function in its quadrant (from c to d).

This is equivalent to (but as we have seen in previous sections, is not) a decrease in artistic labor productivity.

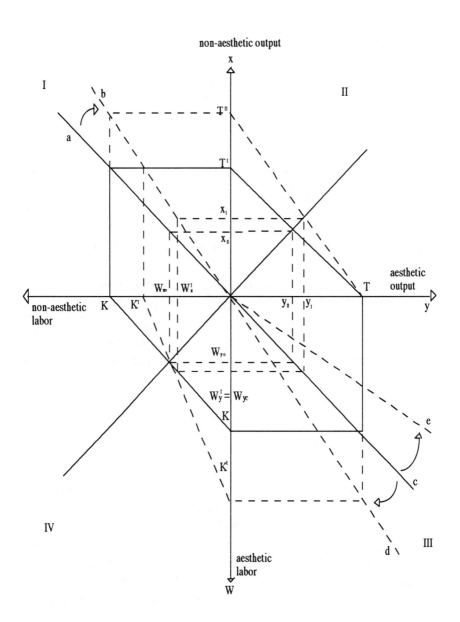

FIGURE 7

It also causes a re-adjustment of the labor constraints on the bisector of quadrant IV (from KK to K'K'). The wage increase is followed by a migration of labor from the non-artistic to the artistic sector.

This can easily be seen in figure 7, if we impose for analytical purposes the condition:

$$W'_Y = W_{YC}$$

The increase of productivity of the non-artistic sector can explain, in the long run, the constancy of the artistic/non- artistic outputs ratio. Furthermore it can help in understanding that the same analytical scheme can host all the possible non-monotonic marginal productivity values deriving from the aesthetic qualification of the production process.

If we turn, as we have done, the labor constraint on the bisector of quadrant IV (which means keeping the total available labor resources constant) we can reach situations where, in real terms, the marginal productivity of artistic labor may decrease (the production function passing from c to d) and others where it can increase (where it shifts from d to c).

5.8 Sraffa and aesthetics

The definition of the rent of the aesthetic factor as a function of price, and at the same time, as a price determinant, makes the labor earnings similar to "surplus", or profit, in Sraffa's conception.

Following Sraffa, this "surplus" cannot be distributed among factors before prices are determined, as can be done with all other costs. This is because it has to be distributed proportionally to the means of production which were anticipated by each industry, and such a proportion between two heterogeneous aggregates (that is the profit ratio) cannot be determined before the prices of commodities are known.

Neither can the distribution of "surplus" be delayed after the definition of prices, as prices cannot be determined before the definition of the profit ratio (17).

The modification of

$$P_yY_i / P_xX_i = W_{yi} / W_{xi}$$

into

$$P_yY_c / P_xX_i > W_{yi} / W_{xi}$$

in Baumol's system (which was based on a zero-profit assumption) is equivalent to introducing profit, attributing it completely to the artistic factor.

In Sraffa's terms, this is equivalent to introducing a new class of "luxury commodities" (the price of which is represented by the profit ratio) which are used neither as production tools nor as means of subsistence to produce other commodities (18).

This takes us back to Ricardo (see chapter 2), as the artistic factor could be consequentially defined, following Sraffa, a "non-basic" commodity, because of its passive function towards the production of all commodities except the "luxury" ones (19), which is exactly the productive function of labor in Baumol's scheme.

The Ricardian position on "Old Masters' paintings" is thus clarified in a post-Ricardian sense. Sraffa also includes in the general production model those commodities which were simply excluded by Ricardo and he does this on Ricardian grounds; that is, by distinguishing them on the bases of their productive role. The above mentioned contradiction in Ricardo's theorizing between the unproductiveness of the arts and the growth of welfare due to aesthetic satisfaction is, by these means, overcome.

The parallel with Sraffa's position on "luxury" (or "non-basic") commodities, moreover, gives an authoritative (even if involuntary) (20) confirmation of the argument on the effects of aesthetic qualification presented in the previous paragraph.

He says that if an invention were to halve the quantity of each of the

means of production needed to produce a unit of a "luxury commodity", the price of this commodity would be halved with no other consequence: the relative prices of the other products and the profit ratio would remain equal.

This is exactly what happens in the version of Baumol's model we discussed above.

5.9 Conclusions and summary

The aesthetic qualification also has significant effects on the supply side. Namely, it modifies the way in which general production conditions are usually presented. It may change the usual assumption of: positive decreasing marginal productivity of factors, decreasing negative marginal rate of substitution among factors, convexity and monotonocity of isoquants and technology. This leads to the possibility of:

a. positive inclination of the inverse demand function of the artistically-qualified factor;
b. non-single costing and pricing;
c. non-monotonic inverse supply function with non-single inclinations (as in the case of equilateral hyperboles);
d. conflictual output distribution among factors.

In the following chapters, however, supply as well as demand representation will be simplified and taken as grounded on the usual Neo-classical assumptions. This will be done by considering their conformity as given, which is plausible ex-post and which corresponds to a *ceteris paribus* condition of isolating the analysis of a single parametrical variation in a well-determined context.

Notes

(1) Varian (1987) pp.163-167.

(2) Chapter 4.

(3) Varian (1987) p.379.

(4) Mc Cain (1981).

(5) Mc Cain (1981).

(6) See also chapter 9 for a further discussion of this point.

(7) We have already discussed this point in chapter 3 from the point of view of its consequences on market equilibria under perfect rationality conditions.
We will now look at its consequences on productivity and supply under the non-consequentiality axiom imposed in chapter 3.

(8) Varian (1987) pp.297-301.

(9) Gapinski (1980) pp.578-586.

(10) Ibidem p.584.

(11) Haller, Carter and Hocking (1957).

(12) Gapinski (1980) p.579.

(13) Ibidem p.578.

(14) See Throsby and Withers (1979). In any case, Gapinski has the merit, together with Mac Cain (1981) of having clarified the exclusive and self-identifying nature of an artist's work:"Any art form is an artist's personal vehicle of expression, and this self-identity should be captured by the production function. Without the artist there would be no art". This is reflected in his choice of a farm-like production function (Gapinski (1980) p.579.

(15) A perfect-substitutes kind of factors relationship between factors will, on the contrary, lead to a Bentham-like distribution, that is

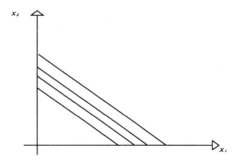

(16) The formulation presented here is the one adopted by Fossati (1989) pp.300-303, to analyse the relationship between private and public sectors. See also the already-quoted, Baumol and Owen (1966) and Baumol (1967).

(17) Sraffa (1960) p.7.

(18) Ibidem p.9

(19) Ibidem p.10

(20) Sraffa's exemplification unfortunately does not include the arts but only "ostrich eggs" and "racehorses".

CHAPTER 6

AESTHETIC "CERTIFICATION" AND ITS STRATEGIES

6.1 What is "certification"

Information asymmetry from aesthetic qualification gives rise to the search for information on the consumer's side. Neither the market nor the fixing of administrative standards can solve the information problem (see chapter 4). Consumers in search of a higher level of certainty on the quality of the goods they are going to buy resort to institutional solutions. They explicitly ask "someone" for a previous judgement on their quality. "Someone" who has to be trusted not because he represents any sort of public interest or collective willingness, but because "he knows" what other people do not know about quality. In people's opinion, this "someone" is entitled to "certify" because he is able "to interpret"; that is to perceive the aesthetic qualification of the good, even while other people (ordinary consumers) do not.

In this case, therefore, the information asymmetry characterizing the aesthetic market does not simply exist because the nature of the person expressing the judgement is such that the lack of information is a priori cancelled.

The increase in information included is supplied to the market through "certification". Certification, therefore, has also an economic meaning:it is a transfer of value from the interpreter to the consumer, which enables the consumer to act as such.

On the other hand, certification is also important for the producer because it enables him to find a buyer for his product in all the cases in which the market could fail to do so because of its aesthetic qualification (see chapter 3). Collectively speaking, certification is socially important because it can prevent the need for subsidization which has been demonstrated to be grounded on creativity itself. Certification is not necessarily synonymous with "paternalism" because it can be based on commonly-accepted values to be referred to the prevailing tastes of any given historical period.

The certification solution, therefore must not be classified among the merit good - like solutions because it does not refer to an external planner endowed with special information, and it is not imposed by anyone. On the contrary, it comes from one of the agents ("the interpreter") and from the specific demand of information arising from

consumers.

6.2 The "certifier's" entitlement

The "certifier" is such because he is able to "interpret" the aesthetic qualification of the good and because people think he is. His entitlement to judge about quality, is not (or not only) due to a collective decision, making him the decision-maker (as in the case of political representatives in ordinary democratic schemes). It is the result of a rather more sophisticated selection process.

First of all the certifier must be an interpreter in order to be recognized as such. In order to become an interpreter he has to invest in specific learning to increase his initial specific skill. In order to be recognized as such, he has to invest in his reputation. A marvellous interpreter with no reputation is useless as a certifier. His capability to certify is submitted to formal and informal tests on which his reputation is built. Art Academies turn out potential certifiers, as well as the dust of the editorial offices of art journals.

Being a reputed certifier does not mean being a "good" certifier. It only means being asked to certify by a significant number of consumers or producers (significant from the point of view of the certifier's reputation). No aesthetic connotation is included in this. The most famous critic may be unable to "interpret" a "new" style only because it is new and he does not subjectively recognize its aesthetic qualification.

We are concerned here with certification itself as a transfer process and, therefore, we can assume for the moment "good" certifiers, in the sense that they are able to "interpret". In all other cases the result of the transfer will be socially worse.

The intrinsic validation of any creativity and interpretation process, as illustrated in chapters 1 and 3, has however, very important consequences for the way in which the certifier's reputation is built up.

Given that both these aesthetic processes are endowed with a specific "non-consequentiality" (arising from the break between "beauty" and "functional beauty"), the ability to certify a work-of-art as such (in other words to interpret it) is a personal attribute, the recognition of which is

subject at least to the same "non-consequentiality" axioms on which the attribute is based.

In other words, if certification has its origins in the ignorance (or non-perception) of the aesthetic qualification of a good, how can we - as ignorant odservers- certify the ability-to-cerify? Who cerifies the certifiers? The answer to this question does not come from logic but from history. The certifiers self-certify themselves as such. They are the aesthetic (and, widely, the cultural establishment). To gain a reputation as certifier means, therefore, being accepted as a member of the establishment.

6.3 Some economic consequences

Let us imagine culture as a monopoly sector, dominated by a monopolist to be identified in its establishment (1).

Culture has effectively been a monopoly from the most ancient times. Egyptian priests, Medieval monastic orders, Renaissance arts and crafts guilds, modern and contemporary professional associations, and in many countries Universities, act as monopolists.

Why do consumers accept this state of things, and buy in a monopolistic condition instead of directing their demand elsewhere? This is because, here, quality is "good". The monopolist is organized and has invested in order to assure the quality of its products. Barriers to entry qualify market quality.

To be admitted to the sacerdotal hierarchy in ancient Egypt, one had to be initiated in writing, reading and often in medicine. Finally, one had to pass subsequent levels of examinations. Initiation and admission tests generally characterize cultural production. Both can be seen as quality-assuring investments.

Independently from the specific nature of each of its products, therefore, culture too can be defined through a well-determined by-product that I shall call "quality-assurance". "Quality-assurance" is present in all different cultural products and is a distinctive feature of cultural goods. In other words, a good can be defined as "cultural" if its "quality" is certified by cultural institutions, either because it was produced by them or because it has been ascribed by them to "culture"

after having been produced.

An artist may have been born in Cimabue's workshop like Giotto, or may have been recognized as an artist after his death, thanks to a merchant's intermediation, like Van Gogh. In all cases the quality must somehow be certified to become part of the "culture" of one's age. This does not mean that "quality-assurance" is the only distinctive characteristic of culture, but only that it is a necessary one.

Two other attributes qualify cultural supply: self-certification and a priori untestability. "The uncultivated cannot be a competent judge of cultivation" in Mill's words (2). The source of knowledge on culture is culture itself.

This is even truer because of the impossibility of enjoying cultural products a priori; that is, before their consumption. Naturally, no other products can be enjoyed except by consuming them. Their quality, however, is generally known, either because it is the same as other identical products or because it has been advertised by producers. Advertising is also a means of quality-assurance. In the cultural field, there are no identical products, and advertisement without description will inevitably be unsuccessful. Each novel is a new and different one, even if it has been written by the same successful writer, and the best way to advertise it is to make it win a literary prize.

Information asymmetry is stressed as a consequence of all this. Consumer information on quality is specifically penalized. Consumers have to resort to culture in search of information quality. They need someone to trust in, to certify a priori the quality of the good they consume. Culture is a "service industry" or a "broker" (3) between consumers and the truth with reference to quality. Consumers are ready to pay for this "service" with in-kind or monetary transfers (in ancient times offers to the Temple, contemporary grants, and donation to cultural institutions).

Let us then assume the existence of a demand for trust, growing with the size of cultural market, to be satisfied by a cultural monopolist on payment of a price or an insurance premium. This situation can be represented through the ordinary scheme of a monopoly market (fig.1).

Here the perfect competition price level ($P_0 = A_c = M_c$) is defined in

the absence of quality certification. If the culture monopolist comes into action, quality assuring service is available at a price which is the difference between the monopolist price ($P_1=p$ (M_r, M_c) for every $M_r=M_c$) and the perfect competition price (P_0). The presence of the "certifier" monopolist also has an effect on social welfare in itself. The market size will be reduced from Q_0 to Q_1 and consumers will transfer P_1 P_0HK to cultural institutions for their quality-assuring service. Social welfare (judged on the bases of Harberger triangles) will be decreased by HKL (the monopoly dead-weight loss).

The final position of society, therefore, will depend on the balance between the social loss involved into the non- optimization of the market due to the aesthetic information asymmetry and the monopoly dead-weight loss due to the activity of the certifier.

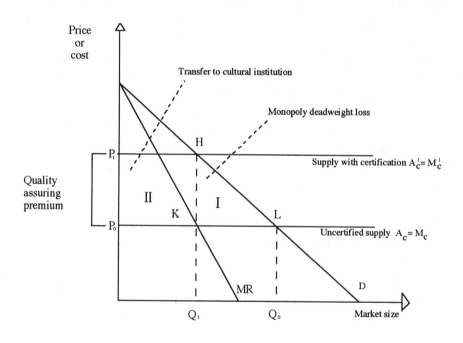

FIGURE 1

6.4 Certification and quality

This leads to a non-coincidence statement between "certification" and quality enhancement, and furthermore to an economically-grounded denial of the "positive" connotation of culture already discussed in chapter 1.

6.4.1 "Kitsch"

A Journal of Economic Literature data base inquiry using the cross key words "culture and waste" recently resulted in an empty set.

Culture, however, creates waste in the environment where it acts as its influence is not always beneficial to the preservation or the enhancement of its aesthetic quality. Culture may often have harmful effects, as we can see in "kitsch" objects, which are the result of the spread of culture. Mediterranean coasts and countries, despite their ancient culture, are full of "kitsch" buildings. There is no lack of tradition for Italian, Spanish or Turkish architects and urban planners designing the horrible new landscapes of the Calabrian coast, Marbella, or Kusadasi. Nor it is a merely a problem of the misguided "invisible hand of the market", because profit maximization can be reached by producing lovely objects just as well as by producing ugly ones, as the Italian fashion industry demonstrates.

Culture, itself, includes different utilization of the same goods both for consumption and production purposes; that is, their different allocation, with different outputs. Culture may enhance quality or reduce it.

Without being involved in judgements on how "good" or "bad" a culture may be (which could be considered "value judgements" by some economists), we can therefore correctly say that culture is a set of choices on quality which have different economic effects on social welfare.

People in general, and cultural economists in particular, think that "Culture is a Good Thing" (4) which explains their apparent lack of interest in associating culture and waste, which is not necessarily true

under the above mentioned definition of culture. Culture may be a good thing or not, depending on its effects on quality. Choices on quality may increase or decrease social welfare. Culture will be beneficial in the former case and harmful in the latter.

6.4.2 Marshall and "Kitsch"

From a further exploration, economic literature supplies some examples of culturally-originated quality waste which may be useful for further insight into the problem.

The first case to be mentioned here is in Marshall's analysis of the effects of cultural changes (5). Differing from the standard Marginalist point of view, Marshall allows the possibility that exogenous taste changes may give rise to demand increases. The desire for excellence for its own sake creates new tastes and new demand.

"It is the desire for the exercise and development of activities (...) which leads not only to the pursuit of science, literature and art for their own sake, but to the rapid increase of demand for the work of those who pursue them as professions" (6).

He also thought that the widening of the market could result in a worsening of quality, and that this could affect social welfare. The Arts and Crafts Movement provided him with a solution:

"Technical education can yet save much natural artistic genius from running to waste (...) when a great deal of excellent talent is insensibly diverted from high aims by the ready pay to be got by hastily writing half-thoughts for periodical literature" (7).

His model can, thus, be defined as

Exogenous cultural	Demand	Loss of
change (creativity)	--> increase	--> quality

to be recovered through an exogenous rise in people's level of education.

158

This model describes rather than explains the cause-effect process that creates economic waste from cultural enhancement. It suggests its possible origin in a market misguidance of natural resources, but does not explain why such a misguidance could be eliminated by an increase in culture, given that it is introduced by this very phenomenon.

A possible interpretation of cultural waste (and of Marshall's case) can be based on the analysis of the behavior of the cultural establishment.

Let us return to figure 1, and assume an exogenous increase in the market size (the demand shifts from D to D'). In this case, the quality-assuring prime will also increase as will the monopoly deadweight (fig.2).

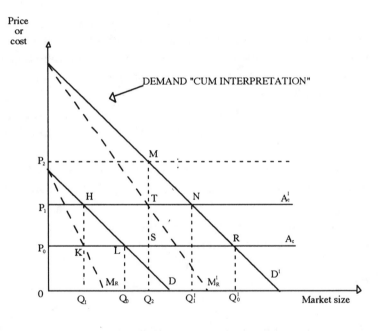

FIGURE 2

The shift of the demand curve above and to the right of its quadrant gives rise not only to a new perfect competition equilibrium (R), but also to a new equilibrium under quality-certified conditions of supply

(N). Cultural institutions, however, in order to maximize the transfer they obtain from consumers, restrict the quality they certify (from the desired Q'_1 to the supplied Q_2) and increase its premium (from (P_1 - P_0) to (P_2 - P_0)). *Ceteris paribus* (that is, elasticities being constant) this increases the social loss (MTN - HKL>0). In order to avoid this, uncertified quality products come into the market and quality decreases. The model, therefore, explains Marshall's analysis without resorting to any value judgement on the welfare effect of "good" or "bad" quality. It only takes into account the results of the market strategy of cultural institutions, which is the only cause of quality deterioration and causes environmental waste. No other obstacle is theoretically preventing the market from maximizing welfare by adopting quality and quantity to the new demand.

6.5 The certifier's strategies

A further insight into the problem is offered by another well-known literary case of economic waste due to cultural certification: Tullock's Mandarins' selection.

"From the social standpoint (...) it is clear that this was a negative-sum game (...). Assuming that the very large amount of learning undertaken by the candidates for the examination was partially screening and partially capital investment and that the capital investment failed for those people who did not complete the examination, it is clear that the social cost must have been much greater than the social benefit, regardless of the rationality or irrationality of the individual resource investments.

The problem is that the individual invests resources in a form in which they are not readily transferable to other uses (...). When the individual candidate invested the same amount of resources " (he had to invest in case of a distribution of government charges by auction)" in learning to write Tang dynasty poetry of a somewhat stuffy nature, it was just as rational from his standpoint, but society has lost these resources, except insofar as having one more producer of rather stuffy Tang dynasty poetry may have a positive value" (8).

Monopoly rent-seeking is an additional cause of social losses (9). Let us refer this to our model. The behavior of cultural institutions is now represented on the long run as a function of the quality-assured quantity and of the prime consumers who will correspond in exchange for quality-assurance service (fig.3).

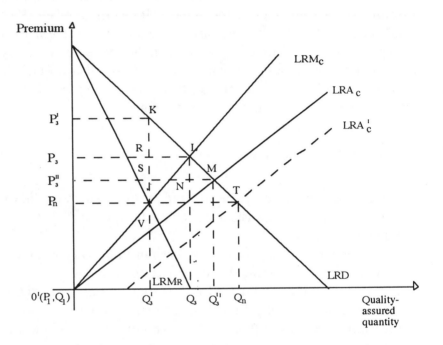

FIGURE 3

The long-run investment in rent-seeking (the starting transfer P_1HKP_0 of figure 1) is represented through the shift of the origin of the axes to $0'$ (P_1, Q_1). Rent-seeking cost is thus considered a no-longer-retransferable amount of resources, which are no longer at society's disposal. They can be seen as productive only insofar as they "produce" the monopolistic condition in which the cultural establishment is acting.

Long-run marginal costs (LRMc) are assumed as increasing, given

the conclusion of previous analysis (fig.2) which is confirmed by the increase of quality screening costs as the market size increases.

Perfect competition market solutions lie in L-like points, where LRMc = LRD, that is where the long-run marginal cost curve intersects the long run demand function. This solution is different both from that which maximizes the monopolist's prime and income (K) and from that which optimizes social welfare (M).

The social ranking of these solutions can again be determined using Harberger triangles, again:

$$M \, P_s \, L \, P_s \, K$$

that is, M is socially preferred to L and to K.

Cultural institutions, however, will restrict their certification to K. An extra-rent will thus be transferred from the consumer to the institution (P_3'' KSP_3''), and an additional deadweight loss will also be imposed on society (KSL).

Social loss is due to a deficiency in quality-assuring and it is a function of the difference between the social and the monopolist's optima. If we assume (as we have done) that this deficiency can be made up by introducing uncertified-quality commodities into the market, the social deadweight loss can also be considered a significant proxy of the level of the quality waste which has to be suffered by a given environment because of institutional behavior.

The total social loss (or environment waste) imposed by cultural institutions is composed of a fixed loss (HKL in figure I) and a variable loss (KSM in figure 3).

Increasing marginal costs give rise to increasing social marginal losses. The variable loss share, therefore, is also marginally increasing.

In Tullock's case, the selection of Hsien dynasty magistrates is harmful because it involves a considerable waste of human resources in order to obtain monopolistic privileges (P_1HLP_0 in figure 1). In our model, cultural institutions create environmental waste as their ascription system supports permanent non-optimizing choice conditions

162

(KSM in figure 3).

6.6 Optimization policies

Some interesting conclusive remarks can be drawn from this version of the model, in the light of the optimization policies to be practiced on cultural markets.

a. Subsidizing culture may help in moving from L-like to M-like solutions. It may, however, increase the deadweight loss if it results in decreases of long-run marginal and average costs or in demand increases. This apparent contradiction between tools which are ordinarily considered as culture-enhancing and the results of our analysis is illuminating *vis-à-vis* experiences such as that of subsidization publishers to create "public opinion", where the public good to be produced ("the opinion") risks being transformed into a "public bad" ("the illiterate opinion") by means of a public subsidy to the opinion makers.

b. To prevent this, subsidies have to be accompanied by public intervention on information or have "to police the market for quality and truth" (10). This will depreciate the variable capital stock invested in quality-assuring (P_3'KRP$_3$ in figure 3) and eliminate the variable part of the rent, taking the system to L-like points. Social welfare will thus be improved also through subsidizing policies.

c. All public intervention is conditioned by a lobbying attempt by the cultural establishment. This attempt is likely to be successful every time that

$$KS'P_3^{ll} P_3^l > KMS$$

that is, when the total variable monopolist rent to be cancelled is greater than the total variable consumer loss to be recovered through the policy to be passed. In this case cultural institutions can successfully lobby against quality assurance improvements.

d. The true prevention of culturally-created environmental waste can only be obtained by cutting the original monopoly condition, and lowering long-run costs, to LR$^{A'_c}$, the intersection of which with abscissae is

X= (Q$_0$ - Q$_1$) if the initial rent is totally eliminated.

This can be obtained by a general deregulation of the cultural market, which has to be assisted by a general improvement of information on quality. Disinterest in deregulation can be caused by an excessive disproportion between the deadweight loss to be recovered on the regulated market (KRL or even KSM) and that originally arising from the creation of the monopoly (KVT), (11). Finally, lobbyst efforts against deregulation are, naturally, likely to be exerted by the establishment. Their success is conditioned by

$$P_nTQ_nO' \gtrless KVT$$

that is, by the consumer's net loss to be recovered through deregulation which is greater or smaller than the original net capital investment in rent-seeking by the monopolist. In this case market size plays an opposite role from the one it had in monopoly creation: the larger the size, the higher the possibility of the deadweight being greater than the rent (12).

6.7 Summary and conclusions

Certification is the alternative to market information in overcoming the information asymmetry problem due to aesthetic qualification. Due to the self-validatory nature of "interpretation" the "certifiers'" reputation is largely based on self-selection by the cultural establishment.

Culture is considered as a self-certifying monopoly supplying a service of "quality-assurance" to consumers, who turn to cultural establishments in search of someone to trust in, given the uncertain "quality" of cultural products.

Monopolistic behavior, aiming at transferring maximization, re-

stricts quality-assuring to levels lower than those demanded by consumers.

Uncertified quality commodities enter the market and quality worsens.

A deadweight loss is imposed on society by the monopolist. This loss must be added to that implied by the creation of monopoly itself (the rent-seeking cost of monopoly).

Culture is not always a good thing. It can also cause waste in the environment, thus deteriorating its quality.

The reason for this has been explored using two literary examples: Marshall's case of quality deterioration in expanding cultural environments and Tullock's Mandarins' selection.

Subsidies to culture can worsen the situation and be an exogenous cause of waste increase.

Recovery and prevention are possible with public intervention to improve information on quality, as well as deregulating the market. They are likely to succeed only if rent-avoiding behaviors can be set up on stronger economic bases than those motivating the monopolist.

Notes

(1) Tollison (1992) suggests the conception of the Medieval Church as a "coercive monopoly" acting as a multi-national profit-maximizing organization.

(2) Mill (1848), book V, chapter II, sec. 8.´

(3) Tollison (1992) refers that definition to the Medieval Church, explaining how it was "the broker between adepts and salvation".

(4) Scitovsky (1988).

(5) Mossetto (1992 b) for a wider discussion of Marshall's position on the arts.

(6) Marshall (1920), pp. 215-216.

(7) Ibidem, loc. cit.

(8) Tullock (1980) "Rent-seeking as a negative-sum game", in Buchanan, Tollison, Tullock (1980), p. 20.

(9) "Rent-seeking (...) refers to activity motivated by rent but leading to socially undesirable consequences". Buchanan "Rent seeking and profit seeking", in Buchanan, Tollison, Tullock, (1980) p. 8.

(10) McChesney "Rent extraction and rent creation in the economic theory of regulation, " in Rowley, Tollison, Tullock, (1988), p.189.

(11) McCormick, Shughart, Tollison (1984).

(12) The market size, increasing the screening costs of quality definition and the risk of failure in quality identification, is a good justification of the monopolistic organization of the cultural market.

CHAPTER 7

THE AESTHETIC STOCK AND ITS PRESERVATION: WHY, WHAT, AND FOR WHOM?

7.1 The aesthetic qualification of a stock

The aesthetic qualification of a stock gives rise to a number of specific optimization problems which are not included in any other analytical approach to investment.

All stocks are characterized by the capacity to generate flows, (e.g. income/interest flows) the capitalization of which gives origin to its value. Moreover they are defined by the necessity of being renewed because of depreciation (through amortization).

The aesthetic qualification of a stock may differentiate it from any other stock from both aspects.

a. An artistic stock may be unproductive from the economic point of view but it may nevertheless have a positive value, only because it was produced through a process of aesthetic "creativity". We have already analyzed the case of market failure due to the aesthetic qualification of supply (chapter 3).

A work of art can be left unused for hundreds of years after having been "created" but it still keeps its intrinsic value, which is finally displayed at the moment of its historical recognition ("interpretation") as an artwork.

Ricardo's "scarce books and coins" can be mentioned here.

b. The renewal of an artistic stock can simply be impossible. There is a technical problem of replacement which is due to the non-homogeneity of each artistic product.

One cannot substitute Leonardo's "Mona Lisa" with his "Lady with the Ermine", not because the former is aesthetically more beautiful than the latter (which is, in my opinion, untrue), but because of the uniqueness of the two products. These paintings cannot be replaced, but only preserved.

Furthermore, there is a general "dying-arts problem". Art forms of the past cannot generally be re-vitalized when dead: either they exist or not. In other words, their existence is an "all-or-nothing" kind of alternative: either we preserve that specific art form or not. This makes the preservation problem under aesthetic qualification very similar to that of environmental preservation in its most recent terms.

The degree of functionality of a stock decreases with its deprecia-

tion. When its depreciation is complete, its functionality is theoretically over. It will be replaced by a new stock of equal or of increased functionality.

Aesthetic qualification, in principle, denies any intentional functionality to stocks. Their depreciation is therefore independent from their functionality, as new styles are independent from enhancements in functional attributions of the goods (see chapter 3).

7.2 Preservation and history

The use of a stock with aesthetic qualification needs its "interpretation". This submits the process of preservation to history, "interpreters" and their tastes being changed through time. The concept of preservation is itself subject to deep historical modifications.

"Restoration" (etimologically coming from restaurare) has its conceptual origin in the sixteenth century, while all the previous examples of preservation of artistic objects are cases of "re-use" of the same object in a new context (conceptually "reficere" or to re-make) (1).

The Venetian restoraton of frescoes in the Doge's Palace (starting from 1409) is the first example of an intervention aimed purely at conservation (2).

Notwithstanding this, and the progressive generalization of a philological attitude in restoration starting from the eighteenth century, all restoration up to the end of the nineteenth century was characterized by the strong influence of the ethical, political or aesthetic beliefs of the contemporaries. The best-known example of this is the moralistic "retouching" by Daniele da Volterra of Michelangelo's Last Judgement (he "clothed", among others, the naked Saints Catherine and Blaise; earning the nickname "Bracchettone" for his skill in painting "trousers") (3).

Besides the political and ethical dictates of the Counter-Reformation, however, the contemporaries' point of view on architecture and internal decoration was also deeply influential.

Throughout the sixteenth and seventeenth centuries, for instance,

restoration included altering the size of paintings to make them suitable for their location in houses and palaces (4). More recently, the choice of the elements to be preserved and the preservation techniques themselves, are good evidence of the contemporaries' tastes, as in the highly controversial case of the nineteenth-century restoration of the Basilica in Assisi (5).

The determination of heritage may, therefore, be seen as the product of a conflict between the dominant groups of the past and the present. Ashworth talks about a process of "disinheritance": "the hijacking of history by the dominant groups" (6).

7.3 Alternative uses of an aesthetic stock

A stock endowed with aesthetic qualification has also another characteristic which has to be taken into account in discussing its preservation.

It is a multi-use product, as it can be utilized either for cultural or for non-cultural purposes, and it is a "place-product" (7), that is a product to be used in a specific location.

This has some significant consequences for its use, which are also a simplified way of representing the historical conflictuality discussed above, leading to heritage formation.

a. Its existence can give rise to its cultural consumption and/or, at the same time, to a non-cultural destination, by agents such as hotel owners, tour operators, cultural sponsors, etc, whose products are built or promoted by its use. While the former can be more or less endowed with "interpretation" skills, the latter, unlike ordinary consumers, do not need it in order to consume. The stock is, as they perceive it, a productive factor since they are only interested in the external effects of its consumption on their own market. The more the stock is consumed, the more their products are sold.

While the cultural positive external effects arising from the existence of the stock are generally non-excludable, these specific effects are subject to exclusion. In this case the stock has the usual economic attributes and destination.

b. As the heritage is a "place-product", its use is strongly subject to congestion especially as regards its quality. The higher the number of consumers, the lower the enjoyed quality of the stock.

All of us have had the terrible experience of queueing in front of the "Mona Lisa", and getting only a thirty second glance after 30 minutes of crowded waiting.

Congestion worsens the inefficiency due to the existence of alternative uses for the good in the same location which generally may give rise to a non-convex transformation function between the two productive destinations (8). Only specification can achieve the maximization of the product.

The opposite nature of the externalities enjoyed by cultural and non-cultural agents on the stock market under congestion conditions is the basis of conflictuality between the two categories of consumers.

Cultural agents will be interested in limiting the market size of the stock, while non-cultural ones will push it to its extreme exploitation (9). The simplest and most clarifying example of this, is the already mentioned case of "overbooking".

In that case, the non-cultural consumer (impresario) is interested in widening the opera audience to equalization of price with average cost even if this means someone will be standing or sit in the aisles, instead of running the risk of a partially empty theatre, the cultural consumer (melomane) aims at limiting the audience to the available seats.

This conflict is strengthened by the distributional effects which are often connected with these decisions in the field of cultural goods. Consider for example, the well- known question of so-called "sustainable development", that is, the determination of the level of touristic development of a location, compatible with the preservation of its cultural heritage. How can the "carrying capacity" of this location be determined (in order to avoid cultural destruction) when the higher its level, the higher the increase in residents' income, but when, after the congestion threshold, the quality of the heritage enjoyment from the point of view of any cultivated person, is so much lower?

7.4 Who has the right to decide?

Any decision referring to a stock endowed with aesthetic qualification is therefore characterized by a specific conflictuality (due to its historical formation process and to its economic nature) on the one side, and by a high level of economic underdeterminability (due to the need of "interpretation" to determine its value and to its intrinsic non-functionality) on the other.

The destination of the stock (that is its economic use) and its maintenance and/or replacement are decisions the outcome of which may be different depending on which subjects will be entitled to them.

The economic information originally needed to determine these choices is, moreover, not always available. The stock value at a given time, being independent from its functionality (but depending only on its aesthetic "interpretation"), is partially economically ungrounded. Its possible disconnection with any economic flow to be generated by the stock over time, makes the evaluation of any actualization rate very hard.

All this makes the question of who has to decide even more crucial.

If, as Baumol has pointed out (10) for ancient paintings, the determination of values for artistic goods has the characteristics of "a floating crap-game", where the winner is only the one who privileged his subjective aesthetic preferences, the importance of being this one, in order to win, is trivial.

Less trivial is the fact that the entitlement of the decision-making right cannot in this case follow Coase's rule of the "lower cost avoider" (11). In other words, the right of disposal cannot be given to the agent whose cost will cause the higher increase in the case of non-disposal of the resource.

This will be correct in a world of cultural consumers in which some are endowed with "interpretation", and others are not.

In this case the shift of demand to the right due to "interpretation" skills (figure 1), will enable the former to pay the latter for having the right to dispose of the resource, as his consumer surplus is wider.

In the case of non-cultural use of the resource, however, the higher

cost of non-disposal could well lie on the non-cultural consumer. A good example is the case of overbooking of seats of an Opera house. The impresario is the only one to run the risk of an empty theatre (and of the related loss in his producer's surplus represented for instance by the area OMPo in figure 2), where qo is the saturation size of exploitation of the production capacity of the stock ($P_o=M_c$).

The agents' willingness-to-pay is not an optimizing mechanism because the non-cultural consumer of our stock (the impresario) will always have an advantage in oversizing the supply (which is represented by the area STM of the extra surplus the producer can obtain by breaking the social optimum size of the audience). The cultural consumer (the opera-lover), on the contrary, faces a fixed price, which is equal for every quantity and his surplus is always equal to zero. The former, therefore will always be able to pay the latter, while the contrary does not hold (12).

The former, however, is on the same basis, incentivated to overcome social optimum, damaging society for his own advantage. If q_1 is reached by *overbooking*, a net loss will result for the cultural consumer (to be measured by the area MVT on marginal cost pricing bases) from the net benefit SMT for the non-cultural consumer, where, under increasing marginal cost conditions, we always have:

$$MVT>SMT$$

The entitlement of the decision-making right is therefore not indifferent, one agent internalizing the social cost deriving from the excessive use of the stock, the other getting an extra advantage from it.

This, of course, could correctly be seen as a short-term point of view as the average cost function is likely to be influenced in the long-run by the progressive destruction of the stock (which will also destroy a part of the producer's surplus) or, to be extreme, causing the unreplaceability of the stock as an "all-or-nothing" alternative for the non-cultural consumer, too, (with the cancellation of the demand curve)

FIGURE 1

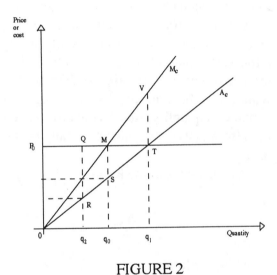

FIGURE 2

In the real world, however, the distributional effects of the stock exploitation for the non-cultural consumer are immediate while its results in terms of welfare losses on its availability have to be predicted for the future. Due to the need for a discount rate, therefore, the future losses have to be nominally higher than the current advantage, which makes the non-cultural consumer rather insensitive to the current stock destruction.

7.5 Non-aesthetic strategic behavior

This kind of conflictual problem can easily be extended to any decision-making process where the cultural stock is used for non-cultural purposes.

As we have already mentioned, a stock with aesthetic qualification is subject to "interpretation" in order to have a current utilization. Interpretation, however, unlike what we have assumed until now, may be influenced by (or directed to) non-aesthetic aims (Asworth's "hijacking of history by the dominant groups").

In this case, of course, it will no longer be "interpretation" according to our definition. It will, however, be a strategic distortion of it, transforming a cultural into a non-cultural consumer using the stock not to enjoy it for its aesthetic qualification but, generally, to produce and increase his own surplus indifferently (based on his political, religious, or market position). Strategically behaving as non-cultural, the consumer will modify his demand function, the inclination of which may become positive (the higher the price, the higher the demanded quantity), due to the difference of its price-quality/utility ratio from that of the non-strategically behaving consumer (see section 4.2).

Ceteris paribus, the former will always be

$$\delta \, u_{is} \, / \, \delta \, u_{ms} > 1$$

while the latter

$$0 < \delta \, u_{ins} \, / \, \delta \, u_{mns} < 1$$

This behavior is of course different from the cultural establishment's surplus strategy illustrated in chapter 6, where the certification is always assumed to be based on aesthetic grounds (that is where interpretation is consistent with our initial definition). The certifiers' strategy has different consequences. On the one hand, their cost for

consumers (the primium of assuring quality) increases the long-run marginal cost function. On the other, their rent-seeking activity tends to maximize the expansion of the field of assurability.

Strategically acting on non-aesthetic bases, "history hijackers" do not cause a social loss only because they give rise to an excess of utilization of the stock, and then, to congestion. This is only one of the possible outcomes of their behavior. More generally, they modify the information which is included in interpretation for non-aesthetic aims.

All this may lead to significant consequences in decisions concerning the management of the stock.

7.6 Some economics of preservation

The management of a stock with aesthetic qualification can be studied by analyzing either its consumption (as we have already done here, as well as in chapter 4), or its preservation.

As mentioned, the consumption itself, having different effects on the conservation of the stock, can be seen as dependent on the preservation. (In the long-run: no consumption without preservation).

The economic analysis of preservation must answer these logical questions:

- why preserve?
- for how long?
- what and for whom?

7.6.1 Why preserve?

To preserve a stock for aesthetic reasons requires first of all that it be identified as being aesthetically qualified.

This means adding to it an information value stemming from its interpretation as art, which can be included in the production function

based on the stock itself. Its inclusion can be represented by lowering the marginal cost function (as we have already seen in chapter 3) to qualify the supply aesthetically.

There is more value for the same price, that is the same quantity has a lower cost. This gives an immediate economic reason for preserving aesthetic stocks, because preservation results, *ceteris paribus*, in an expansion of welfare (figure 3, area KML).

Of course, as preservation has a cost (direct and indirect, including the cost of "certification" of the stock to be preserved), its expansive effect will be at least partially absorbed in the long-run (LRM_c)in figure 3). Therefore, if $q_{lr} > Q_o$, the preservation will be beneficial, otherwise it will not.

The"dying-arts" problem as we have mentioned, is however more complicated. In this case the decision to preserve allows the existence of the stock, no preservation meaning, in the long run, no stock. As some stock is virtually always better than no stock, this could absurdly result in a decision to "preserve everything", which will be analyzed later. As resources to be destined to preservation are scarce, this is, of course, an unsatisfactory solution. We then need to introduce some further element for economic calculation into our decision.

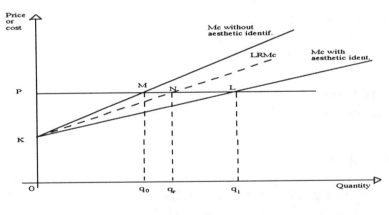

FIGURE 3

7.6.2 What to preserve: the reason for preserving everything

"Preserving everything" is a characteristic of many countries' contemporary preservation policies. Besides the trivial truism that something is better than nothing (and all is better than something), there are also economic reasons for this.

The first and maybe, most important, is the certifiers' strategy of maximizing their "quality-assurability" field. The larger the domain to be certified, the larger the transfer from consumers. The more extensive the definition of the stock to be preserved (as "aesthetic" or "cultural"), the larger the monopolistic power of "certification".

This reason, however, can be mentioned for the past as well as for the present consideration of the problem, while the "urgency for preservation" is typical of our days, and more generally, can be referred to the twentieth century. In the eighteenth-century, the ruins of ancient Rome were contemplated without any concern about how to preserve them. Papal Rome transformed the Teatro Marcello into a prince's palace and swallowed up Pompey's theatre in a slum in a sixteenth-century version of real-estate speculation.

Renaissance towns were built up on their Medieval forerunners and were in turn, devoured by Baroque construction, and successively demolished by twentieth-century "vanguards". Only communist regimes allowed Prague and Crakow to remain untouched in the last fifty years and not to suffer the evolutions of Paris, London and Rome. Prague, however, is a unique and fascinating museum precisely because of the huge transformations it suffered in the past. Nobody, however, is shocked by this.

Why then should the residents of Paris scream against the destruction of the "Marché aux Halles" and the Romans strongly defend Vittorio Emanuele II's Memorial, both being rather modest examples of questionable architecture?

Two economic answers can be given: either nineteenth-century cultural production seems less important in terms of quality and quantity to our contemporaries than that of their times to the decision-makers of the past; or the net destruction rate of the culture of the past has been increasing. Both arguments are historically grounded.

Benedictine monks copied Classical works to preserve them, but, at the same time, they invented the great Gothic cathedrals with a concern for permanence shared only by the great architects of the past. Contemporary re-examination of the cultural themes of the past is not linked to any permanent innovation. This is not because any innovation is present, but rather because, nowadays innovation is the behavioral rule in the arts.

The "vanguard" is now the "post-vanguard" of the "vanguard", as it is expressly and conceptually intended to be consumed and destroyed. Modern and contemporary art is conceptual and, as such, it is structurally ephemeral over time.

Technology is also responsible for the increase of the destruction rate in art and culture. Conserving a movie is different from conserving a literary work. Modern and contemporary art is multimedial and, therefore, is technologically ephemeral.

Economic growth has supplied several good arguments for the urgency of preservation, too.

It has created an unprecedented increase in the industrialization of negative externalities, with similar destructive effects on environmental and artistic resources. For example, water pollution in the Venetian lagoon also has unprecedented negative effects on its artistic heritage.

On the other hand, economic growth, with the related market expansion has caused a decline in quality due both to economic reasons (an ugly thing is often cheaper than a beautiful one) and to the above-mentioned strategic behavior of certifiers. All the arguments discussed, however, besides this last one, refer to contemporary art (what has been produced today), not to the art of the past. From that point of view, the only difference between us and a citizen of the sixteenth century is the level of pollution and its effects on the artistic heritage. This is a good reason for intensifying preservation initiatives, not for preserving everything, stopping any transformation of the heritage.

Contemporary attitudes to freezing the past are more likely to result from a negative judgement of contemporary artistic and cultural production. If culture is a different way of using the same resources, it is evident that our contemporaries' opinion of their own way is worse than that of their grandparents. Why should the re-use of the Venice

Arsenal give aesthetically worse results than sixteenth-century restoration?

The truth is that this negative judgement is mainly grounded on negative empirical administrative evidence.

What is considered worse is the decision-making attitude of those who should "interpret" the heritage in order to preserve it.

Why should Venetian public officials make worse decisions than their sixteenth-century predecessors? As well as all ideological arguments, there is also an economic reason for this.

Their decisions are worse because they do not pay for them. *Ceteris paribus*, that is assuming for decision-makers of all times the same level of interpretation and social welfare maximization capability, contemporaries decide on a heritage they perceive as being a public good subject to their free-riding behavior, while decision-makers in the past mainly owned it personally or as a part of a collectively-shared wealth, the accumulation and maintenance of which they paid for.

A bureaucratic behavior may be developed on these grounds, aimed at non-Pareto optimum solutions for society (13). This has nothing to do with the aesthetic process, which cannot therefore be considered a reason for "heritage freezing" in itself.

Preservation decisions go through an interpretation process which helps in defining aesthetic priorities but which also gives non-consequentiality to these choices they can also be influenced on economic and political grounds. This can lead to the refusal of the present as well as of the past.

"What to preserve?" is a question that must be analyzed on this basis.

7.6.3 For whom? The optional consumer

The importance of consumer interaction in defining preservation choices, makes the "for whom" question crucial.

Economic theory gives some well-known answers to this question. Three main user groups are delineated: current effective consumers, optional consumers and future consumers (or the so-called future

generations).

The current effective consumers have already been considered here (and in chapter 4), especially with respect to the two different subsets of cultural and non-cultural consumers. The negative effect of their interaction on social welfare has been discussed.

Let us now explore the effects of the existence of the other two categories on the management of the aesthetic stock to be preserved.

Preserving an artistic heritage for those who wish to use it independently of any expressed demand, means, first of all, stating its not completely private nature. Optional consumers cannot be excluded from the consumption of the preserved heritage even if they never express their demand for it. If the good were strictly private, in principle it could be produced and exchanged only in presence of effective demand to be expressed on some market (including the so-called "futures" market).

On the contrary, the optional consumer by definition does not express his willingness to consume, even if he holds a right to do so (in this sense he is the freest among free-riders).

The optional consumer's safeguard involves not only the assumption of a public or "mixed" nature of the good, but also the utilization of "peak-load" demand functions.

The possibility that currently non-active consumers can become active at any time in the future gives rise to the possibility of fluctuations of demand over time. If fluctuations occur in the presence of non-storable goods (such as the services deriving from an artistic heritage), marginal cost may prove to be no longer a non-controversial measure of price determination (14). Marginal cost can differ for the same supplied quantity, depending on whether it is supplied in "load-peak" periods or not. Different production capacities are needed in each period involving different fixed (and often also variable) costs to satisfy total demand.

The same good, therefore, has different optimum prices according to the period in which it is consumed. They are bound to be higher in "peak-load" periods and lower for the rest of the time. Peaks can be determined in time (and therefore be "fixed") or not (and therefore be "mobile").

Optional consumption gives rise to "mobile peak-load" periods. Optimum price, therefore, must be determined in presence of public goods, through a total demand curve resulting from the vertical sum of individual demand functions in the two periods (the "peak-load" and the "ordinary").

Optimum price will be the sum of variable (a) and fixed costs (b) needed to expand productive capacity to the adequate level to face the "peak-load" demand (figure 4).

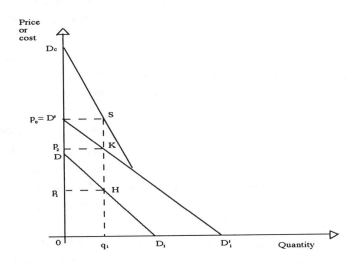

FIGURE 4

where $p_1 = a$
$p_2 = a + b$
$p_0 = 2a + b$

The distribution of price among consumers depends on their expressed willingness to consume in a peak period. The peak period consumer will declare his willingness to pay the peak period tariff while the ordinary consumer will pay a lower price but will also lose his discretionality in assessing the service.

The optional consumer could act the same way if willing to consume q_1 in a period if total demand were

$$D_c > D_t$$

184

that is, higher than the maximum of the non-peak period. He has to declare his willingness to pay at least

$$P_2 = a+b$$

a price including the long-run fixed cost of the increase in productive capacity caused by his own existence as an optional consumer.

Besides free-riding problems, preservation choices in the presence of optional consumption should, therefore, require a system of price discrimination to differentiate consumers. Without the discrimination of prices and consumers, the determination of b (which represents in this case the level of conservative investment) and of its related returns may be completely arbitrary.

Moreover, the optional consumer is, as mentioned, a free-rider. No optional consumer will ever declare his willingness to consume, as instead will any peak-period consumer of a power or telecommunications network. By doing so, he would, in fact, become an effective consumer. The definition of the optimum level of investment in preservation b is therefore even more critical.

In our scheme, the optional consumer can be seen as someone expressing a demand without "interpretation" (DD_1 in fig. 4)who can at any time qualify it from an aesthetic point of view (passing to $D'D_1'$).

This demand shift will lead him to be a peak- load period consumer with all the above-discussed consequences.

The conceptual indetermination of the consumer, involved by the concept of optional consumer, is grounded on the merger of value judgement (on the freedom of general access to the heritage) with a prediction on reality (the probability that some will effectively have access to it in the future).

7.6.4 The future generations

The third theoretical category of artistic heritage users is that of future generations, to be distinguished from optional consumers because they are not able to express their willingness to consume today, as they are not yet born, unlike optional consumers who deliberately do not want to do so.

The economists' stronger reaction against this preservation argument is: "Why shouldn't we let future generations get themselves out of this trouble (and therefore decide) by themselves?" They will certainly be the best "interpreters" of their own interests and preferences.

This argument, however, apparently ignores the fact that alternatives are needed for choice. The already-discussed "all-or-nothing" characteristic of artistic heritage preservation choices risks eliminating all alternatives before any decision is taken.

Incidentally, this logic supports the "freezing heritage" attitude discussed above. As future generations' preferences are unknown, all the heritage of the past has to be preserved, in order to let them have the widest range of choice for the future. Once again this is a truism. To let future generations get out of trouble by themselves means not making any choice now; in other words it means preserving everything.

Any preferences on which a decision can be based must in this case be submitted to a usual discount process of the elementary kind where:

$V_c =$ current value of the heritage
$V_n =$ nominal value of the heritage
$t =$ discount rate
$i_n =$ net expected benefit rate of the heritage for future generations

$$V_c = tV_n$$

where the discount rate

$$t = 1 / (1+i_n)^n$$

"Preserving everything" is therefore equivalent to an "all-is-impor-tant" approach in evaluating the discount rate where:

$$i \ -> \ \infty$$
$$t \ -> \ 0$$

which, however, also means

$$V_c -> 0$$

A zero evaluation of the rate of actualization of the future value of the currently preserved heritage is involved here as this rate should be a current decison-maker's estimate of future generations' preferences. This is, however, in contradiction with the non-zero evaluation of the opportunity-cost of the resources currently invested in preservation. This cost is equal to the benefit of the most convenient alternative for the current decision-maker.

Resources would be rationally diverted from any other use but preservation. Current decision-makers could turn out to be masochis-tic decision-makers, which is historically inconsistent. This dilemma is economically-grounded on the incompatibility between the theo-retical non-limitation of the needs for conservation investments and the scarcity of the available resources of an economy. Two ways out can be foreseen.

One is to go back to the market, assuming that it can also discount the future generations preferences on the good it prices. The other is to assume the existence of well-established and trustworthy non-masochistic estimates of our great grandchildren's interests.

In the long-run, every market discounts future generations evalu-ations. This is even truer for hoarding stocks like those we are dealing with.

In this case, preservation processes should be evaluated on the grounds of their expected economic pay off, like any other investment project. The discount rate could not be other than the long-term loan interest rate of the market where the project is funded, or any different rate that the market might establish.

The lower the rate, the higher the future generations' estimated preferences to consume the preserved good (to be weighted, of course, with the estimated probability of realization of this forecast).

By doing so, we take the preservation decision-making process back to the discussed frame of reference of the current effective consumers' demand.

The second way out of the future generation trap is paternalistic. There is someone who now knows what will be the best for the future and who preserves it.

Neither way is satisfactory and neither is independent from the other.

Taste changes (also exogenous changes), discoveries and "re-discoveries" of the art of the past supply historical evidence both against the market and the "good grandfather" argument. Had it been up to Ruskin-to cite an important universally recognized art critic-fourteenth century Venetian palaces would have been razed to the ground, Poussin's paintings destroyed, Palladio's architecture ab-horred etc. (15).

Veblen - to cite an economist who paid considerable attention to cultural and artistic phenomena - would have banned all modern American art from the early nineteenth century (16).

No consistent demand was expressed by the market for Italian nineteenth-century paintings up to less than thirty years ago, just as in eighteenth-century France nobody cared about thirteenth-century Italian "primitives".

To let the market or experts decide what to preserve is, therefore, equally unsatisfactory from the point of view of the historical evidence of a great grand-child's judgement on past choices.

Something, however, can be added to the manifest inadequacy of economic theory in prescribing optimizing preservation policies. This can be derived from historical analysis.

History shows that, in spite of the non-optimizing results of the application of economic schemes, decisions influencing the state of the artistic and cultural heritage have always been taken. Less trivial is the fact that it was generally the market that took these decisions. In other words, we must recall the previous argument that heritage itself,

188

as it comes to us, is a market product and no declaration of non-market, ethical, political or generally ideological interest or principles can change this.

The "interpretation" of the heritage was made by the market agents endowed with their own preferences orderings. Sometimes they were in a dominant position (and they were "certifiers" of the aesthetic qualification of the heritage), like critics, art, merchants, or even politicians (in a "Min-cul-pop" -like world). Sometimes they were mere consumers, interested in buying, selling, collecting or simply enjoying heritage goods.

Had it not been for Florentine or Venetian merchants, French courtesans and tyrants and Roman cardinals in search of social standing, most of the ancient art heritage would not exist. Without the Paris or New York art merchants, a large amount of Modern art would not exist. No concern for any form of public interest was expressed by decision-makers on art investment before the French Revolution (and the consequent creation of the Louvre for educational-political purposes). All consumers were aesthetically qualified by definition and free-riding was limited. From this point of view the only possibility of analyzing the heritage formation process is ex-post and the discount process has to be re-defined as a capitalization process where:

$$V_c = (1 + i_p)n\, V_p$$

being

$V_p =$ nominal value for past generations;
$i_p =$ net expected benefit ratio of the heritage for past generations;

all the rest being equal.

7.7 Conclusions

The aesthetic qualification modifies the nature of a stock with

significant consequences both for its market and for the decision-making process referring to its preservation.

The artistic (and more generally) cultural heritage is qualified by its "interpretation" by current consumers and certifiers. Its economic value is strongly influenced by this, independently of its capacity to generate income and/or previous or subsequent "interpretations" over time.

This gives rise to unusual processes of depreciation (possibly unrelated to its functionality) and of amortization (which happens to be economically impossible because of the lack of derived income flows).

Impossibility of current evaluation may also occur.

Preservation decisions on the stock are moreover influenced by the existence of its different alternative uses.

Non-aesthetically-qualified consumption may be characterized not only by the lack of interpretation but also by strategic behaviors aimed at the maximization of external excludable benefits deriving from aesthetically-qualified consumption. This may result in an oversizing of the equilibrium and therefore in a destruction of the heritage, due to congestion. This also makes the process of decision-making rights entitlement crucial as the "lower cost avoider" rule cannot be applied here, as it would result in the entitlement of the right of decision to the non-aesthetically qualified consumer.

The considerations of optional consumers and of future generations do not help further optimizing solutions.

Serious evaluation dilemmas arise from the definition of these consumers' categories which can result either in heritage freezing policies or in absolutely discretional solutions.

Notes

(1) Mossetto (1991).
(2) See, for example, the main economic literature on this subject: "The two part tariff", in Economica, Aug. 1941, pp.249-270; Boiteux, "La clarification des démandes en point:application de la théorie de la vente au cout marginal", in Revue générale de l'électricité, Aug.1949, pp.321-340; Houthakker, Little, The Price of Fuel, 1953 Oxford; Steiner P., "Peak loads and efficient pricing", in Quarterly Journal of Economics, Nov. 1957, pp.585-610, to the more recent:AA.VV., Essays on Public Utility Pricing and Regulation, Ann Arbour, 1971; Muskin S.J. (ed) Public Prices for Public Products, Washington, 1972; Crew M.A., Kleindorfer P.R., Public Utility Economics, London, 1979; K.Judge (ed), Pricing the Social Services, London, 1908.
(3) Ruskin (1852).
(4) Veblen (1899).

CHAPTER 8

THE ENTITLEMENT OF RIGHTS: GENUINE AND FAKE

8.1 "Self-certification" and rights entitlement

Rights entitlement (1) is crucial under aesthetic qualification be-cause of another feature of aesthetic processes we mentioned in chapter 6: self-certification.

"Creative" and "interpretation" processes in the arts are not such because of any external identification of their results. As we discussed when defining them (chapter1) their aesthetic nature only involves the necessity of being identified by the "creator" or by the "interpreter" themselves with no other reference to other agents. In this sense we defined it as an "internality" (chapter 3). In other words, self-certifi-cation, can be seen as a part of a non-consequentiality axiom defining the aesthetic domain.

This is the cause of a controversial application of the Coase theorem, and more specifically of "lowest-cost-avoider" assignment rule (2) as being at the origin of some particular agents' strategies, which are usually considered illegal behavior. The general argument can be summarized as follows:

a. Individual "self-certifying" agents can decide to behave strate-gically in order to maximize their net benefits. "Self-certification"involves the assumption of "non-price taking" for the agents. Agents may decide either to declare the aesthetic qualification of their production and consumption or to hide it in their own interest. This will, of course, make a difference in their market functions, which will alternatively be "cum" or will not have the aesthetic connotation as seen in chapter 3.

b. "Self-certifiers", like "certifiers" are monopolists (or at least oligopolists), and they are likely to act as discussed in chapter 6. A relative shortage in market supply will result from this.

c. This gives rise either to a quality decadence ("kitsch"), because of the occupation of the uncovered social optimum differential share of the market by quality "uncertified" products (as discussed in chapter 6), or to false products, the aesthetic quality of which is apparently the same but which is actually different from that deriving from true "creative" or "interpretative" processes.

d. In this case, therefore, the consumer can be damaged by the

strategic behavior of the producer or of the certifier. This does not necessarily mean that the producer of the art work benefits from the transfer the consumer pays against a good which has a lower value than he estimates, believing that its aesthetic quality is true. This transfer, of course, may be retained by the forger. The original cause of the forgery, however, lies in the strategic market shortage deriving from the behavior of the producer who thus benefits from an extra-surplus (which is another kind of transfer due to a different operation). This has to be removed to eliminate its effect.

We have already discussed the "kitsch" hypothesis in chapter 6. In the case of "kitsch" production, nobody is entitled to start legal proceedings claiming damage because what he consumed was "kitsch" instead of "beautiful". The consumer of "kitsch" is a voluntary one. The producer voluntarily limits his production causing "kitsch". Rights assignment on the aesthetic qualification is therefore not significant.

e. In the case of a false production, the damage is caused by a voluntary action of the producer who reduces the quantity to a lower-than-optimum level to benefit a surplus. The damage is suffered by the involuntary consumer of the object. No damage is suffered by the producer because, in principle, if no forgery has occurred, the producer's transfer would not be modified.

f. The right of acting against a fake should be assigned to the consumer because he will always be able to pay the producer in order to avoid the quantity shortage causing the forgery.

g. A controversial producer's strategy can, however, arise from "self-certification" (point a); that is, from information asymmetry caused by the aesthetic qualification of the supply, the results of which may contradict these conclusions.

In the presence of supply "cum creativity" and of demand "without interpretation", and without public support, the market may fail to supply exchange solutions. The "self-certifying" producer can decide to hide the aesthetic qualification of his supply in order to let some consumption exist, that is to make a start up investment on the consumer.

In this case, if forgery occurs, the fake will also damage the producer. Furthermore, as we will see, the damage he suffers may be greater than that suffered by the consumer. He could, therefore, correctly be entitled to the right on the aesthetic qualification to react against forgery.

h. The assignment to the producer of the rights on the aesthetic qualification of the product, however, is the legal ground of his monopolist's position on the market and can, therefore, cause the fake.

8.2 The economic foundations of aesthetic forgery

This argument can be better analyzed through a little formalization.

Let us assume the existence of two supply functions: the fake and the genuine; the former without aesthetic/artistic qualification and the latter with aesthetic/artistic qualification (S_{NA} and S_A) (figure 1).

Let us also assume two demand functions; the former is able to distinguish the genuine from the fake (D_A), as it is endowed with intepretation, the latter (D_{NA}) is not.

In our model the artist is originally the only one aware of being an artist, because his creativity generates a higher (aesthetic) value which needs interpretation to be recognized by the market.

This may lead to the market failure already discussed in chapter 3.

Art may be non-saleable. Nobody is willing to buy q_A if the perceived price is p, that is if the demand is D_{NA}.

The artist invests an amount of resources equal to the area KLQQ', hoping that his work of art will be interpreted after being created, and, therefore, that a demand such as D_A will arise.

In this case the equilibrium will shift to M (q_A' p'_{NA}), allowing the artist to pay his investment off, making a profit equal to Q'QMM'. Later on, since M is not steady, the equilibrium will shift to N (q'_A p'_A), with an increase in the produced quantity sold on the market.

The surplus of the system is increased of $D_A Q'MD_A$ while the

latter causes an additional net welfare growth of $S_A NMS_{NA}$.

The forger's action may be represented through the consumer's belief of being on D_A, while effectively staying on D_{NA}, as nothing has to be interpreted the good being fake.

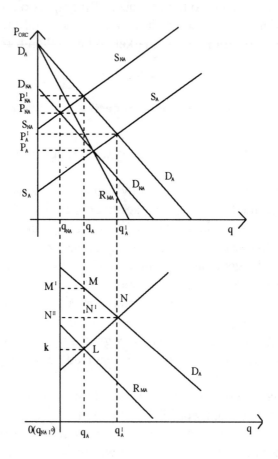

FIGURE 1

The consumer is defrauded and moves to M, while he should stay in Q'.

a.1 The consumer's fraud area is, therefore, equal to the lower

value he attributes to the fake transferred to him by the forger, net of its value as fake, that is:

$$(p'_{NA} MD_A - p_{NA} Q'D_{NA}) + KLMM'$$

a.2 The forger's benefit is equal to his "free-riding" on the artist's investment (the area KLMM') plus the net transfer he deverts from the artist (which is equal to the same area), therefore, it amounts to:

$$2KLMM'$$

a.3 The artists's damage is due both to the loss of his profit (QQ'MM') and his investment (KLQQ').

a.4 Society suffers a net welfare loss equal to the difference between the two consumer's surpluses (in Q'and in M), that is:

$$p'_{NA} MD_A - p_{NA}Q'D_{NA}$$

Both the artist and the consumer are entitled to react against forgery.

No contradiction, therefore, can be seen, on economic grounds, to the assignements to the producer of the right of pursuing forgery even if it gives rise to his monopolistic action and, by consequence, to the creation of a market for the fake.

There is an extreme case, however, where neither the consumer nor the producer are damaged by forgery, not technical difference existing between the genuine and the fake, (except for the artist's signature, that is for the monopolist's auto-certification), and quantity being voluntarily limited by the producer.

This is the case of the perfect technical reproduceability of the artwork. No difference can be defined between artistic and non-artistic supply. The difference of price between M and L is only due to the limitation of the quantity supplied by the artist.

This is easily represented in our model by assuming that the marginal revenue function of the demand curve endowed with

interpretation intersects the marginal cost/supply function S_A in L.

M (p'_{NA}, q_A) becomes therefore the monopolist's equilibrium, too, and the area KLMM' becomes his rent.

The artist, acting as a surplus maximizer, stops in M, instead of moving to N, like in the previous case. This leaves a partially unsatisfied demand $(q'_A - q_A)$, and, therefore, a market space for the fake and the genuine being in this case coincident, the forger can satisfy this excess of demand without damaging anybody.

b.1 The consumer is indifferent if $q'_A - q_A$ is supplied either by the artist or by the forger, since the genuine cannot be distinguished from the fake.

b.2 The possibility that $q'_A - q_A$ is supplied by someone else is irrelevant for the producer, (the artist), because he has no convenience in producing it. The surplus increase deriving to him by moving from L to N is lower than the surplus decrease he has to suffer from the forgery

$$LNN' < N''N'MM'$$

b.3 Society has a net welfare benefit equal to the area LNM and no agent is economically entitled to act against the forger.

8.3 Genuine, fake and genuine fake

This analytical frame of reference can be used for a better understanding of the phenomenon of fakes in the arts.

A fake can be defined as an imitation of what is genuine. The difference between the genuine and the fake can be objectively grounded and be caused by the nature of a good, or be subjectively based on the nature of the rights on the good.

Genuine and fake can be complements or substitutes, according to the consumer's perception of fake as genuine or as a genuine fake.

The forger's behavior is based either on the lower cost of faking

compared with the cost of the genuine, or on the criminal diversion to him of the transfer destined to the producer of the genuine. As we have already seen, the damage for a producer whose output was faked may be equal to the income loss deriving from the decrease in the sales of his products, when genuine and fake are substitutes.

The consumer's damage consists in the price difference between genuine and fake for a given quantity.

When the forgery is due to an output shortage deriving from the monopolistic behavior of the producer of the genuine, however, genuine and fake are no longer substitutes but become complements. The fake is intended to fill the net social loss caused by monopoly.

The producer's net loss is theoretically nonexistent. The more the genuine is consumed, so the more is the fake.

The consumer's damage can also depend on his intention of consumption. He can either involuntarily consume the fake believing it is genuine or voluntarily do it knowing it is a genuine fake.

A true fake market is a well-known phenomenon in the visual arts, mainly for paintings. Auctions and exhibitions of genuine fakes are currently held (7). A genuine fake heritage is spreading around, like "kitsch".

Fakes can therefore be reasonably considered as endowed with a specific value in the real world.

The nature of forgery is, of course, modified both by the intentionality of the consumption of the fake recognized as a genuine fake and by the fact that it may or may not result in a diversion of an income transfer from the producer to the forger.

If forgery results in a voluntary consumption of the fake without any transfer diversion, it can economically be seen as a legal behavior, as no damage is caused to anyone by it. Otherwise it has to be considered as illegal.

8.4 Technological reproduceability

Technology increasingly allows perfect reproduceability of artworks.

The distinction between genuine and fake is therefore also increasingly subjective, depending on the producer's claims, as he is originally the only one able to say if the reproduction is a genuine reproduction or not. Self-certification is therefore the technical basis of the right to claim; that is of the right on the idea embodied in the aesthetic good. More generally, in the case of perfect reproduceability (which is not only significant for movies and music recordings, but also for other conceptual or minimal artworks, as for instance in the case of Andy Warhol's portraits, Duchamp's famous water closet or Manzoni's "artist's shit"; the original assigner of the right on the aesthetic qualification of the work becomes the "self-certifier" of the aesthetic quality of the genuine, that is of the embodied idea itself.

This has some significant consequences, in the light of our analytical scheme. The first is that, in this case, forgery has to be seen only as a violation of the right on the embodied idea. No consumer's right to violation is theoretically involved in the consumption of a fake good which is perfectly identical to what it is thought to be.

The second consequence is that as the assigner of the right is the self-certifier, he is also able to decide with no limitation on the supplied quantity of the good. From his point of view, too, there is no difference between the genuine and the fake except for the destination of the transfer coming from the consumer. No "creativity" limitations are any longer imposed on his production capability. This is not only a contemporary feature; Old Masters commonly used to have minor paintings done by their pupils and signed them personally.

The so-called value of the signature is a well-known price-differentiation device on the art market currently used by unscrupulous, or starving, artists to increase their income, minimizing their production efforts. Technological reproduceability, therefore, is not a condition denying the monopolist's position of the producer and (as one might think in the light of the unlimited quantity increase it can cause in consumption possibilities), more generally of the assigner of the right on the embodied idea, but exalting it. The producer, will keep acting as a monopolist to the maximization of his rent.

8.5 Prevention strategies

The producer will, moreover, worry about the possibility of someone else reproducing (or producing) identical goods and selling them on the market, diverting its consumer transfers from him.

He will therefore react by investing in reputation in order to build up barriers-to-entry against the forger. These are long-term investments which increase the incentive to rent-seeking behaviors (9) of the assigner of the right on the aesthetic qualification. The society welfare position will therefore worsen. Resources used by the producer for protecting himself against forgery generally cause social waste, as such a destination is inefficient (10). This would not, at least partially, be needed if the producer were not originally allowed to act as a monopolist.

Let us assume, as we have so far done, that technically perfect reproduceability can cancel any difference between the genuine and the fake and therefore that there is neither additional cost in producing the genuine nor additional advantage in consuming it. However, as the producer of the genuine fears forgery, he is willing to invest to make the fake different from the genuine in order to conserve the reputation of the genuine. This means he has to cause a shift of the demand curve on the right upwards in its quadrant, passing from D'D' to DD. In order to do this, he has to pay the consumer the difference between the two equilibrium positions or, which is equivalent, suffer a loss which consists in the area P_0HKP_1 (fig.2). This represents the producer's investment in reputation.

$K (P_1, q_0)$ position is protected against forgery because no demand is expressed for fake perceived products at price P_1. If the producer invests P_0HKP_1, the consumer, on his side, is indifferent between H and K, as it is, by assumption the information value difference is considered as a "lump-sum", his surplus

$$P_0HD'=P_1KD$$

equal in the two positions.

202

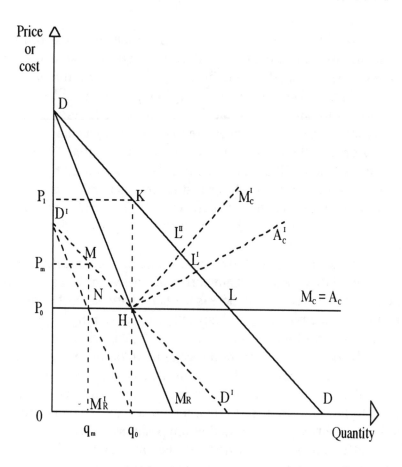

FIGURE 2

Society, however, has to suffer a loss because qo is in this case no longer the social optimum, and a monopolist dead weight loss (KHL) is imposed on it by the producer's behavior. This is true even if the producer has already previously been acting as a monopolist as

NHM<HLK

is always true.

Even if the monopolist intended to abandon his strategy and adopt a social welfare maximizing attitude, L-like points would no longer be attainable.

As the investment in reputation has increased the long-run cost functions, only L' or L"-like points can be attained. The social waste can, therefore, be measured through HL"L or HL'L areas.

a. When the difference between the genuine and the fake is objective, that is, when the aesthetic good is not reproduceable, things are different. In this case, the producer can be indifferent to the fake, and therefore not invest in reputation. The consumer will, on his side, pay for "certification" as seen in chapter 6. This will reduce the quantity but decrease the possibility of the fake. In this sense, also the producer's welfare could be affected, but his investment in reputation is not needed.

b. Both the producer and the consumer are damaged. In this case, both "certification" costs and reputation investment can occur.

c. Only the producer is damaged as the consumer consumes the fake voluntarily, knowing it is false. In this case reputation investments are useless.

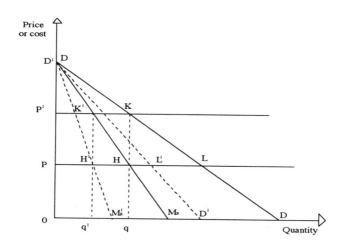

FIGURE 3

Case a is represented in figure 3. Here the quality-assurance prime causes a decrease in the demand curve (from DD to D'D') as it reduces proportionally the net resources available for consumption. The need for "certification" against forgery therefore causes a reduction in consumer's welfare as

$$P'K'D'<P'KD$$

which is true in any case of reduction of the demand curve. But it causes a reduction in the producer's rent, as

$$PHKP'<PH'K'P'$$

The social monopoly dead-weight loss is in this case unchanged as the first and second derivate of the demand curve are assumed to be unchanged (that is, the quality- assurance cost is assured to be proportional to quantity). It could, of course, not be so in the case of lower or greater than proportional incidence of the assurance premium on demand. Proportionality is, incidentally, assumed on the logical bases of the "certifiers'" monopolist behavior, as seen in chapter 6.

8.6 The abolition of copy-right

There is a radical remedy for at least partially avoiding the cumulative social waste of resources deriving from forgery.

If the producer's monopolist behavior were impossible, the supplied quantity would be equal to the social optimum one and no demand would be left unsatisfied.

This does not eliminate the need for "certification" which is based on the information asymmetry created by aesthetic qualification, but it eliminates the incentive to fake due to the monopolistic behavior of the self-certifier, that is on the assignment of the right on the aesthetic qualification.

To deregulate the right on the ideas embodied in an aesthetic good

means therefore to limit or to cancel copy-right in the literal sense of the word; that is, the certifier's right on the copies coming from the self-certified reproduction of the artwork. This does not include the cancellation of all the rights of the producer or of the interpreter to be protected against forgery. It includes, however, the impossibility of being protected against forgery reproduction in the process.

The producer's right on the idea embodied in his work is protected against forgery as far as the original piece of art (and its subsidiary use, like movies for novels) is concerned, not for its copies. This does not involve, of course, the opportunity of defending the publishers' right (if any) against pirates in those cases in which the fixed and variable copying costs are such as to create a welfare maximization problem to be resolved through regulation. This allows us to avoid the already mentioned contradiction between the producers' monopolistic behavior and his start-up investing strategy.

The producer has the right to react against the damage arising from the falsification of his original work, and, therefore, against information free-riding. His subjective monopolistic power, however, cannot be grounded on it. Perfect reproduceability, therefore, can no longer be a source of monopoly and, consequently, of forgery. The controversial assignment of the right to the producer's on the bases of his investment protection still needs to remain grounded in the possible "natural monopoly" argument. The producer must be guaranteed a monopoly market because of the specific ratio between the market size and the start-up investment needed for production.

This argument, however, can be rejected in the light of history and of Baumol's productivity law for artistic markets.

The legislation on the rights on "the embodied ideas" is a very ancient one, dating from the fifteenth century (Venetian law on the protection of the intellectual property dates from 1474). Copyright legislation, however, is much more recent, dating from the eighteenth century, that is from the very start of the technical mass reproduceability of art and cultural products.

No significant increase in artists' investment can be histori-

206

cally related to this, to ground the extension of the producer's monopolistic power in the natural monopoly scheme. Artists' investments are constant in historical trends while the market size of their products increases. The composition of a symphony requires an amount of learning, practice, talent and time-material which is substantially the same today as in Mozart's time. Contemporary composers's audiences, on the contrary, are incomparably larger.

This is, in fact, a very strong argument against natural monopoly, one that supports its elimination. The elimination of copy-right would put contemporary composers back in Mozart's shoes, without however eliminating the historical modifications in the market.

They would sell their music on "one shot" prices, as Mozart did.

Rent-seeking strategies would no longer be allowed on these bases. Mozart had to compose, and not just sign, to make his money (11).

The abolition of the right on copies would not solve, however, the problems rising from information asymmetry itself. The need for certification will always cause some market shortage. Forgery can be incentivated by it as well as by the mere possibility of illegally diverting the consumer's transfers from the producer.

Prevention strategies are therefore to be taken into account with the related net welfare loss. In this case, however, the validity of the Coase theorem could be restablished by means of the comparison between the producer's reputation/private prevention costs and the consumer's certification ones. (fig.4).

In this case, only qc-type quantities involve an equal cost for the two parties. Any cost asymmetry causing upward shifts of the curve of supply without reputation puts the consumer in the position of being "entitled" as "higher-cost-avoider". Viceversa for any downward move of the supply (12).

where

$P_cKHP'_c$	=	certification and reputation direct cost
$L(q_n, P_1)$	=	equilibrium with reputed supply
$H(q_c, P_n)$	=	equilibrium with certification

as H and K-like points are socially indifferent, because the areas

$$SHD = SKD$$

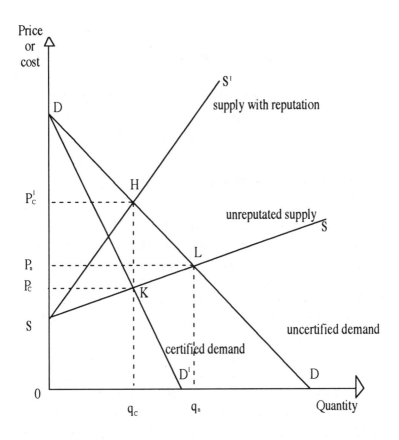

FIGURE 4

Of course H and K are different from the agents' point of view because for the consumer

KPH

and for the producer

$$HPK$$

as their surpluses are greater and lower in the two situations respectively.

Specifically

$$P_cKD-P'_cHD=SHP'_c-SKP_c$$

that is the consumer's benefit increase is equal to producer's loss and viceversa. This explains their willingness to act respectively to have a "certified" consumption and a reputed production.

8.7 Conclusions and summary

Forgery can be defined as an imitation of what is genuine. The difference between the genuine and the fake can be objective, and therefore caused by the nature of a good in itself, or subjective, and therefore caused by the nature of the rights on the good.

Genuine and fake are, moreover, linked by complementarity or substitutability according to the producer's attitude and to the consumer's perception.

Forgery is created by the different cost of the genuine and the fake but also by the market shortage due to the rent-seeking attitude of the producer. In this case genuine and fake are generally complements to increase his production to social optimum. This will be possible, without denying him protection on his right on his product, by abolishing his right on the "embodied idea", that is on the copies of his product. This would eliminate the incentive to forge arising from his monopolistic attitude, but not the protection and prevention costs and the related net social losses, restablishing, however, a Coase-theorem-type situation.

Technical reproduceability of aesthetically-qualified goods stresses this conclusion. The distinction between genuine and fake

is in this case only based on the assignment of the right on the idea embodied in the good (that is on its aesthetic qualification). The assignment of the right on the idea to the producer is moreover due to self-certification, which allows the producer's investment strategies to overcome the effects of information asymmetry. This right is, however, the grounds of the producer's monopoly giving rise to forgery. The rational solution for this vicious cycle would be to incentivate the producer.

210

Notes

(1) The "entitlement" is the "entitlement to prevail in case of conflictual interests of the parties" (Calabresi, Melamed (1972)).

(2) Coase (1960), Veljanosky (1982), Stephen (1988) pp.27-40, 41-63. Negotiation should make the rights "entitlement" indifferent under conditions of: perfect information, rational behavior of the agents, competitive markets, absence of transaction costs and of wealth effects. Negotiation need not necessarily be effective. It may be potential, following a Kaldar-Hicks version of the Pareto principle. In this case the right can be efficiently allocated to the party who should support the higher cost to defend himself against its violation, because he will always be able to refund the other for his loss, with a net welfare increase for himself and for society.

(3) Assuming that no wealth effects occur, in other words, that the "equivalent variation in income" is equal to the "compensating variation in income". Neither ask/offer kinds of problems nor bargaining strategies of the parties (for example "chicken-game"-like) are taken into account. This is in order here to isolate the mere effects of the information asymmetry due to aesthetic qualification and the "certification" strategies arising from it (see Sugden (1988)).

(4) To put it another way: who can protect himself at the lower cost? The producer. The entitlement should therefore be given to the consumer, compelling the producer to supply protection to society at the lower cost (which is the cost of abandoning his rent position). The entitlement could also be seen as the result of the application of Posner's position: "When transaction costs are prohibitive, rights should be assigned to those who value them the most" (Veljanovsky (1982)), as the consumers' large numbers are a source of effective negotiation impossibility.

(5) Burrows, Veljanovski (1981), pp.170-171.

(6) Stephen (1988) p.61.

(7) Bonhams auction house has organized a new great sale of fakes (including those of Rembrandt and Van Gogh) at the end of 1992. Some years ago this house auctioned a set of copies by Tom Keating, the greatest living English forger of ancient paintings. He produced more than two thousand fakes in more than twenty years of undisturbed work. Auction prices

reached the not insignificant level of £ 30, 000 per copy.

The Times reports that a New York Gallery ("True Fakes") has recently exhibited Picasso, Miro, and Leger's fakes.

(8) I am obliged for this definition to Tony Puu of the University of Umea and Stockholm, who first used it referring to cultural goods during an ICARE seminar in Venice, May 6, 1992.

(9) Buchanan, Tollison, Tullock (1980) and Rowley, Tollison, Tullock (1988).

(10) This is closely similar to the case of theft prevention. (Tullock (1967)).

(11) Some wider significant historical evidence of the uselessness of the copyright as a legal construct can be found in O'Hare (1982), where the illuminating case of the American eighteenth century unprotected market versus the British protected market is discussed. The American publishers' need to saturate the market with the first printing, to prevent piracy, made them substitute negotiations on the existing editions on the British market with those on "secret manuscript copies of works before their publication in Britain". "The price at which these secret manuscripts changed hands often exceeded the royalties British authors received from the entire British editions of their works, and did so in a country with a comparable but less wealthy population" (O'Hara (1982) p.34).

(12) Some kind of producer's liability could in this case be worked out on a "Learned Hand formula" basis that is under the principle: "The defendant is guilty of negligence if the loss caused by the event (...) multiplied by the probability of the event occurring, P, exceeds the cost of the precautions that the defendant might have taken to avert it, C" (Hirsch (1979)).

CHAPTER 9

AESTHETIC TRADE-OFF AND INFORMATION THEORY:

SOME CONCLUDING REMARKS

9.1 Aesthetic qualification and information

The economic approach to aesthetic qualification used in the previous chapters arises from the meta-theoretical redefinition of the subject suggested in chapter 3.

The non-consequentialist nature of aesthetic qualified processes of production and consumption is analyzed by an over-simplified representation which is based on the informative nature of "creativity" and "interpretation". All the schemes put forward are also legitimized by the assumption of equivalence between "beauty" and "functional beauty". In other words, there is a perfect consequentialist situation from which all the other hypotheses are derived.

Differentiating "beauty" from "functional beauty" allows us to differentiate the agents' behavior by means of an internal qualification of non-consequentiality (either for the producer or for the consumer, or for both of them). This qualification results, first of all, in modifications in the agent's behavior because it changes his economic functions (of consumption, production, investment, etc) as his decision-making axioms have been changed.

Starting from a theoretically "perfect world" we move to a "new world" where aesthetically-based strategies are significant and where non-consequentialist optimization is possible. In doing so, we used the equivalence: information=aesthetic qualification by means of the representation of the economic value of the information in which the aesthetic qualification is assumed to consist. This value has been considered as a "lump-sum" value throughout this study with no reference to the specific aesthetic content of the information, which is outside the scope of the analysis.

9.2 The hermeneutic nature of information

We do not know what link there is between the aesthetic attribute and its value. We only know that it has a positive value for the subject creating or interpreting it, as no structuralist or linguistic formalist

analysis can give a complete decription of an artwork. All this is consistent with the modern theory of aesthetics and specifically with the most recent development of hermeneutics which has come to a definite denial of the "methodological pretensions of structuralism" (1) to give a complete analytical explanation of an art work. "The linguistic-symbolic form is not a well displayed whole but rather only some mere vestige of the strength (of life, of the "presence" of art) which cannot return to reality " (2).

"This explains the deep note, the spleeny pathos sounding through the triumphal claims of bright technicality and mathematical sophistication of some 'structural' analysis" (3).

In other words, aesthetic qualification can be detected but not scientifically "measured" even from the point of view of aesthetics. This does not mean, however, that it has no value. Its value can simply not be defined by means of structural measures and relationships.

"The work of art represents paradigmatically the idea of a 'trace' which cannot be definitively consumed either through interpretation or through the pretended exhibition of its object" (4).

This position in the field of aesthetics is anything but a part of the more general decline of "neo-positivist pretention of art and science to be the complete and adequate representation of an objective and steady reality". On the contrary, "Philosophers do not describe the same object, do not talk about the same things, but they rather use different words in order not to understand the world in its physical consistency but aiming at a self-understanding of culture as a system of linguistic-symbolic forms" (5). Descriptions of reality through its measurement aiming at universal validity, are substituted by literal descriptions:"Philosophy is a kind of writing", no different in its pretentions of objectivity and universality from poetry or novel-writing (6). Aesthetic information, therefore, cannot be measured, but only hermeneutically-described in this sense.

9.3 What economic value do descriptions have?

The above-presented conclusion takes us back to the parallel

between the aesthetic and ethical qualification of economic analysis.

No redistribution principle based on pure quantitative measure can be satisfactory from the point of view of equity if individual capabilities are taken into account. How can we objectively measure the redistributional need of a cripple if compared with a healthy man? (7)

Like aesthetic quality, ethical quantity cannot be measured but only described. Some kind of "incommensurability principle" has thus to be stated (8). Aesthetics do not permit economic consequentialism between causes and their effects. But a non-consequentialist point of view is not a nonsense point of view.

Descriptions can be economically, ethically and aesthetically meaningful at the same time, that is, they can be an instrument for organizing the trade-off among the three analytical attributes that also characterized any normative solution.

As in Sen's illuminating example, the proposition "Michelangelo produced the statue of the David" differs from that "this stone quarry produced the statue of the David" because the former captures the source of "imagination" of the statue, while the latter describes its material source (9). The implication of choosing one description or the other on the theory of value is now clear to us in the light of the discussion in chapter 5, where the problem of income distribution under aesthetic assumptions was examined.

As Sen points out, the limitation of the theory of utility to a "theory of the silent choice", precludes any descriptive enquiry into human joys and sorrows (10). Deprived of aesthetics, not only the economy but also economics become "joyless" (11). A descriptive world is thus more exhaustive than a merely utilitarian one.

To describe raises the question of how to describe, as description is a discriminating definition of the links between any agent's options (or actions) (12), and this is an open question. In this sense tentative quality interpretation exercises offer meaningful possible solutions (see chapter 2).

The description of the agent's options is thus, on one side, a description of individual motivations and obligations, generally of each agent's "capacities", and on the other, a description of the conflicting social set of motivations and obligations, as any description involves a language (and therefore a "communication" aim)

218

which has to be situated in history (13).

Aesthetics involves specific individual internal specific "obligations" (on the part of the artist or of the interpreter towards the artwork, to the need to satisfy their creative or interpretative requirement the best they can). This "obligation" is manifested by the "wonderment", (Kant's "shiver", Shiller's "play" or Nietzche's "spirit of music") which precedes the "contemplation" of the created or the interpreted perfection (14).

The problem of describing the agent's options has therefore been tentatively solved here by the attribution of a positive value to the information representing individual aesthetic motivations and obligations. This involves a positive relationship between aesthetic experience and preferences.

For artists, creating is better than not creating, which is plausible under an "obligation" constraint of the above certified nature. This grounds the assumption on the positive economic value of aesthetic information on the same meta-theoretical axoms on which the aesthetic qualification of economics has been grounded. The "obligation" to produce is something that places the whole production process on un-necessarily consequentialist bases.

On the contrary, this is not a value judgement referring to theoretical aspects of the analysis: that is to say, it is not a judgement of the kind: "beautiful is good" or "ugly is bad".

This is not in fact an assumption concerning "beautiful" or "ugly", but only the relationship between the "creation" process and the "creator's" preferences which is, in itself, perfectly consequential.

9.4 Descriptions and aesthetic trade-offs

The second problem to be solved using descriptions either as decision-making or analytical bases in economics is that of how to take into account their "historical" nature. This affects individual motivations influencing both their own frame of reference and the collective one. This also affects the meaning of descriptions as it changes the lexical significance of the descriptive terms.

The well-known example of the nice house in a slum environment can be recalled here. A family will certainly always be better off if it is allowed to move from its small house with a backyard to a larger one with a nice garden surrounding it. *Ceteris paribus* (that is, the size of the new house being equal) they will be happier if the environment changes and they are able to move from a slum area to a residential one. To put it in another way, they will be happier in a house with a small backyard in a residential area than in a large house with a garden in a slum (15). Moreover, what is "nice" in a slum environment can be "ugly" in a residential one. Historical deep modifications of tastes and of the aesthetic theory itself have already been discussed in chapter 1. The word "art" has constantly changed its meaning throughout history.

Describing the aesthetic qualification under this respect means, therefore, resorting to historical analysis. To choose to represent the link between the information expressing the aesthetic qualification and the economic frame of reference (that is, its value) by means of a "lump-sum" value, depends on this.

Lump-sum values supply the more neutral modifications in a partial equilibrium context, as the one we have chosen to simplify the analysis. Using them, we suspend our judgement on how the aesthetic qualification of a process may be defined in history. We merely say that it affects positively and at least once, the value of the good it qualifies (or the one which is the object of the aesthetically-qualified process).

This is, incidentally, all that is needed to mark the difference, in other words to define the effects on value of our new metatheoretical axiom. All the rest is useless because it can always be explained by means of the usual theoretical consequentialist schemes, or rather because any further reference to meta-theory for a consequential foundation of the value of aesthetic information would be contradictory in itself. This leads back to the presentation (chapter 3) of the aesthetic problem as the introduction of a third trade-off dimension in any decision-making process. As for the ethical problem, this new dimension is one which can be historically expressed by constraining efficiency maximization problems. How can this be done? In a way which changes depending on historical times, independently from the market and from functionality enhancements.

220

The complexity of any aesthetic description in this sense is encapsulated in a critic's judgement on John Cage, expressed at the musician's recent death: "He was worth more than his music". His "prepared piano" sonatas, as well as his "4'33" celebrated "non-silent silence", or his sounding plants recording ("Song of a tree") were, and continue to be, a matter of permanent conflict in the aesthetic field, which nevertheless influenced all contemporary music, from Stockhausen and Kagel to Moog-Keith Emerson's "electronic way to rock" of the Sixties and Brian Eno's music in the Seventies, to the most recent works by Laurie Anderson and Philip Glass.

Aesthetic terms of reference for decision-making trade-offs are based on complex aesthetic descriptions which change over history as the result of interpersonal conflicts, the nature of which is also non-consequentialist. What is aesthetically influential can, with no contradiction, be unsuccessful on its market at the same time.

9.5 Conclusions

The specific discussion on the information meaning and value of aesthetic qualification clarifies the grounds on which our analysis has been based and specifically the assumption we made on the value of information.

This is positive in its value because of the positive relationship between the author's or interpreter's "obligation" to the work of art and the "creativity"/"interpretation" process. A creator is better off if he creates as he is compelled to.

No value is added to the information representing aesthetic qualification by its specific contents. As a matter of fact it is not conceived as information on the quality of the good aimed at filling the information gap on its quality due to its artistic nature (see chapter 4).

On the contrary, it is the source of an information specific asymmetry which characterizes the whole aesthetic process. The information value is also conceived as a "lump-sum" value, as it has at least one effect in a whole given "creation" or "interpretation" process. No more can be said without moving into arbitrariness, because of the complex

historic nature of any judgement. Methodologically speaking, aesthetic terms of reference for decision-making trade-offs can be better studied through neutral assumptions.

Incidentally, no more needs to be said to transfer the original non-consequentiality axioms to the field of economic theory, as all the rest is perfectly consequential.

222

Notes

(1) Givone (1988) p.212.

(2) Givone (1988) p.211 also Derrida (1967), (Italian edition). "Form fasci-
nates when interior strength becomes unattainable, that is when one no
longer has the strength to create. This is why literary critics have always
been structuralist in their being and destiny."
"The 'difference' between Dionysus and Apollo, between 'burst' and
'structure' is not cancelled by history, because this 'difference' is simply
neither a part of history nor 'structure'. " (Derrida (1967) Italian Edition
p.36).

(3) Derrida (1967) p.5.

(4) Givone (1988) p.212 reporting Derrida p.6 (1967).

(5) Ibidem, p.219.

(6) Rorty (1982), Italian Edition, p.108, and Givone (1988), pp.219-220.

(7) Sen (1986).

(8) See Taylor (1984), p.174, for this discussion applied to ethics.

(9) Sen, (1986), p.415.

(10) Ibidem, p.418.

(11) See Scitovsky (1976).

(12) See Schick (1982).

(13) Rorty (1982).

(14) Pareyson (1991), p.200 and p.295, and Formaggio (1977), p.31.

(15) Frank (1989).

References

Abbing H. (1980), "On the Rationale of Public Support of the Arts: Externalities in the Arts Revisited" in Hendon, Shanahan, Mc Donald (eds.) (1980). pp. 34-42.

Adler M. (1985), "Stardom and Talent" Amer. Econ. Rev, Mar, 75, 1, pp.208-12.

Adorno T. (1975), Teoria estetica, Turin, Einaudi.

Akerlof G.A. (1970), "The Market for "Lemons": Qualitative Uncertainty and the Market Mechanism", Quart. Journ.Econ. Aug., 84 (3), pp.488 - 500.

Anonymous (1738), Some Thoughts on the Interest of Money in General, in R.L. Meeks, (1956) Studies in the Labour Theory of Value, London, p.43.

Ashworth G.J., Voogd H. (1986), "The Marketing of Urban Heritage as an Economic Resource", in Angenent J. Bongenaar A. (eds.) Planning Without a Passport, Utrecht, Elinkwyk.

———— (1992) "Whose History, Whose Heritage? Management Means Choice", mimeo, University of Krakow International Seminar on "Managing Tourism in Historic Cities", July.

Austen-Smith D. (1980), "On Justifying Subsidies to the Performing Arts", in Hendon, Shanahan, Mc Donald, (eds.) (1980), pp.24-32.

Baumol W.J. (1967), "Macroeconomics of Unbalanced Growth: The Anatomy of Urban Crisis", Amer. Econ. Rev., June, pp.415-426.

Baumol W.J. (1980), "Unnatural Value: or Art Investment as Floating Crap Game", Amer. Econ. Rev, AEA P&P, May, 76 (2), pp.10 -14.

Baumol W.J., Bowen W.G. (1956), "On the Performing Arts: The Anatomy of their Economic Problems", Amer. Econ. Rev., May.

———— (1966), The Performing Arts: The Economic Dilemma, New York, Twentieth Century Fund.

Bayer E. (1961), Histoire de l'estétique, Paris.

Becker G.S., Grossman M., Murphy K.M. (1991), "Rational Addiction and the Effect of Price on Consumption", Amer.Econ.Rev., AEA P&P, May, 81 (2), pp.237-241.

Becker G.S., Murphy K.M. (1991) "A Theory of Rational Addiction", Journ.Pol.Econ., August, 96 (4), pp.675-700.

Becker G.S., Stigler G.J. (1977), "De Gestibus Non Est Disputandum", Amer.Econ.Rev., March, 67 (2), pp.76-90.

Besley T. (1988), "A Simple Model for Merit Good Arguments", Journ.Publ.Econ.,

224

35, pp.371-383.

Biolo S. (ed.) (1991), La questione dell'utilitarismo, Genoa, Marietti.

Birch D. (1971) "Toward a Stage Theory of Urban Growth", Amer. Institute of Planners Journ., March, pp.78-87.

Blaug M. (ed.) (1976), The Economics of the Arts, Boulder, Westview.

Blaug M. (1978), Economic Theory in Retrospective, Homeward, Irwin.

Boulding K. (1987), Ecodynamics: A New Theory of Societal Evolution, Beverly Hills, Sage.

Breadsley C. (1966), Aesthetics, London.

Buchanan J., Tollison R., Tullock G. (eds.) (1980) Toward a Theory of the Rent-Seeking Society, Texas, A&M, University Press.

Burrows P., Veljanovski C. (1981) The Economic Approach to Law, London, Butterworth.

Chatelet F. (ed.) (1976), La filosofia dell'Illuminismo, Milan, Rizzoli.

Coase R. (1960), "The Problem of Social Cost", Journ. Law and Econ. 3, pp.1-44.

Conti A. (1988), Storia del restauro e della conservazione delle opere d'arte, Milan, Electa.

Cournot A. (1872), Considerations sur la marché des idées et des événements dans les temps moderns, Paris.

Cournot A. (1911), Traité de l'enchainement des idées fondamentales, Paris.

Croce B. (1958), Estetica, Bari, Laterza.

Deaton A. Muellbauer J. (1986), Economics and Consumer Behavior, New York, 1986.-

Deleuze G. (1976), "Hume", in : Chatelet F., (ed.) (1976) Rizzoli, pp.42-51.

Denis H. (1978), Storia del pensiero economico, Milan, Mondadori.

Derrida J. (1967), L'écriture et la difference, Paris, Ed. du Seuil.

Desné R. (1976), La filosofia francese nel Settecento, in Chatelet F. (ed.) (1976), pp. 52-95.

Dyer A.W. (1986), "Veblen on Scientific Creativity: The Influence of Charles S. Pierce". Journ. Econ. Issues, XX, 1, March, pp. 21-41.

— — — — — — — (1988) "Economic Theory as an Art Form", Journ. Econ. Issues, vol. XXII, 1 March, pp.157-166.

Downs A. (1956), Economic Theory of Democracy, London, 1956.

Formaggio D. (1977), Arte, Milan, ISEDI.

— — — — — — — (1981), Trattato di estetica, Milan.

Fossati A. (1989), Economia pubblica, Milan, Angeli.

Frank R.H. (1989), "Frames of Reference and the Quality of Life", Amer. Econ. Rev., AEA P&P May, 79 (2), pp.80-85.

Fullerton D. (1991), On Justifications for Public Support to the Arts, Journ. Cultural Econ. vol. XV, n.2, December. pp.67-82.

Galbraith J.K. (1973), Economics and the Public Purpose, Boston, Houghton Mifflin.

Gapinski J.H. (1981), "The Production of Culture", Review Econ.and Stat., 62, 4, Nov. pp.578-86.

Giardina E. (1969), "Contributo alla teoria pura dei beni pubblici: la scelta della qualità", Riv. dir. fin. e sc. fin., marzo., pp. 3-20.

Gibbard A. (1974), "A Pareto Consistent Liberation Claim", Jour. Econ. Theory, 7.

Givone S. (1988), Storia dell'estetica, Laterza, Bari.

Gold A. (1975-6), "Welfare Economics of Historic Preservation" Connecticut Law Review, 8, pp.348-369.

Greenwald B.C. Stiglitz J.E. (1986), "Externalities in Economics with Imperfect Information and Incomplete Markets", Quart.Journ. Econ. 1986, May, pp.229-264.

Greenwald B.C. (1989), "Pareto Inefficiency of Market Economies:Search and Efficiency Wage Models", Amer.Econ.Rev., AEA P&P, May, 78 (2), pp.351-355.

Grossman, Sanford, Stiglitz (1976), "Information and Competitive Price System", Amer.Econ.Rev., May, 66 (2), pp.246-253.

— — — — — (1980), "On the Impossibility of Informationally Efficient Markets, Amer.Econ.Rev., June 70 (3), pp.393-408.

Hale R.D. (1978) "Economic Aspects of Historic Preservation", Jour.Cult.Econ., 2, 2, Dec., pp.43-53.

Haller A., Carter O., Hocking J. (1957), "A Note on the Transcendental Production Function", Jour.Farm.Econ., 39, Nov. pp.966-974.

Hammond P.J. (1981), "Ex-ante and Ex-post Welfare Optimality under Uncertainty", Economica, 1981, August 48, pp.235-250.

Harsanyi J. (1988), L'utilitarismo, Milan, Saggiatore.

Haskell F. (1976), Rediscoveries in Art, London, Phaidan Press, It.ed. Milan, Edizioni Comunità, 1990.

Heilbrun J. (1974), Urban Economic Policy, New York, St. Martin's Press.

Hellbrun J. (1984), "Keynes and the Economics of the Arts", Journ. Cultural Econ. vol.VIII, n.2, Dec., pp.37-49.

226

Hendon W., Shanahan, J. Mc Donald A. (eds.) (1980) Economic Policy of the Arts, Cambridge (Mass) MIT Press.

Hirsch W. (1979), Law and Economics: an Introductory Analysis, New York, Academic Press.

Hollander S. (1973), The Economics of Adam Smith, Toronto, Univ. of Toronto Press.

Hutcheson V. (1747), Introduction to Moral Philosophy Glasgow.

Jessen F., "Addictive Goods and the Growth of Government", Public Choice, 40, pp.101-103.

Kalman P.J. (1968), "Theory of Consumer Behavior, When Prices Enter the Utility Function", Econometrica, July-Oct.36, pp.497-510.

Kant E. (1790), Critique of Judgement, it. (ed.). 1991, Bari, Laterza.

Kakee A., Towse R. (eds.) (1992), Cultural Economics, Berlin, Springer Verlag.

Lee K. (1991), "Transaction Cost and Equilibrium Pricing of Congested Public Goods with Imperfect Information", Journ.Publ.Econ., 45, pp.337-362.

Leibenstein H. (1950), "Bandwagon, Snob, and Veblen Effects in the Theory of Consumers Demand", Quart.Journ.Econ., May, pp.183-207.

Marshall A. (1906-1920) Principles of Economics, London, Mac Millan.

Mc Cain R.A. (1979), "Reflection on the Cultivation of Taste", J. Cultural Econ., June, 3, pp.30-52.

——————— (1981), "Tradition and Innovation: Some Economics of the Creative Arts, Science, Scholarship and Technical Development" in Galatin M., Leiter, R. Economics of Information, Boston, Nijhoff, pp 173-204.

——————— "Artists' Resale Dividents:Some Economic - Theoretic Considerations, Journ.Cult.Econ. (...), pp.35-51.

Mc Closkey D. (1983), "The Rhetoric of Economics", Journ Econ. Literat., 21 June, pp.481-517.

Mac Closkey D. (1985), The Rhetoric of Economics, Madison, Univer. of Wiscounsin Press.

Mc Cormick R., Shugart H., Tollison R. (1984), "Disinterest in Deregulation" Am.Econ.Rev., n.74, 5, Dec.pp.1075-79.

Mill J.S. (1863), Utilitarism, it. (ed.).reprinted in Fanni G. (ed.) Antologia, Turin, Loescher, p.196, (1958).

——————— (1848) Principles of Political Economy, Robson J. (ed.)

(1965) Collected works of John Stuart Mill.

Mossetto G. (1990), "A Cultural Good Called Venice" IACE Conference, Umea, May, in Kakee A, Towse R. (eds.) (1992) pp.247-256.

———————— (1991 "The Economics of a City of Art:a Tale of Two Cities", Ricerche Economiche, 1-2, 1992 (ed.).

———————— (1992 a), "Arts as A Public Good: An Analysis of Consumer Demand", Note di Lavoro, 1, Dept. of Economics, University of Venice.

——————— (1992 b), "Aesthetics and Economics:a Social Choice Approach", Note di Lavoro, Dpt of Economics, Univ. of Venice.

——————— (1992 c), "Why Have Economists been Concerned with the Arts?", Ricerche Economiche, n.1-2.

Netzer D. (1978), The Subsidized Muse: Public Support for the Arts in the United States, London, Cambridge Univ. Press.

Nijkamp P. (1991), "Evaluation Measurement in Conservation Planning", Journ. Cult. Econ., 15, 1, pp.1-27.

O'Hare M. (1982), "Copyright and the Protection of Economic Rights" Journ. Cult.Econ., pp.33-48.

Pareto V. (1896-97), Cours d'économie politique, Losanne, it. trans. Turin, Boringhieri, 1961.

Pareyson L. (1991), Estetica, Milan, Mursia.

——————— (1984), L'estetica di Kant, Milan, Mursia.

Peacock A. (1968), "Public Patronage and Music:An Economist's View", Three Bank Review, March.

——————— (1969), "Welfare Economics and Public Subsidies to the Arts". The Manchester School, XXVII, 4, Dec. pp. 323-335.

——————— (1991), "Economics, Cultural values and Cultural Policies, " Journ. of Cultural Econ. pp. 1-18.

Pierce C.S. (1931-35-58), Collected Papers of Charles Sanders Pierce, Cambridge (Mass), Harvard Univ. Press.

Pietranera G. (1963), La teoria del valore e dello sviluppo capitalistico di Adamo Smith, Milano, Feltrinelli.

Puu T. (1991), On Progress and Perfection in the Arts and Sciences, Ricerche Economiche, 2-3, 1992.

Ricardo D. (1817), On the Principles of Political Economy and Taxation, in P. Sraffa ((ed.) (1951-73), The Works and Correspondence of David Ricardo,

228

Cambridge, Cambridge Univ. Press, Ital. (ed.). 1976, Milan, ISEDI.

Robbins L. (1935), An Essay on the Nature and Significance of Economic Science, London, Mac Millan.

Robbins L. (1963), Art and the State, in Politics and Economics: Essays in Political Economy, London, Mc Millan.

Rosen S. (1981), "The Economics of Superstars", Amer. Econ. Rev., Dec. 71, 5, pp.845-58.

Rowley C., Tollison R., Tullock G. (eds.) (1991), The Political Economy of Rent-Seeking, Boston, Kluwer.

Ruskin J. (1882), "The Stones of Venice" in The Works of John Ruskin, 1903 -12, London.

Scitovsky T. (1988), "Culture is a Good Thing", Jour.Cultural Econ: 1989, June, vol. XIII, n.1, pp.1-16.

Sen A. (1982), Choice, Welfare and Measurement, Oxford, Blackwell.

Sen A. Williams B. (1982), Utilitarism and Beyond, Cambridge (Mass), Camb. Univ. Press.

Shubik (1984), A Game - Theoretic Approach to PoliticalEconomy, Cambridge (Mass) MIT Press.

Smith A. (1789), An Inquiry into the Nature and Cause of the Wealth of Nations, in Cannan E. (ed.), London, Methuen, 1961, Ital. (ed.). Milan, ISEDI, 1973.

Sraffa P. (1960), Production of Commodities by Means of Commodities.Prelude to a Critique of Economic Theory, Cambridge, Cambridge Univ. Press.

Stephen F. (1988), The Economics of the Law, Hemel Hamstead, Harvester Wheatshealf.

Stiglitz J. (1987), "The Causes and Consequences of the Dependences of Quality on Price" Journal of Economic Literature, XXV, March, pp.1-48.

Sugden R. (1986), The Economics of Rights, Co-operation and Welfare, Oxford, Basil Blackwell.

Tatarkiewicz W. (1979-84), Storia dell'estetica, Turin.

Throsby D. (1990), "Perception of Quality in Demand for the Theory", Journ. Cultural Econ., June, pp.65-82.

Throsby and Wither G. (1979), The Economics of the Performing Arts, Melbourne, St. Martin's.

Tollison R. (1992), "The Economics of Medieval Church", mimeo, Venice, ICARE, 1st International Workshop, Feb.

Troub. R. (1980), "The Art in Economics: Conventional, Institutional, and Neoinstitutional", in Hendon, Shanahan, Mc Donald, (eds.). (1980), pp.7-17.

Tullock G. (1967), The Welfare Costs of Tariffs, Monopolies and Thelf, Western Journ. Econ. (Econ. Inquiry), 5, June, pp.224-232.

Veblen T. (1964), "Kant's Critique of Judgement", in Essays in Our Changing Order, New York, Kelley, (reprint).

Veblen (1899), The Theory of Leisure Class, reprint, New York, Penguin, 1981.

Veca S., "Utilitarismo e Contrattualismo" in Lecaldano E.,

Veca S. (eds.), Utilitarismo oggi, Bari, Laterza.

Veljanovski C. (1982), The New Law-and-Economics-A Research Review, Oxford, Center for Legal Studies

———————— (1982 b), "The Coase Theorems and the Economic Theory of Markets and Law" Kyklos, 35 (1), pp. 66-81.

Walras L. (1874), Eléments d'économie politique pure, ou théorie de la richesse sociale, (1952 rep.), Paris, Pichou, Durand.